EMMA PEARCE'S Artists MATERIALS

THE COMPLETE SOURCEBOOK OF METHODS AND MEDIA

EMMA PEARCE'S STUSIS MATERIALS

THE COMPLETE SOURCEBOOK OF METHODS AND MEDIA

Arcturus Publishing Limited 26/27 Bickels Yard 151–153 Bermondsey Street London SE1 3HA

Published in association with foulsham

W. Foulsham & Co. Ltd, The Publishing House, Bennetts Close, Cippenham, Slough, Berkshire SL1 5AP, England

ISBN 0-572-03146-7

This edition printed in 2005
Copyright © 2005 Arcturus Publishing Limited
Emma Pearce has asserted her right to be identified as the author of this work, in accordance with the Copyright, Designs and Patent Act 1988.

All rights reserved

The Copyright Act prohibits (subject to certain very limited exceptions) the making of copies of any copyright work or of a substantial part of such a work, including the making of copies by photocopying or similar process. Written permission to make a copy or copies must therefore normally be obtained from the publisher in advance. It is advisable also to consult the publisher if in any doubt as to the legality of any copying which is to be undertaken.

WINSOR & NEWTON, SANSODOR, LIQUIN, SERIES 7 and the GRIFFIN device are trademarks.

Winsor & Newton, London, HA3 5RH, England. WWW.WINSORNEWTON.COM

British Library Cataloguing-in-Publication Data: a catalogue record for this book is available from the British Library

Printed in China

CONTENTS

Preface		5
Chapter I	OIL PAINTING	7
Chapter 2	ACRYLIC PAINTING	41
Chapter 3	ENCAUSTIC PAINTING	49
Chapter 4	TEMPERA PAINTING	57
Chapter 5	WATER COLOUR AND GOUACHE PAINTING	71
Chapter 6	GESSO GROUNDS	89
Chapter 7	PAPER	109
Chapter 8	DRAWING MATERIALS	117
Chapter 9	PIGMENTS	135
Chapter 10	COLOUR MIXING	155
Chapter II	ARTISTS' BRUSHES	163
Chapter 12	HEALTH & SAFETY	171
Appendix I	STORING, FRAMING AND CARE OF ARTWORK	175
Appendix II	NOTES FOR VEGETARIANS	177
Glossary		179
Bibliography		181
Acknowledgements		184
Index		185
About the author		192

PREFACE

On setting myself the challenge of revising Artists' Materials, Which, Why & How, I was pleasantly surprised by what a useful little book it was! As my work continued, however, I realized just how much I have learnt from thirteen years at Winsor & Newton. The result is a completely updated edition with more than fifty per cent of the content revised or completely new.

For me, the technical side of painting is a jigsaw, with every piece interlocking and somehow all belonging to the whole. My efforts have been to cover all these pieces and show how each part of the painting process can affect the next.

I sincerely hope I have been successful and that both new and established artists will find most if not all the answers to their questions in Artists' Materials – The Complete Sourcebook of Methods and Media.

EMMA PEARCE

The information in this book is supplied in good faith and to the best of the author's knowledge is correct.

However, neither the author nor the publisher can be held responsible for any harm which results from contact with or use of the methods and materials within this book.

The advice regarding studio-made materials is given in general terms and does not relate to the detailed formulations which make up Winsor & Newton colour.

CHAPTER ONE OIL PAINTING

Oil paint can be used thinly or thickly, smooth or textured, opaque or transparent, wet into wet or wet on to dry. Once dry it is insoluble. Painting can be resumed at any time, but the original cannot be removed and pentimento (see page 34) and residual texture should be considered. Oil painting rules need to be considered at all times (see page 32).

SUPPORTS

CANVAS on open stretchers gives a sensitive, receptive woven support on which to paint and provides a tooth for the primer and paint to grip.

BOARDS can be used if a hard weaveless surface is preferred. See Chapter 6 (page 90) for types of board and their initial construction and preparation.

CANVAS MOUNTED ON

BOARD can be used for a hard surface which retains the texture of cloth.

PAPER Oil paint can acceptably be applied to a heavyweight rag paper (although it will be fragile) provided it is kept flat and supported in a portfolio or frame. Stretch the paper first and then prime it thinly with acrylic gesso primer, see fig. 92. Millboard (a dense grey/brown paper-based board) can be used instead of hardboard and should be primed thinly with acrylic gesso primer on the front, back and sides.

OTHER SUPPORTS include metals (aluminium, steel, copper) and glass.

CANVAS

Canvas provides a surface which the priming and painting can grip. The less hygroscopic the canvas is, the less it will expand and contract and the better for long-term tension. Artists' canvas, as opposed to other fabrics, should be used because the thread has been evenly spun and woven, resulting in more even tension during the preparation of the canvas and the life of the painting.

TYPES OF CANVAS

The various types of canvas each provide a different surface.

Pure unbleached linen is made from the flax plant from which linseed oil also comes. The heavier-weave linen is often called flax canvas. It sizes, stretches and primes well and comes in a variety of surface textures.

Bleached linen does not take sizing and priming as well as unbleached linen and is not easily available.

Cotton canvas (often called duck) does not size or prime as well as linen; the size and primer tend to lie on the surface rather than grip the cloth. It does not have the physical property of stretching like linen. It comes in one basic surface texture, depending on the brand, and has a less sensitive feel to it. It is approximately half the price of medium-weight linen.

Linen and cotton mixtures are not desirable to use for painting, despite the fact that the size and primer grip more than on cotton. The conflicting fibre characteristics create differing tensions across the cloth which outweigh any other advantages.

Natural and synthetic mixtures are not recommended for the same reason.

I. Canvas pieces, from left to right: portrait linen, fine linen, flax, bleached linen, cotton, hessian, polyester

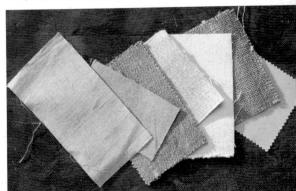

Hessian Hemp and jute are very cheap but do not take a ground at all well and quickly become brittle. Flax canvas offers a similar surface to work on.

Polyester cloths are far less hygroscopic than a natural cloth, do not embrittle and hence suggest greater stability. They can come with different surface textures. Unfortunately, not enough research has yet been done on how to size and prime them for oil painting and those concerned with permanence should stick with linen or cotton.

Commercially prepared canvases and

boards There is no doubt that preparing your own supports will give you added control over your work. However, if you don't want to make your own, ensure good handling and permanence by buying grounds from a reputable brand. The quality of ready-made canvases and boards can vary in the market place (see page 21 for testing the quality of primed canvas).

Primed canvas sold on a roll is more difficult to stretch; an expandable stretcher is a must to get the canvas flat. Commercially prepared supports tend to look rather mechanical compared to ones prepared by the artist.

INITIAL PREPARATION OF CANVAS

A new piece of linen resists the size, possibly because of the use of starch or polishing by the manufacturer. It is important that the size goes into the cloth and doesn't float on top of it (see page 17). New cloth also shrinks when the size is applied. Most warped canvases are due to this tension in the cloth putting the stretcher under undue stress. This problem can be solved by rinsing the new cloth in water and drying it prior to putting it on the stretcher.

If you are cutting linen to fit a stretcher, measure the new cloth 25 cm (10 in) longer in each direction than the dimensions of the stretcher to allow for shrinkage. A 50 \times 75 cm (20 \times 30 in) stretcher needs a new piece of cloth measuring 75 \times 100 cm (30 \times 39 in), which includes enough overlap of canvas to fold over the stretcher bars as well. This is an average in case you don't know in which direction the width/length of the cloth is going. In fact a new piece of linen 184 cm (72 in) in width will shrink to approximately 180 cm (70 $^3/_4$ in), while 184 cm (72 in) from the length of the roll will shrink to approximately 171 cm (67 in). Cotton shrinks far less than this and still resists the size. There is probably little gain in pre-wetting cotton canvas.

Keep the creases to a minimum when wetting the cloth as they will not come out if you have squeezed it. They will interfere visually with your painting. To avoid creasing, wet manageable-sized pieces, lightly rolled, in as large a bath or sink as possible. Simply submerge the cloth until fully wet and then hang it up to drip dry. When damp-dry the cloth can be ironed on the hottest setting. See *Using creased cloth* (page 14) if you must use creased canvas; for alternative methods of preparing the cloth, also see page 14.

If using linen with acrylic gesso primer you may get the final canvas flatter by not rinsing the cloth.

De-acidifying canvas

Before ironing you can de-acidify the canvas, which may increase its life by up to 10 times. Canvas can also be de-acidified for use with acrylics and other media.

Proprietary de-acidifying products are available, but a cheaper method of de-acidifying is to spray the canvas with a solution of fresh calcium hydroxide and water. Put 2 g of calcium hydroxide and I litre of distilled water in a bottle and shake it. Allow it to settle. Use the clear liquid in an atomizer (fig. 94) or plant mister to wet the canvas. Leave to dry and then iron.

For cotton, you can de-acidify after stretching and before sizing.

Sewing canvas together

Canvas can be joined together by sewing, though the join is likely to show. The thread should ideally be the same fibre as the canvas and a strong sewing machine will be needed. Use a flat seam and keep the weave of the cloth running parallel up the join.

STRETCHING CANVAS

An adjustable stretcher makes it easier to get a flat canvas to the tension you want.

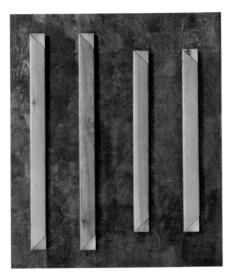

2. Stretcher pieces

3. Assembled stretcher

Making up a stretcher

For work under about 60×60 cm $(24 \times 24 \text{ in})$, 45 mm $(1\ ^3I_4\ \text{in})$ stretcher pieces can be used. For larger work use 57 mm $(2\ ^1I_4\ \text{in})$ or 70 mm $(2\ ^3I_4\ \text{in})$ pieces. A crossbar should be used for sizes over 71×91 cm $(28 \times 36\ \text{in})$, and multiple crossbars used for larger works. Without them the stretchers are very flimsy. Where possible, choose stretcher pieces with bevelled edges (fig. 4) to ease the long-term stress on the canvas and prevent the inner edge showing as a ridge on the front surface.

Use a wooden mallet to put the stretcher pieces together. Drive the corners together until they meet. This leaves maximum room for expanding the stretchers later. If there are any bevels, make sure they all face one way. If there are crossbars, ensure the joint with the frame is below and not above the front surface of the frame.

4. Cross-sections of stretcher pieces showing variety of bevels

5a. Chassis with one crossbar

5b. Three chassis with various multiple crossbars

A mason's set square can be used to ensure the chassis is square. Lie the chassis flat and butt up the set square to each corner. Keep working round the chassis until all the corners are square (you will find it easier to make small adjustments with your hands rather than the mallet). Once it is square, you can pin the tongue and groove joints together with four 12 mm (1/2 in) tacks to prevent it being knocked out of true. These can be removed later if you use the wedges (keys). The sized canvas will help to keep the chassis square once it is dry. Smaller set squares can be used but are not as accurate on larger canvases as the larger mason's set square.

6. Mason's set square and chassis

Placing canvas on the stretcher

Place the canvas on a flat surface and put the chassis bevel-side down with equal overlap all round. In order to be visually insignificant and to promote equal tension, the weave of the cloth should run parallel with the stretcher bars.

Unevenly pulled canvas will make the weave wavy on the front of the canvas.

7. Stretcher bar parallel with weave, and tack inning together tongue and groove joint

Size contracts the canvas as the size dries. Linen stretches more successfully than cotton and therefore needs minimum pulling over the stretcher and can in fact be quite floppy. If you pull it too much the weave will not remain parallel with the stretcher. Cotton canvas does not stretch and therefore needs to be pulled tight and flat on to the stretcher. If using acrylic primer then both linen and cotton should be stretched as flat as possible. Canvas pliers will help with cotton, particularly on large canvases. In either case follow the weave of the cloth in relation to the stretcher bar as you attach the canvas.

Put the staples or tacks into the back of the chassis; using the edge is awkward, makes framing difficult and reduces the durability of the canvas. Use 10 mm ($^{3}/_{8}$ in) staples or tacks – heavy-duty staples as lightweight ones rust too quickly. Put the first staple in the centre of one side and go from the centre to one corner and then from the centre to the other corner. Repeat on the opposite side, followed by the next two sides.

8. Canvas stretched except corners

To secure the corners, stand the canvas up and with the reverse of the chassis towards you, tuck in the excess canvas on the top of the right-hand corner. Drive a staple into the back of this edge, which is the thickest part of the stretcher piece. Do this to all four right-hand ends.

9. Stretcher piece corner showing tongue and groove joint

10. Final stretched corner pattern

Then go to each left-hand end and drive a staple into the front part of the stretcher edge (again the thickest part). This pattern avoids pinning the tongue and grooved joint together with staples. Any loose canvas on the reverse of the stretcher can either be tacked together with a few stitches or will be covered by the paper backing (see

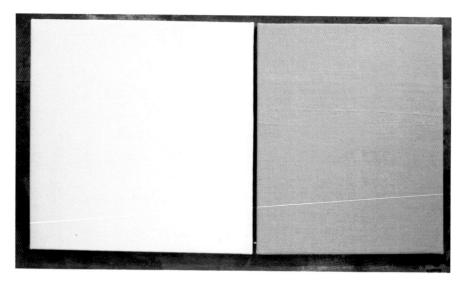

11. Stretched cotton (left) and linen

page 22). Staples can be driven fully home by using a pin hammer.

Using creased cloth

If you have to use a creased piece of cloth, re-soak it, dry flat and iron damp as before. If the creases remain, the following procedure will reduce them further:

- Stretch the canvas as normal.
- Wedge the canvas out until there is approximately I mm gap in each stretcher joint.
- Wet the canvas with water, using a plant mister, and leave it to dry for 6–12 hours.
- Wedge it out another I mm and wet it again.

If you do this three times the creases will be somewhat pulled out, but the end result will never be as good as a piece of uncreased cloth. The canvas will be rather taut as well, which will put a greater stress on the final paint film.

Alternative to dipping the cloth in a bath

Instead of submerging the cloth in water you can lay the cloth flat and spray it with water using a plant mister. Turn over and repeat. Leave it to dry, approximately 6–12 hours. This will prevent any creases occurring but it becomes more challenging the larger the cloth becomes.

You can also temporarily stretch the linen on its stretcher and then spray it. You will need to be careful of the corners as these will take up the shape of the wood. You can avoid this by stretching the cloth on a larger stretcher than you intend to paint upon.

Using wedges

Use wedges, or keys, to increase the tension of the canvas if it is not tight enough for you. The left-side of the photograph (fig. 12) shows the traditional way of putting in the wedges. This is to stop the wedges splitting down the grain as they are hit but it does make them rather awkward to hit at all! Using them as in the right-hand side of the photo makes them easier to hit and in practice they rarely split. Remove the tack from each corner joint.

12. Canvas corners showing traditional (left) and non-traditional (right) insertion of wedges

Place a piece of card behind the wedges in each corner between the canvas and stretcher. This prevents you from denting the canvas accidentally with the hammer:

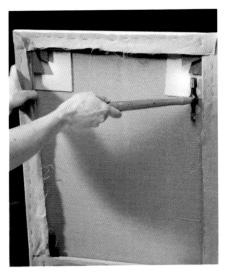

13. Holding canvas while hammering in wedges. Pieces of card behind wedges to protect canvas

14. Arrows indicate wedges which move out the horizontal stretcher bar

Always use the wedges by moving one stretcher bar at a time rather than splaying open a corner. This keeps the stretcher square. Stand the canvas upright and, using a pin hammer, move the bar upwards while holding on to the vertical stretcher bars. Move out the stretcher bars in succession until the canvas is flat. Usually the gap in the joints will be $1-2 \, \text{mm} \, (1/16 \, \text{in})$.

If a fixed chassis has been used you can try to tighten the canvas by removing the staples from one side or part of one side and stretching the canvas tighter. This is not easy. Canvas pliers might help, especially with cotton.

Making your own stretchers

Simple fixed stretchers can be made to save money on expandable ones (fig. 67). Quadrangle beading can be added to fixed stretchers to act as a bevel (fig. 15).

15. Cross-section of stretcher showing beading

SIZING CANVAS

Size is a glue used in a certain dilution to reduce the absorbency of a surface. It is employed in this case to stop the canvas absorbing any oil from the ground. If the ground and/or colour is absorbed by the cloth, the paint film will be dull and underbound.

Size achieves its purpose by being absorbed into the fibres which make up the cloth - it should not fill the holes in the cloth itself, as the ground has to be pushed into these holes later for structural reasons. A size therefore is never a continuous layer. The size used should be as flexible as possible and have the least possible hygroscopiscity. It needs to be flexible to endure the movement of the canvas, which is actually increased by the size upon it. The less hygroscopic it is, the less movement it will encourage of the canvas and the painting. Although it is far from meeting the above criteria, the most suitable glue is a rabbit-skin type. This means an animal glue made of skin and bones. Other possible sizes are acrylic sizes,

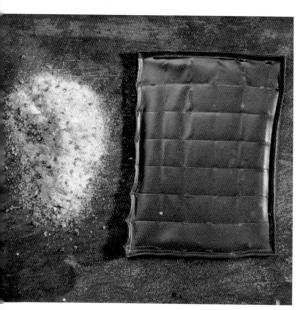

16. RSG (rabbit-skin glue) granules and sheet

sodium carboxy methyl cellulose (SCMC, SMC or CMC), and gelatin. Thorough research has yet to be done to conclude if any of these could supersede rabbit-skin glue.

As size is a natural product it is not possible to give specific measurements, but approximate figures are 30–45 g (I-I-I/2 oz) of glue to I.I litres (2 pt) of water. The only way of knowing the right strength is to test the set of the cold size; volume measurements are not reliable as the strength of different glues can vary. If the size is too strong it will be too hygroscopic. Taken to the extreme, if the size has acted as a layer the ground and painting can peel off. If the size is too weak the oil from the ground will sink into the cloth. You will need I.I litres (2 pt) of size to cover a $I22 \times I83$ cm (4×6 ft) canvas.

A double-boiler is used so that the glue is not scorched and is evenly distributed; scorching or boiling size makes it brittle and reduces its pore-filling properties, while uneven distribution will mean some parts of the canvas will have too strong a sizing and other parts too weak. A double boiler can be any two pans, as long as there is water in the bottom one so that the size can be heated without it boiling.

Making and using size

As a starting point put 40 g ($1 \frac{1}{3}$ oz) of glue with 1.1 litres (2 pt) of water into the top part of a clean double boiler.

When using a new bag of glue, make the initial batch by estimating the proportion of glue on the high side. It is quicker to adjust the glue if it is too strong than if it is too weak since, if you need to soak more granules in the prepared size, you will need to wait up to 12 hours for them to swell. Buy a big bag of glue and take note of the proportion of glue to water you need. Once you know the proportions that work for your bag you'll be able to make size quickly.

17. Swollen granules in water

The granules will swell in the water to a uniform pale beige colour in approximately 2 hours. (Sheet glue can be used but will take 24 hours to swell and is more difficult to measure).

Once swollen, the glue is melted by heating in the double boiler for a few minutes. Remove the top pan and leave the glue in a cool place to set. This can take 2–10 hours. Keep the lid on the boiler when possible throughout the process to prevent loss of water through evaporation. Test when it is at room temperature, otherwise it might appear stronger than it really is. When split with the finger the walls of the jelly should be uneven, not smooth, and if you mix up the size with your finger the resultant lumpy consistency should be that of apple sauce.

18. Split size

19. 'Apple sauce' size

If the set is like consommé it is too weak and needs some extra granules; if it is like a fruit jelly it is too strong and needs more water. Add whichever is necessary. If the size is too weak, add an extra 5-10 g ($^{1}/_{4}$ oz) of glue to the warm glue and leave to soak for at least 12 hours. If it's too strong, add an extra 70-140 ml (up to $^{1}/_{4}$ pt) of water. Melt it again and leave to set. Repeat the process until you have the right set.

Continued heating reduces the strength of the size. Once you know the workable proportions for your bag of glue, the size should only need soaking, melting, setting, testing and reheating to use, that is to say heated only twice. Extra heating is probably unavoidable while you're learning, and you may also need to melt it more than twice in order to use it up on other stretched canvases.

The size is applied hot to ensure even distribution. Heat it until it feels hot to your finger. Use a 7 cm (2 3 / $_{4}$ in) varnishing brush for sizing; it doesn't flood the canvas with size, like a cheap decorator's brush does. Let the canvas slowly absorb the size from a short brush stroke and then move on to the next bit of canvas. Do not make back and forth movements with your brush – it's wasted effort and too much size will be applied. Nor should you go over a wetted area again as too much size will be deposited. However, cotton

does not absorb the size like linen and it is often necessary to go over a patch again where the size has floated off. Just try to apply it evenly and sparingly.

Size the edges of the canvas as well as the painting plane. This will give you the same surface to paint on right up to and over the edge if required and increase the life of the canvas. Only one layer of size is necessary; more than one is similar to having too strong a size. Leave the canvas to dry flat naturally, which will take approximately 12 hours. After six hours or so, run your fingers gently round between the chassis and canvas to ensure none of the canvas has stuck to the stretcher. If the canvas is not flat when thoroughly dry, spray the reverse of the canvas with water using a plant mister and leave it to dry again.

Size will keep in the refrigerator for up to a week before beginning to decompose. Make sure size is fresh before use or make a new batch. The size will be watery and smelly if it has gone off.

20. Partly sized canvas

Slubs and/or rough cloth

If you want to smooth the cloth and remove any small irregularities from it, you can do so from the sized canvas with a scalpel blade and/or a pumice stone. The blade can slice off any slubs (little lumps of oversize thread) while a gentle rub over with the pumice will smooth the cloth. Don't be rough with the pumice as it can cut through the cloth. Because this will expose more cloth fibres, you will need to apply a second coat of size and leave to dry.

SIZING A BOARD

Size all boards as for canvas, except for tempered hardboard which does not need sizing. Size both sides and the edges of an uncradled board in order to even up the hygroscopicity of the board and keep it flat. See Chapter 6 (page 95) for explanation of sizing boards.

CANVAS MOUNTED ON BOARD

Canvas should be cut with enough overlap to fold over the edges of the board. It can be attached using canvas-strength size, but sticks better, particularly the overlap on the back, with gesso-strength size (see page 94). This also reduces the risk of blisters developing.

A cradled board is best because it will withstand the tension of the glued cloth on one side. Boards should be degreased and sanded (see pages 92-93).

Coat the prepared board sparingly with hot glue on the face (and edges) which is going to receive the canvas. Place the prepared canvas on this surface with equal overlap all round. Ensure the weave of the cloth is parallel with the board. Glue the canvas down on the front with hot glue and a 7 cm (2 $^{3}/_{4}$ in) varnishing brush. Press it down with your fingers to ensure it is thoroughly glued down and no blisters can develop in the future. You can ensure there are no bubbles of cloth by looking across the board at eye level.

21. Pressing canvas on to board

22. Glued corner on reverse of board

23. Canvas glued on board

Coat the edges and back of the board with hot glue where the overlap is to be glued down. Then fold the corners over the edge of the board in a similar way to using a chassis. This is more fiddly than corners on a chassis, especially on small boards, as all corners will need to be

folded before all the overlap can be glued down flat. Your fingers will be rather gluey too.

If using small uncradled boards, coat the whole reverse of the board, otherwise the board will warp. Leave to dry thoroughly, which will take 6–12 hours. See page 42 if using acrylic primer:

PAINTING ON SIZED CANVAS

Oil paintings on sized but not primed canvases have survived well and from this point of view they seem acceptable. They are more absorbent than primed canvas and produce quite a matt paint film. They should not be varnished (see page 36).

Sized but not primed canvases on open stretchers will tend to sag a lot. Use a paper backing as suggested (see page 22). The paint film will be underbound from oil sinking and the finished work will therefore be more delicate and susceptible to damage. If a translucent priming is acceptable, a clear acrylic gesso can be used and has the advantage of tooth and more controlled absorbency compared to rabbit skin glue only (see page 24).

PAINTING ON SUPPORTS WITHOUT SIZING OR PRIMING

Use gelatin surface-sized rag paper of a reasonable weight or tempered hardboard. An extra coat of Lifting Preparation (Winsor & Newton) on the paper will reduce the absorbency, while sanding tempered hardboard to produce a key is recommended.

GROUNDS

A ground (primer) offers control of colour, texture and absorbency for the painting. Tube colour is not suitable as it is too oily and has no added tooth.

Oil paint becomes more and more transparent as it ages. If the ground is an opaque white then the maximum light is reflected back and the painting remains as bright as possible. In fact it will become brighter! If you do not want that to happen, a pale beige opaque coloured ground is the most suitable (see Coloured grounds, page 24).

A ground for oil paint must be lean (see Fat over lean, 32). The quicker the primer dries, the sooner you can paint.

TYPES OF GROUNDS

Oil grounds There are no longer any oil primers formulated on the traditional white lead, in part due to its toxicity but mainly because its great disadvantage is that it takes up to six

months to dry. Oil primed today is most likely to mean alkyd primed (see below).

Genuine gesso grounds Gesso offers a lean, rigid ground durable for oil paint. As it is used on board there is greater rigidity for the paint film but the gesso must be sized, see gesso chapter (page 99).

Half chalk grounds See Chapter 6, page 106.

Alkyd grounds, oil-modified alkyd resin

An alkyd is a synthetic resin. It is combined with a drying oil in order to produce an oil binder with faster drying properties. Hence it is called an oil-modified alkyd resin.

Alkyd primers have been used since the 1960s and on balance are equally as durable as an oil ground. The oil ground is initially more flexible than the alkyd but over the medium to long term they equalize. Alkyds yellow less than linseed oil. The pigment is titanium.

Alkyd primer will take at least 24 hours to dry thoroughly and should be left perhaps 48 hours before painting. Rabbit-skin size is still required underneath. This primer can be used on canvas or board and is commonly called Oil Painting Primer. As the preparation is lengthy, most artists use acrylic gesso primer (see below). Alkyd primer is recommended when you want a stiffer, more opaque ground and because of the rabbit skin size the canvas may stay flatter. Some artists prefer to use a traditional oil-based ground for aesthetic reasons.

Acrylic grounds An acrylic is a synthetic resin. Acrylic primers have been in common use for more than 30 years and are suitable for oil paint, provided the primer is formulated correctly to have a suitable degree of rigidity. The pigment is titanium.

Acrylic primer is very quick-drying – touch dry in less than an hour for one coat. It is also

used without applying rabbit-skin size because it does not adhere well to a canvas over it. It is this quick preparation which explains its popularity, both with artists and for many commercially primed canvases. Acrylic primer can be used on canvas, board or paper and is commonly called acrylic gesso primer or just 'gesso'.

Clear Gesso Base is also an acrylic primer but contains no white pigment, therefore providing a translucent, textured surface.

Household paints and commercial

primers These products are made with vinyls, some acrylics and alkyds but are made for decorative purposes and are likely to be far inferior to any of the above grounds. They should not be substituted for artists' primers as they are likely to be over-absorbent, lack tooth and embrittle over time.

GROUNDS FOR ALKYDS AND WATER-MIXABLE OILS

Alkyd colours can be used on either alkyd or acrylic grounds. Water-mixable oils may be better suited to acrylic grounds if water is used in the first layers, due to lack of surface wetting on alkyd grounds.

OIL PRIMER USED OVER ACRYLIC PRIMER

This is not recommended because oil does not adhere well over acrylic.

QUALITY OF GROUNDS

Of all artists' materials, grounds are arguably the most important — no matter how good your colour, it can only ever be as good as the ground it sits on. Grounds are also perhaps the area of greatest variety regarding their quality. It is recommended that alkyd or acrylic primers from the very best suppliers are used. All artists' grounds should have tooth and you should reject any which feel smooth when dry.

If you must make some cutbacks, it is better to have a good acrylic ground on cotton and a fixed stretcher (see *Making your own stretchers*, page 15) than to use household emulsion on linen. Cheaper still would be acrylic primer on paper or gesso on board. Nowadays it may be cheaper to buy ready-made canvases. For permanence buy these from the very best brands.

TESTING THE QUALITY OF A PRIMER OR COMMERCIALLY PREPARED CANVAS

A finished canvas can be tested for absorbency by applying a 50 per cent glaze of colour using linseed oil. If the colour dries spotty or patchy (sinks) there is too much absorbency; if the colour dries to a continuous film the primer is good.

Although this is essentially a destructive test for the canvas in question, you should only need to do it once to satisfy yourself with the brand you are buying.

Applying alkyd ground

Oil paint is a poor adhesive. The structural durability of the ground and painting is ensured by driving the primer into the weave of the canvas where it can grip, that is, into the holes in the cloth. On a board the primer will grip the wood fibre.

The ground is applied as thinly as possible. It will dry more quickly and thoroughly. An excellent brush for priming is a 115 mm (4 $^{1}/_{2}$ in) wavy mottler (fig. 25). Its stiffness will help you to drive the ground in and keep it thin, and its width will help to spread the pressure of the priming.

The sized canvas will have a flat, springy surface. In order to protect this a thin piece of card is placed between the stretcher and the canvas. This spreads the weight when you push the ground in and also prevents the inner edges of the stretcher bars showing on the front of the canvas.

24. Card in reverse of stretcher

25. Primer on wavy mottler brush

Alkyd primer is thixotropic – stiff in the tin but increases in flow under the stress of the priming brush. There is no need to thin it. Put a small amount of primer on the brush. Keep the brush upright and rub the ground into the weave of the cloth, thinning it out all the time. Move the brush in all directions to fill the weave. Complete each area before you move on and don't forget to prime the edges of the canvas.

Leave the canvas to dry in daylight for 24 hours. Apply a second coat and leave to dry for 48 hours. You can sand between coats if you want a smoother surface. Drying in excessive darkness or humidity will cause the canvas to darken. If this happens, hang the canvas in daylight until it is bleached white. A litre of alkyd primer will cover approximately 10 sq m.

See Chapter 11, page 169, for information on cleaning brushes.

26. Alkyd primed canvas:

a. correctly primed
b. weave not filled due to skimming

Using acrylic primer

Apply the primer at full strength. Use the card between the stretcher and unsized canvas as above. Ensure the canvas is as tight as possible and the weave is parallel with the stretcher as the primer will not contract the cloth very much. Using a clean wavy mottler, apply the primer thinly (as above) and leave to dry for a few hours. Two coats can be used for maximum opacity. You can sand between coats if you want a smoother surface. Leave the canvas 24 hours to dry before use. See also page 24, fig. 28(iv, a) and page 169 for cleaning brushes.

Preventing sagging of canvases

27. Paper on reverse of chassis protects canvas from changes in humidity

Once primed, staple a heavy (at least 200 gsm) sheet of paper or card over the back of the chassis. It is not desirable to make a tight seal between this backing and the chassis because that would encourage mould. The paper does not need to be acid-free. This backing simply stabilizes the atmosphere immediately between the back of the canvas and paper and makes the canvas far less susceptible to changes in humidity. It is the absorption of moisture by the size and canvas which makes the canvas sag. The less the paint film is relaxed and stretched, the smaller the chance of the painting developing cracks. This is much better than continually using the wedges to take up the slack of the canvas. That just puts more and more stress on the paint film as it is stretched by the tightening canvas.

A double stretched canvas would also make the painting less susceptible to humidity, that is, one canvas is stretched, followed by another on top. The second canvas is then prepared as usual, but this is much more costly than paper:

Canvases which are primed on both sides are also less susceptible to changes in moisture.

Priming a board

The alkyd primer should be brushed on thinly with the wavy mottler, including the edges of the board. The colour of the board will not be masked because the primer is so thin. Using MDF, which is the lightest in colour of the wood fibre boards, will help, or apply more coats of primer. Acrylic can be applied directly onto sanded and degreased boards, see pages 92-93.

For the ultimate in bracing uncradled boards, paint a layer of primer on the reverse, followed by a layer of oil paint when the painting is made.

Priming a canvas board

Coat small uncradled canvas boards all over with either alkyd or acrylic primer to prevent warping.

Priming metals

Metals should be degreased and abraded. If using steel, ensure there is no rust. You will then need an appropriate primer for each metal. Look for one in the DIY/hardware store or investigate on the internet. See also Bibliography (page 182). Ensure your priming is suitable for whichever paint you are going to use.

PAINTING ON GLASS

Glass should be sandblasted and degreased before use. Most artists do not use a primer in order to maintain the transparency of the support.

COLOURED GROUNDS

There is no structural difference in coloured grounds. It is the optical differences that should be taken into consideration.

Transparent veils The optical advantage of the white ground can be retained by colouring the ground with a veil. This is a transparent colour which allows the light to travel through it to the white ground. Dilute your chosen transparent colour with around 50 per cent solvent to ensure a lean, staining colour. Brush or rub on and leave to dry. Use oil or alkyd colour on an alkyd ground fig. 28(i). Acrylic can be used on an acrylic ground for either subsequent oil or acrylic painting fig. 28(ii).

Opaque tinted grounds The white ground can be coloured by mixing some alkyd paint into the alkyd ground fig.28(iii) or acrylic paint into the acrylic primer fig.28(iv, b). Because of its tooth, absorbency and rigidity, the ground should be coloured rather than replaced.

To maintain the tooth, keep the addition of paint to approximately 10 per cent. This will produce a tinted ground which does not reflect back as

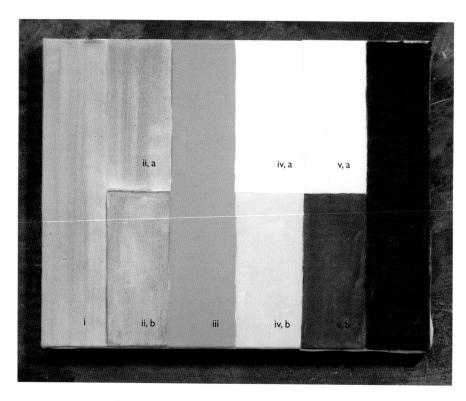

28. Canvas showing from left to right: (i) transparent oil veil on alkyd, (ii, a) transparent oil veil on acrylic, (b) transparent acrylic veil on acrylic, (iii) opaque tinted alkyd ground, (iv, a) acrylic gesso primer, (b) opaque tinted acrylic ground, (v, a) clear gesso base, (b) clear gesso base with transparent acrylic hue, (vi) clear gesso base with opaque acrylic hue

much light as a veiled ground but can be used for coloured effects within the painting. The amount of white in the ground results in the ground being opaque. A pale beige ground is produced by this method. The dark-toned grounds of previous centuries were made in this way. See Bibliography (on page 182) for sources of information on the colour effects of a ground.

Using clear gesso base A structurally superior translucent ground can be achieved in preference to sizing only by applying clear gesso base onto raw canvas fig.28(v, a). A transparent ground can be made by mixing a transparent

acrylic colour with clear gesso primer before application fig.28(v, b).

More strongly coloured grounds can be produced by mixing an opaque artists' acrylic colour with clear gesso primer before application fig.28 (vi). Because of the absence of white pigment in this primer, a stronger hue is maintained as the ground colour. The best clear gessoes provide tooth, controlled absorbency and correct rigidity.

Examples (v) and (vi) in fig. 28 are upon raw canvas. You may if you wish apply (v, b) and (vi) on top of dried acrylic gesso primer for a brighter effect.

OIL PAINTS

TRADITIONAL OIL PAINTS Oil

paints are bound with drying oils. A drying oil is a vegetable oil which dries by oxidation. Linseed oil is used in the majority of cases because it dries to the most durable film. The effects of different oils are discussed in Making oil paint (page 37).

OIL/RESIN PAINTS are either oil/natural resin or alkyd resin paint. Both have different handling properties to conventional oil paint. The former should be durable provided the resin content is below 10 per cent. More than that may cause yellowing and increased solubility of the paint film.

Oil/natural resin paints are not recommended for home manufacture. The manufacturer is experienced at controlling the quality of the binder, and heating oil and resin is a fire risk.

Alkyd paint is more durable than oil in outside conditions and should yellow less than conventional oil paint. It is great for underpainting, impasto and glazing because of its speed of drying, which is 18–24 hours (touch dry).

WATER-MIXABLE OIL PAINTS

Oil can be made water-mixable by either making it into an emulsion of oil and water or by modifying it to accept water as a diluent. The latter are better as they do not have the colour change issue associated with emulsions. Drying rates are the same as conventional oils, see page 30.

OIL PAINTS IN STICK FORM are a mixture of linseed oil and wax. They are

compatible with conventional oil paint, provided the oil painting rules are considered.

DRIERS Most brands of oil paints contain driers in some colours in order to bring the drying times closer, to a range between 2 and 10 days. This helps to prevent problems with slow-drying colours and is perfectly safe for the paint film when controlled by experienced chemists (see page 30 for drying rates).

PIGMENTS

Permanent pigments should be used. Fortunately pigments have continued to improve and very few pigments with poor lightfastness should be used by the best manufacturers. To establish the colours you want, use the pigment chapter (page 135) in conjunction with manufacturers' catalogues.

Pigments which are sensitive to atmospheric pollution are substantially protected in oil by the binder and the subsequent picture varnish and can therefore be considered permanent in oil, for example flake white, ultramarine.

ARTISTS' VS. STUDENTS' COLOURS

Generally there are two grades of colour available. Artists' denotes the highest pigment level, while students' colours are usually identifiable by their lower, often uniform price. Artists' colours will have the widest colour choice, broadest handling properties and highest pigment strength. Both can be mixed together. It is worth noting however that qualities differ between manufacturers. Your experience with the paint combined with the level and quality of information from the manufacturers should help you to find the best colours for your needs. Artists' colours are often in bands of prices, according to the relative cost of the pigment, and are called 'series'.

MAKING YOUR OWN OIL PAINT

Oil paint can be made by machine with less oil than is possible by hand, and it can be dispersed more effectively, producing a stronger, more stable colour than paint you can make yourself. However, do not let this deter you if you do want to make your own oil paint. Getting a feeling for the raw materials may help you achieve a greater understanding of painting in general. See Making oil paint, page 37.

THINNERS AND MEDIUMS

Oil paint has a rich, thick quality fresh from the tube. However it can also produce the deepest glazing layers of any media. The versatility of oil colour is achieved by the use of thinners and mediums. The thinners for oil paint are turpentine or white spirit or water for water-mixable oils. They dilute the colour to ease application but should evaporate completely from the drying paint film.

TURPENTINE is distilled from the sap of pine trees (a distilled oleoresin). It will oxidize, leaving a gummy residue which yellows badly and leaves the oil paint sticky and non-drying. To reduce the risk of this, use only double-distilled or rectified turpentine as sold by art materials suppliers. By leaving some turpentine to evaporate on a palette you will see if it leaves a gummy residue. Storing turpentine in half-empty bottles and in daylight will cause oxidation. Try to use up turpentine quickly or store in full, dark, capped bottles. Turpentine substitute is not suitable for fine art.

WHITE SPIRIT (also mineral spirits) is a petroleum distillate which does not oxidize. It is faster evaporating and less viscous than turpentine. Although buying artists' grade is not imperative, you should buy a white spirit with a BS (British Standard) on the container. White spirit is significantly cheaper than turpentine and low-odour thinners.

LOW-ODOUR SOLVENT is a petroleum distillate manufactured in a low-odour variant and is less hazardous than

either turpentine or white spirit. Use this type of solvent (for example Winsor & Newton SansodorTM) if you are sensitive to turpentine or white spirit before giving up conventional oil painting.

Turpentine, white spirit and low-odour solvents are hazardous. See Health and Safety (page 171).

'SAFE' SOLVENTS There are some 'safe' solvents available in the marketplace, perhaps based on citrus oils or other materials. There is yet to be such a solvent which dilutes the oil paint yet evaporates totally from the paint film. Until such a product is found, if you must avoid hazardous solvents then you should use water-mixable oils instead. Alternatively you could consider painting with conventional oil paints and oils only, provided you maintain fat over lean and can cope with the limited viscosities.

WATER is the 'solvent' for water-mixable oil paints.

USING THINNERS

Thinners should not be used to thin the paint to a water-like consistency. This will prevent any oil film forming because it has been thinned to the extreme and the pigment will be left underbound or unbound on the ground. If a loose stain is required for the intial sketch, paint on the water-like paint and then immediately rub it off with a rag. This will leave a stain without loose pigment. If you find yourself wanting this effect often, consider using tempera or water colour!

Thinner should be used in combination with medium during the painting to ensure the pigment is coated with binder. Otherwise an underbound, absorbent film will result.

ECONOMICAL USE OF THINNERS

Thinners can be used in a wide-lipped jar or tin, with the lid replaced at the end of the painting session. By the next day, most of the pigment will have settled at the bottom and you can decant the thinners into another empty tin. The first can be wiped clean for the following session, and so on. The thinners can be topped up as needed. Place any solvent-soaked rags in plastic bags and run some cold water on them, tie the bag and place in an outside bin.

MATT OIL PAINTING

Oil colour is a gloss medium and as such provides its characteristic richness and depth of hue. However, matt oil paintings may be desirable to some. Using white spirit to effect mattness can thin the paint too much and give uneven mattness across the painting. For a thin matt painting, using a sized but not primed canvas may be more effective (see page 19). For a heavier matt painting, using wax is possible. See Impasto, page 29.

Using a very absorbent ground, for example unsized gesso, is not recommended for achieving mattness because the pigment would be left underbound on the surface. In the absence of a reputable matt medium the safest way to achieve an even, matt oil painting is to varnish it with a matt removable picture varnish when the painting is dry. See Varnishing, page 35.

GRADATION OF LAYERS

When building up an oil painting, each underlayer will absorb oil from the paint of each subsequent layer. If the ground is over absorbent this will be very noticeable in sunken patches. Layers can be oiled out, see Oiling out, page 33. However, more usually, the thinners include some oil (or Liquin™) instead as you apply each

layer. Stand oil is recommended because it is non-yellowing. The principal is that each subsequent layer must have more binder (oil or Liquin) overall than the previous layer. This is the 'fat over lean' rule (see page 32).

GLAZE MEDIUMS

A glaze is a transparent layer built up over dry underlayers, which results in a spatial atmospheric surface. A glaze medium provides a reflective surface which contributes further to this effect. Such a medium can also be used as a general medium for oil paint, giving an inner glow to the paint.

TRADITIONAL GLAZE MEDIUMS

The traditional studio-made glaze medium consists of a mixture of oil, varnish and thinners; however, varnish runs the risk of remaining soluble and if used with a slow-drying oil may cause cracking. Stand oil and thinners will produce a more stable structure. Stand oil and solvent mixtures can be bought ready-made (Artists' Painting Medium, Winsor & Newton) or made using around 50 per cent solvent to oil. Stand oil is recommended because it levels well, is flexible and is the least yellowing oil. However, any of the artists' quality oils can be used (see page 37). Excessive use of oil should be avoided as it will cause wrinkling.

RESIN GLAZE MEDIUMS

Resins will give a glassy effect, be faster drying and give a harder finish to the glaze. Natural insoluble resins such as copal have been depleted and so today we look to alkyd resins to provide such glaze mediums. The most popular medium for oil painting is Liquin, which is an alkyd medium. It speeds the drying of the colour by about 50 per cent, depending on the colour and quantity used. It is available in different consistencies. Alkyd mediums have been available

for more than 40 years and are as durable as oils. Excessive use of alkyd mediums should be avoided as layers can separate from one another:

Some commercial mediums may contain soluble resins or non-evaporating ingredients. Check the ingredients in manufacturers' catalogues before use.

Avoid using different mediums in different parts of the painting because an over-complicated structure would result. You could, however, mix mediums together — perhaps some oil into Liquin, for example. Mix thoroughly and use the medium throughout the painting.

OLEORESINS, BALSAMS AND OIL VARNISHES

Oleoresins and balsams are mixtures of an essential oil and resin from trees, including Venice turpentine, Strasbourg turpentine, Canada balsam, copaiba balsam. Used for glazing in the past, they tend to darken and crack and are expensive.

Oil varnishes are made of a resin heated and melted in a drying oil. They include amber; burgundy pitch, copal (all types), elemi, kauri, mastic (meglip), rosin (colophony) and sandarac. They produce both dark and pale varnishes for mediums and are not recommended because of their tendency to darken. This tendency is mostly due to poor-quality resin. Meglip can also wrinkle, crack, blister and behave altogether erratically.

Oleoresins, balsams and oil varnishes were first used in the areas in which the trees were indigenous. Today's painters often feel they need these 'original' mediums to re-create old masters' techniques, but this is an aesthetic approach rather than technically sound.

WAXES

Beeswax is mentioned below in impasto. Although microcrystalline wax is a possible substitute for beeswax it is difficult for the individual artist to purchase those that are the least yellowing and with the most suitable characteristics. It is safer therefore to use beeswax.

SHELLAC

A resin from insects, shellac should not be used in oil painting because it embrittles and darkens. The bleached type will darken less.

OIL OF SPIKE LAVENDER

This is similar to turpentine but it has a greater tendency to gum and oxidize and is therefore better replaced by turpentine.

ASPHALTUM

See the pigment list on page 141.

See *Bibliography* (page 182) for sources of other information.

IMPASTO

Oil paint is not structurally sound when used as a heavy impasto technique; consider acrylic or encaustic instead. Alternatively, sculptural pieces can be made out of wood, gessoed and then oil painted over the top. All are more durable than using oil paint for impasto.

However, moderate impasto is possible and is most safely achieved by the use of an alkyd impasto medium (Oleopasto or Liquin Impasto, Winsor & Newton). This speeds drying by about 50 per cent which helps with the execution of the painting but also helps to avoid slower drying underlayers which can cause cracking.

Alternatively, beeswax can be used as a matt impasto medium. A maximum of 5 per cent volume should be used and it should be mixed

well into the oil paint on the palette with a palette knife. Too great a proportion will make the oil paint susceptible to heat, denting, and scuffing. Melt 28 g (1 oz) of yellow beeswax in a double boiler. Once liquid, move the wax away from the heat because of the fire risk. Stir in 100 ml (3 $^{1}/_{2}$ fl oz) of turpentine or 70 ml (2 $^{1}/_{4}$ fl oz) of white spirit. Stir until the wax cools and a paste is formed. Keep a lid on this medium to prevent the evaporation of the solvent. Turpentine is a better solvent and is slower evaporating than white spirit.

The use of beeswax in oil paint is often termed 'encaustic', but strictly speaking it is not (see Chapter 3, page 49). Excessive wax will leave a soft paint film which is solvent-sensitive and susceptible to damage. The oil and wax mixture also makes fat over lean more difficult to control.

WATER-MIXABLE OIL MEDIUMS

Water-mixable oils need their own water-mixable mediums. A similar range to conventional mediums is available, ensuring you can manipulate the colour whichever way you please. The mediums are also useful for three other reasons. First, water evaporates very quickly compared to turpentine so medium is handy to keep the colour at your desired dilution longer, and secondly, when water is added to the paint an emulsion is formed and the colour lightens. Medium will reduce this lightening, making the difference less noticeable when the colour darkens again as the water escapes. Lastly, as the water-mixable system uses modified binders, the manufacturers can produce better-performing mediums than you can in the studio from the modified oils and water.

DRYING RATES OF OIL COLOURS AND THEIR EFFECT ON PAINTING

Oil paints which are slow driers should be avoided in underpainting because the underlayers will remain mobile and move as they dry. If a faster-drying layer is applied over the top, this will be pulled apart as the slower-drying colour contracts. This is also true of colours which only surface dry, like cobalt. Colours ground exclusively in poppy or similar semi-drying oils should be avoided in underpainting for this reason. See page 37 for further information on oils. An underpainting white, alkyd white or flake white (in linseed oil) is recommended for underpainting because of their quick and thorough drying.

Paintings made in layers are also less likely to crack if the underpainting is thinly applied – that is, a thin paint film, not an excessively thinned paint film. It then has more chance to dry thoroughly.

Fortunately the drying rates of colours are rarely a problem because colours are almost always mixed on the palette and so the drying times tend to equalize to a great degree. However, the following list gives a guide to the drying rates of pigments in linseed oil. The categories may be somewhat approximate due to different makes of pigments or different test methods. All colours made with poppy oil or similar will dry relatively slower than in the list.

Rapid driers Aureolin, cobalt blues, flake white, manganese blue and violet, siennas, umbers.

Average driers Cadmiums, chromium oxide green, cobalt greens and violet, Mars colours, perylenes, phthalocyanine blue and green, pyrroles, some natural iron oxides, ultramarine blues and violet, viridian.

Slow driers Arylamide yellows, alizarin crimson, cerulean, green earth, ivory black, lamp black, quinacridones, rose madder, some natural iron oxides, titanium white, Vandyke brown, yellow ochre, zinc oxide.

SPEEDING THE DRYING RATE

The safest way to accelerate the drying rate of oil colours is to use Liquin, which speeds the drying by about 50 per cent. Thickened linseed oil can also be used and will speed drying by about 10 per cent. Neat driers (for example cobalt) are not recommended because they can crack the paint. The safe addition of driers depends on each pigment and is best left to the experience of manufacturers.

RETARDING THE DRYING RATE

To retard the drying rate of oil paint, use a 50:50 stand oil and turpentine mixture to thin it. Oil of cloves is not recommended as it has a tendency to blacken and affect the stability of the paint film.

THREE WHITE PIGMENTS FOR OIL PAINTING

Because it dries to a tough, flexible and lean film, flake white is the best general white for oil paint. If used throughout the painting, the whole painting will become more tough and flexible. Flake white also brushes out more smoothly than titanium or zinc. It is rarely affected by atmospheric pollution because of the protection of the binder and picture varnish. It is the least white of the three pigments and is semi-opaque. However, because of its toxicity it is only available in tins in Europe and this makes it harder to obtain and more cumbersome to work with.

Titanium dries to a softer, chalky and fatter film than flake white. It is the whitest and most opaque of the three pigments and is by far the most popular white. It should be used anywhere a bright, highly opaque white is needed.

Zinc dries to a harder, brittle and leaner film in oil. It is a bluer white than titanium but whiter than flake and is semi-opaque. It should be used where a more transparent white is needed.

Mixed whites are also available and are generally based on titanium. These may be transparent whites for glazing or flake white substitutes. They are formulations which cannot be achieved on the palette from existing colours and are therefore well worth looking into for their specific characteristics. Refer to manufacturers' details as to their uses.

UNDER PAINTING

Underpainting or modelling with

white If using large amounts of white in underpainting you should use a linseed oil white (Winsor & Newton Underpainting White [titanium] or Foundation White [lead]). Most tube whites use a semi-drying oil such as safflower and if used in quantity in underlayers would leave a slow-drying layer under the later faster-drying ones which would lead to cracking.

Underpainting with alkyd paint Alkyd paint also allows you to make a preliminary under-painting which dries rapidly. See page 25.

Underpainting with acrylic paint This is also popular for oil painting and is fine as long as the acrylic painting is not too thick and therefore over-flexible. If this is so, use a board to increase the rigidity of the overall painting. An acrylic ground should be used if acrylic colour is used for underpainting.

Underpainting with tempera paint

Tempera can also be used for underpainting but this will limit you to a gesso board and is a lengthy set-up procedure. The oil paint should be applied as soon as possible after the tempera is complete, and within a couple of months at the most. The adhesion between the two mediums is best while the egg emulsion is still soft and slightly absorbent. Tempera can also be used over wet oil paint (see Chapter 4, page 68).

FAT OVER LEAN AND OTHER RULES

Fat over lean can be equated with flexible over inflexible. If an inflexible coat is laid over a flexible one, then as the flexible coat moves the inflexible one will split. However if the situation is reversed, as the inflexible one moves less than the flexible coat on top of it, the latter will not split. This of course applies to grounds as well. This is why a lean ground is needed for oil paint.

If the picture is completed in one session when all the paint is wet, the principle of fat over lean need not be considered. When a picture is painted in layers, however, the only way to prevent subsequent layers of paint from cracking is to increase the amount of binder in them.

Contrary to a number of sources, oil content or oil 'index' is not a contributory factor to fat over lean. Different pigments require different volumes of oil to make them into a usable paint. Regardless of this, subsequent layers must have increased flexibility relative to the underlayer and therefore more medium is added. Whichever medium you are using, oil or Liquin, simply increase it in each subsequent layer:

Other rules

- Cracking can also be caused by slow-drying colours under fast-drying ones (see page 30).
- The thickness of layers should also be considered because thick colour will be slower drying. For example, a thin glaze over an impasto layer is likely to crack.

OILING OUT AND CONTROLLING SINKING

If your paint is sinking dramatically, ensure that your ground is of the correct type and dry. Spots of dull paint across a correctly primed canvas are due either to areas of thin paint, overthinned paint or new paint over touch-dry paint.

Oiling out is the safest way of preventing further sinking. There is no risk of solvent action but it is not a quick solution. Oiling out replaces the oil which the underlayer has sucked out of the top layer. Use an 80:20 thickened oil/white spirit solution or a ready-made stand oil or thickened oil and solvent medium. Rub it sparingly into the sunken areas with a soft lint-free cloth (that is, the cloth must not leave fluffy bits). Wipe off any excess oil and leave to dry for a few days. If the areas are still sunken, repeat the process. Stand oil is used because it is non-yellowing. An excess of oil will prevent new paint gripping old and will also yellow more.

Retouch varnish can be used to reduce the absorbency of layers but if used too early it may leave a tacky film which will ruin the painting.

Although varnishing the finished picture will produce an even matt or gloss over the picture, it is structurally better to even up the paint film by oiling out.

HINTS AND TIPS FOR OIL: PAINTING

- Resuming a picture when dry When you go back to a part of the picture that is dry you may find the dry paint is somewhat resistant to the new wet paint. Wipe the picture over sparingly with solvent and leave 24 hours to dry. Then use the oiling out procedure to bond the old and new paint together. An eraser should not be used because it will leave a deposit which will interfere with the paint film.
- Matching colours wet to dry Wet colours can be matched to any dry colours already on the canvas either by oiling out or by using retouch on the dry paint. The oil or retouch will gloss the paint again as if it were still wet.
- Oily paints Paint which is just too oily can be dried off by leaving it on absorbent paper for a couple of minutes. Excess oil will be absorbed by the paper. Don't overdo this or the paint will be underbound.
- Removing dents from canvas If you accidentally dent a canvas, moisten the dented area sparingly on the back of the canvas. Use water in a plant mister or dab water on with your finger. Don't rub the canvas because you could disturb the size. Leave to dry flat and the dent should flatten.
- Using tins of oil If you are using tins of oil paint, smooth the surface of the paint in the tin between uses to reduce the surface area. Pour a little oil on to the smooth surface to discourage surface skinning.

METHODS TO AVOID

USING HALF DRY PAINT

Once oil paint is exposed on the palette it starts to oxidize. Half-dry paint will not adhere to the canvas to produce a stable film in the way fresh paint does. Keep your palette clean and once the fresh paint needs an excess of thinners to revive it or if it feels gummy, discard it. Rubbery lumps or hardened paint from the tube should not be used either.

STORING EXPOSED OIL PAINT

Keeping oil paint under water will not prevent it oxidizing. It can still oxidize using the oxygen from the water, and water residue in the paint can disturb the stability of the paint film. If anything, keeping it under oil would be more sensible, but messy. Cling film (protective food film) can be used but is also messy. Lower temperatures will also slow drying, but if a fridge is used it should be for studio use only. Tins of paint are only economical if you use up all the paint quickly.

USING OLD CANVASES

Recycling old canvases is not recommended because the old oil painting will show through eventually as the newer paint becomes more transparent (pentimento), and the texture of the first picture is always visible. The preparation of an old canvas is not recommended because the primer will be less flexible than the original painting. Commercial paint strippers deposit grease and solvent which prevent primer and oil paint taking on the cleaned canvas.

However, if the paint is still wet or just touch

dry, you could scrape it off back to the ground with a palette knife. This will provide a perfectly suitable surface to paint on but it will be stained from the previous paint.

Pieces of canvas which were originally sized can be submerged in hot water and left to soak to see if the priming and painting will peel off as the size dissolves. The canvas can then be reused.

REMOVING CANVASES FROM STRETCHERS

A chassis should not be reused unless you have scrapped the canvas which was on it. It is tedious to re-stretch finished paintings and an expandable stretcher is the only way to achieve a flat canvas again.

Oil paintings are not flexible enough to withstand rolling. However, if you are going to roll canvases, then do so with the picture on the outside, using as large a diameter tube as possible to roll it on to. Any cracks will then fold in on themselves. Do not roll oil paintings on paper:

CARE OF FINISHED OIL PAINTINGS

A finished oil painting should be left to dry in a light, dry atmosphere as in priming canvas (see page 22). If it hasn't been and permanent oil colours were used, the darkened oil can be bleached by normal daylight. Bad luck if you used fugitive colours!

An even sheen which can be achieved by oiling out will give the most stable, continuous, impervious paint film. Do this when the painting is finished in preference to using retouching

varnish. If sinking is significant, look at your ground and amount of solvent used, to ensure your next painting does not suffer from the same problems.

A dried oil film attracts dirt and grease. If it is left unprotected, the dirt ingrains itself and dulls the picture irreversibly. Only oil paintings which are packed away from general life can be left unprotected. If the picture is to be hung it should be varnished or put in a glazed frame. See Appendix I (page 176) for framing pictures.

VARNISHING OIL PAINTINGS

Using varnish will produce an even matt or gloss layer over a picture, covering any slight uneven effects. An oil painting will not be dry enough to varnish for at least six months after it is finished. It must be dry before being varnished or the varnish may remain tacky and ruin your painting.

If the picture must be shown before varnishing is possible and needs an even sheen, oil out. A proper application of picture varnish should be applied after the usual drying time (if the picture is sold, instructions can be attached to the reverse of the canvas).

Paintings on sized but unprimed canvas and other delicate paint films should not be varnished because the varnish will soak into them too much and its attempted removal when dirty will damage the paint film. Instead, these paintings should be hung in glazed frames. See Appendix 1, page 176.

TYPES OF VARNISH

Picture varnish must always be removable. It collects pollution like the oil film and is removed and replaced when dirty. The level of gloss will vary according to the resin and formulation used; consult the manufacturers for their advice. Matt and gloss variants can be mixed in the studio to obtain various degrees of sheen; again manufacturers can advise. Water mixable oils may be varnished with conventioal oil varnishes.

Ketone resin varnishes are recommended because they do not yellow as fast as natural resin varnishes (dammar) and they do not bloom. **Dammar** however remains popular.

Wax picture varnish is matt, easy to apply and easily removed.

Combined resin formulations using UV inhibitors are some of the best around as they remain readily removable for much longer than straight ketone or dammar.

Matt varnishes using wax as the matting agent as opposed to silica, have to be warmed but are much easier to use and achieve an even finish.

Retouching varnish is a more dilute varnish made as a temporary varnish. It must not be used too early or it will remain tacky and ruin the painting. The painting should dry for at least a month, longer if the paint is thick. If you want an even sheen, you should oil out instead as this can be done as soon as the colour is touch dry. It is safer to leave the painting unvarnished than to varnish too early, even with retouching varnish.

UV absorbers It is currently common for artists to be told that paintings can be protected by the use of a varnish with a UV absorber. Although there may be a marginal improvement, generally the varnish would need to be thicker than a sheet of glass to have considerable effect. If fugitive colours have been used you might add on only a few years, while if the colours are permanent they are going to last hundreds or thousands of years anyway. The purpose of the varnish is to collect dirt and grease and it is a red herring to expect it to increase the permanence of the colours used.

APPLYING VARNISH

Using a soft rag and some white spirit, test an area of the painting to ensure it is dry enough to varnish. If anything more than a trace of colour comes off, the painting must be left longer to dry.

If possible, test the varnish first on the canvas edge or a similar spare picture to make sure you like the level of gloss.

Any dirt or dust which has accumulated while the painting has been drying should be removed. Use a soft brush attachment on a vacuum cleaner. If this is not sufficient, wipe over sparingly with solvent and leave to dry for 24 hours.

Varnish in a well-ventilated dry and dust-free atmosphere. Leave the painting and the varnish together to acclimatize for several hours prior to varnishing. Do not attempt to varnish on a damp day; it's bound to fail because moisture and varnish don't mix.

Use a dry 7 cm ($2^{-3}I_4$ in) varnishing brush to apply the varnish. A fresh varnish should not need any additional thinners. Apply the varnish thinly with the painting horizontal. After 24 hours, repeat at right angles if the painting does not look evenly covered. In 15 minutes the varnish will have set and the picture can be leant face-inwards against a wall to prevent dust settling on it while it dries. Wash the brush with white spirit as suggested on page 169.

A spray gun can be used but getting an even layer is difficult if you have had to dilute the varnish to pass it through the gun. Inhalation is also an issue with this method.

Aerosols are excellent for textured painting where a brush would deposit an excess of resin in the marks of the painting. To avoid splattering your picture, test the aerosol away from the painting prior to use. Do not use in cold conditions and start and finish beyond the picture surface. Make sure to follow any instructions on the can and that it is full enough to coat the complete picture.

MAKING OIL PAINT

Studio-made oil paint needs to be used within a few months or it will be likely to separate in the tube. Ideally, you are trying to do what the manufacturers do and disperse the pigment particles evenly in the binder. This is very difficult as every pigment is different and you should consider studio-made colour as an education rather than being a colour maker!

29. Pigment particles evenly dispersed in binder

TYPES OF OILS

Cold-pressed linseed oil (sometimes called grinding oil) is recommended for hand grinding because it maximizes the wetting and dispersing of pigment particles in oil. It does not level as well as stand oil for a medium.

Refined linseed oil can be used but it does not wet nor disperse the pigment so easily. It is debatable how different in flexibility and yellowing are cold-pressed and refined linseed oil, but they are both undoubtedly more suitable than any of the other oils for hand grinding.

Thickened linseed oil dries faster but is less flexible and yellows more than either of the above. It is used as a medium and replaces sunthickened oils

Bodied, blown or boiled oils have the same characteristics as sun-treated oils but embrittle and yellow more. They are hardware grade and are not recommended for fine art.

Stand oil will remain more flexible and non-yellowing than other oils but is a slow dryer.

Raw linseed oil is a hardware product and is too dark and poorly processed to be used in painting.

Refined poppy oil is slower drying and less yellow than linseed. It should not be used for

colours in underpainting because of its slow drying. It is often used in whites, and sometimes in blues and pale colours because it is so pale itself. An underpainting white, alkyd white or flake white, ground in linseed oil, is recommended for underpainting (see page 32).

Poppy oil gives a short (buttery) consistency to an oil paint. This can be useful instead of employing other stabilizers for colours which tend to be stringy. Using up to 20 per cent of poppy oil with linseed oil will not display the disadvantages of poppy oil and should be enough to somewhat shorten the consistency of these colours.

Safflower, sunflower and soya oil have similar characteristics and uses to poppy oil.

Walnut oil has been popular in the past but it has no overall advantages over linseed or poppy.

PIGMENTS

Pigments can be chosen for their hue, colour bias, opacity, texture or drying time. Most modern pigments are permanent (see page 135).

Care should be taken when handling dry pigments. See Health and safety, page 171.

Making the paint

Because of the varying weights and oil absorptions of pigments it is only possible to approximate how much pigment is needed to make a tube of oil paint. About 100 g ($3^{11}/_{2}$ oz) of pigment should fill a 150 ml (5 fl oz) tube.

Place the pigment on a slab (plate) and make a well in the centre. Pour in just enough oil to mix it to a stiff paste with a palette knife as in fig. 40. Try to keep the oil to a minimum. An excess of oil produces a weaker and more yellowing paint

which is more likely to wrinkle. Some pigments will resist being wet by the oil, and you will need to persist. You can stabilize these colours with wax (see page below) if continued mixing and grinding really doesn't help.

Mull the paste until you have a smooth oil paint. Periodically stop and scrape the paste back into the centre of the slab and off the muller, using a large palette knife or paint scraper (fig. 42). As the pigment disperses, the paste will loosen up to a normal paint consistency. This can take between 10 and 60 minutes. Leave the colour to relax and then add any more pigment or oil if necessary. Clean the muller and plate as suggested in Tempera Painting, page 62.

When pigments are ground into very fine particles the colour can be 'killed'. However, it is extremely unlikely that you could manage this by hand.

STRINGY PIGMENTS

Some pigments make stringy/sticky paint, including ultramarine, viridian, zinc white and some yellow ochres. If you don't like it, try leaving the mulled pigment to relax for 6–12 hours, then mix in more pigment and re-mull it. This packing can reduce stringiness. Do not make the paint too stiff or there will be a lack of oil in it. Common sense will tell you when the paint is fully packed. Alternatively, you could try substituting poppy oil for some of the linseed oil. Try 10 per cent first, only adding more if necessary.

STABILIZING COLOURS

Some pigments are apt to separate from the oil. The longer the paint is kept the more likely this is to happen, particularly with colours such as chromium oxide green and titanium white.

Other pigments are gritty and are easier to grind and disperse if wax is substituted for some of the oil, for example aureolin, cobalt green, Prussian blue and viridian. Yellow beeswax melted into the oil will act as a general stabilizer in the case of either separation or grittiness. See page 50 for full information on beeswax. A maximum of 2 per cent by volume of beeswax is recommended because the more wax there is the softer and less durable the paint film will be. Measure 114 ml (4 fl oz) of oil and 3 g of wax for a 2 per cent volume of wax. If a pigment does not respond to 2 per cent beeswax, try adding up to another 2 per cent, but never go beyond a total of 4 per cent wax by volume.

Use a double boiler when melting the beeswax into the oil and be careful as both substances are a fire hazard when heated. Prevent water splashing into the oil, which would lead to an unstable paint film.

Do not add water to smooth and stiffen oil paint because it will make the paint go hard in the tube and produce an unstable paint film.

FILLING THE EMPTY TUBES

Loosen the lid of the tube so that air can escape as you fill it. Use a thin palette knife to shovel the paint into the tube. While holding the tube upright, occasionally tap the tube on the table to settle the paint and to prevent air from being trapped in the tube – but take care to do it gently or you may squash the tube. Fill it until there is approximately 25 mm (1 in) of the tube left empty at the open end. Flatten the tube approximately 30–40 mm (1 $^{1}/_{4}$ to $^{1}/_{2}$ in) from the end so that a little paint and all the air oozes out.

Wipe the tube clean with a rag and use a palette knife to fold the end. Make two folds so the end is totally enclosed and label the tube with a colour sample and name.

30. Empty tubes and palette knife

31. Flattened tube

32. Folding tube with palette knife

33. Sealed tube of paint

CHAPTER TWO ACRYLIC PAINTING

Acrylic is quick-drying (touch dry in 20 minutes) and can be used thickly or thinly, opaquely or transparently, with variable gloss or mattness and without a ground. Once dry it is insoluble. Acrylic is an excellent paint for impasto as thick layers are less likely to crack than oil paint. It is altogether a simpler medium structurally and that in itself can bring its own freedoms.

The emulsion is a much better adhesive than oil so collages and added materials are safer with acrylics. Acrylic has the largest variety of mediums which can be safely used in almost any quantity. Acrylic painting can be resumed at any time but the paint cannot be removed once it is dry and residual texture should be considered. When using acrylic products, either use everything from one brand or test before mixing. Some emulsions do not produce a stable mixture. If any mixtures blister, bubble or gel on the palette, they should not be used.

SUPPORTS

The acrylic paint film itself is not destructive to its support and movement of the support affects acrylic paint less than oil. Acrylic will adhere to any surface that is clean and nongreasy and has some sort of key.

CANVAS See Chapter 1, page 9 for types of canvas.

POLYESTER can be used for acrylics provided it is untreated. Cloths made for boats and clothing are dressed with resins which reduce their key for paint. Other synthetic cloths offer poor paint adhesion. Test any prospective cloth by applying primer, allowing to dry and then rub to see if it is secure.

BOARDS can be used if a hard, weaveless surface is desired. See Chapter 6, page 90, for types of board, their preparation and construction. Plywood and blockboard are less likely to transfer hairline cracks through the painting because acrylic is more flexible than genuine gesso.

PAPER is a good support for acrylics. Rag paper is recommended. See Chapter 7, page 110, and surfaced pastel paper (page 124).

OTHER SUPPORTS include aluminium, steel, copper, glass fibre, leather, parchment, vellum, marble, slate and ivory.

PREPARATION OF SUPPORTS

Canvas can be stretched on stretchers or on to a board. See Chapter I, pages II and I8.

Linen can still be dipped as described under Initial preparation of canvas (page 10). Acrylic

ground/paint is water-based so would still shrink the canvas. It will not stretch the canvas as rabbit-skin size does. The canvas will only tighten slightly as the ground dries.

The canvas should be stretched to make it flat, but make sure the weave remains parallel with the stretcher bars. The canvas can also be tightened by using the wedges (see Chapter I, page 14). Ideally, do this before priming to avoid over-stretching the primer film.

Canvas boards Use acrylic emulsion (sold as acrylic gloss medium) instead of rabbit-skin glue to stick canvas on to board. This makes for a more suitable/continuous structure. Dilute the emulsion with approximately 20 per cent water, otherwise it dries too quickly, fills in the weave of the canvas and doesn't glue the canvas down efficiently. Press the canvas down well with your fingers to ensure no blisters develop in the future. Leave to dry thoroughly, approximately 3–10 hours, before applying ground. See also page 18.

Boards should be degreased and sanded. Acrylic will not take well over greasy boards. See Chapter 6, pages 92-93. Boards larger than 60 cm (24 in) square need to be mounted on a chassis. See Chapter 6, page 92.

Paper needs to be stretched if any quantity of water or sustained painting is intended. See Chapter 5, page 74.

Metals See Chapter 1, page 23.

Glass fibre, leather, parchment, vellum, marble, slate, ivory These

materials should be abraded and degreased before applying acrylic gesso primer which will help with the adhesion of the subsequent colour.

ARSORBENCY OF SUPPORTS

Acrylic primers can be directly applied to canvas or paper. Boards made of wood fibre may be too absorbent. If you have a regular acrylic primer which you have already tested (see page 21), apply the primer to your board, allow to dry and test as before but using acrylic colour. If sinking occurs the board must be over-absorbent and should be sized. This sizing is not done with rabbit-skin glue because the acrylic does not adhere to its support with rabbit-skin glue in between. Diluted acrylic emulsion is used instead (see below).

SIZING BOARDS AND GENUINE GESSO

Use acrylic emulsion diluted with approximately 30–50 per cent water. This depends on the degree to which you want to reduce the absorbency. MDF, hardboard and Sundeala are likely to need a strongish size of approximately 30 per cent water, while gesso, hardwood and canvas are likely to need a weaker one — approximately 50 per cent water.

Brush it sparingly on the face and edges with a 7 cm ($2^{-3}I_4$ in) varnishing brush and leave to dry flat. If using an uncradled board, turn it over once it is dry enough and size the other side. Leave to dry thoroughly, approximately 3–6 hours. Sizing both sides will brace the board. If the board is cradled the back does not need to be sized. Wash your brush thoroughly before it dries.

If, once painting, it is apparent that the sizing was insufficient (the paint is sinking), a coat of acrylic gloss medium may be applied thinly over the painting and allowed to dry. This will act as an acrylic 'oiling out'. Use two coats or a stronger size for the next painting.

PVA is not recommended for sizing as the quality of PVAs is lower than acrylic emulsions.

GROUNDS

A ground allows colour, absorbency and texture to be altered and controlled. It also supplies an extra layer for the painting to 'sit' on rather than just the support. See page 20 for acrylic grounds. Well-formulated primers are suitable for use with both oil and acrylic colours.

Clear gesso primer can be used on raw canvas, see page 24.

Alkyd grounds are too greasy. The acrylic would not adhere well.

Genuine gesso is acceptable for acrylic but the amount of preparation compared to acrylic primer makes it only worth using when its exact surface character is desired. Gesso will need sizing to prevent sinking (see page 43).

Coloured grounds using acrylic gesso primer or clear gesso base can be used, see pages 23-24.

APPLYING ACRYLIC GROUND

A wavy mottler will produce a thin even coat similar to alkyd primer on canvas (see page 22). However, as acrylic primer is easier to apply than alkyd primer a wavy mottler is not so indispensable; a decorator's brush is adequate. A plastic card (such as an old phonecard or credit card) can scrape a very thin layer on to a board but may leave ridges. A plastic ruler is quite good. A very smooth effect can be achieved by sanding the primer in between coats, using a medium abrasive paper. Don't overdo it or you'll remove the tooth. Wash your brush before the primer dries.

A litre of acrylic primer will cover approximately

10 square metres. See also page 22 and fig. 28 (iv)(a) and fig. 92(i).

PREVENTING SAGGING OF CANVASES

Stout paper should be applied as for oil canvases, see page 22.

PRIMING A BOARD OR CANVAS BOARD

See page 23.

ACRYLIC PAINTS

Acrylic paints are bound with acrylic co-polymer emulsion. This is made from polymer resins. Acrylics dry by evaporation of water.

COLOUR SHIFT

The single biggest problem with acrylics is the colour shift from wet to dry. The emulsion is

white when wet but becomes clear as it dries and as a result the colour darkens. You will have to learn to compensate for this when painting. Student colours will have greater colour shift while the highly pigmented, best formulated colours will have minimal colour shift. Avoid excessive amounts of medium too as this will increase the colour shift.

TYPES OF ACRYLIC PAINT

Unlike any other media, acrylic can be made in different consistencies and finishes. This is because binders are available in various viscosities and will remain stable when combined with pigment. There are many brand names for the numerous consistencies and quite a variation. It is a matter of choice which you prefer but there are a few points to consider.

Where different consistencies of artists' quality exist within one brand, pigment levels should be equal, that is, the thinnest consistency will have as much pigment as the thickest paint. So if you want a thin flat film buy the lower viscosity and use straight from the pot — a 'thinned' film of conventional tube consistency will dilute the pigment concentration in comparison. Use a specially formulated super-heavy colour for impasto to minimize shrinking.

Secondly, it is more difficult to tell from the design which ranges are artists' quality, as all acrylics tend to have quite jolly packaging. The two grades exist as with other media, so make sure you know what you're buying (see Artists' vs. students', page 26).

Most ranges today have a satin finish. Those which are too glossy look like plastic while a matt finish dulls the colour.

PVA or vinyl colours Cheaper ranges of paint are made using polyvinyl acetate or vinyl as a binder instead of acrylic resins. They contain less expensive pigments which may be extended as well. They are inferior to acrylic paints in handling properties and permanence.

PIGMENTS

The pigment must be evenly dispersed and suspended in acrylic emulsion (fig. 29). Acrylics are much more complex than oils and may have more than 20 individual ingredients to provide a stable colour. (See Chapter 9, page 135, for permanent pigments and manufacturers' catalogues.)

Pigments which are sensitive to alkali are not suitable for acrylic and therefore are likely to be missing from the range, for example alizarin crimson, Prussian blue.

MAKING YOUR OWN ACRYLIC PAINT OR PRIMER

The complex chemistry of acrylics prevents all but acrylic chemists from making stable colour.

THINNERS/ SOLVENTS

Acrylic paint can be used as fluidly as water colour or thicker than oils. Thinners and mediums extend the boundaries of the colour.

The thinner for acrylic paint is water. Unless you are painting on paper in a water colour style, do not overthin the paint by using too much water. The pigment will be left underbound, absorbent and unstable. If a loose sketch is required at first, do this and then start the painting proper.

When you want very fluid layers, use fluid medium in combination with water or flow improver or use lower viscosity (soft body) paints.

GRADATION OF LAYERS

Acrylic paint is more or less equal in strength and flexibility regardless of the pigment. Unlike oil, it is therefore possible for any colour to be used for underpainting or on top of one another.

MEDIUMS

There are more mediums for use with acrylic than any other media. It is an adhesive medium without the 'rules' of oil colour, resulting in many more options. They can be put into three groups.

Mediums These are the binder, supplied in different consistencies from fluid, tube and gel to impasto, usually in gloss and matt of each. They will provide flow, texture and greater transparency. Slow-Dri ™ medium is also available in a gel consistency.

Additives Flow improver is a wetting agent which will improve flow without reducing colour strength. Retarder will slow the drying rate of the paint.

Texture gels Additive textures are available in natural form such as sand and pumice or in synthetic form such as glass beads or blended fibres. Modelling paste is one of the most popular. For maximum colour impact, apply the textures first and then paint over them.

Adding your own texture You can add your own dry textures to mediums or applied colour but these will not be as stable as the dispersed mediums.

Use of mediums If you use excessive amounts of medium in your colour you will increase the colour shift on drying. Secondly, if colour becomes a minimal addition, that is, there's more medium than paint, the film will be softer and tackier and will collect dirt more readily. Do not use excessive flow improver or the colour may not dry.

Slowing the drying rate of acrylics

Excessive retarder will make the paint film soft and cheesy. As an alternative, 'stay wet' palettes using a reservoir paper and membrane can be employed to keep the paint wet in between sessions by replacing the lid on the palette. During painting sessions, Slow-Dri medium may be preferred to retarder. A plant mister can also be used to lightly spray the canvas to reduce the rate of evaporation of the colour.

WHITE PIGMENTS FOR ACRYLIC PAINTING

Lead whites have never been used in acrylic, principally because of their toxicity. Titanium is the most popular white. Zinc is unstable and is likely to yellow. As a result 'mixing white' is offered. This is a reduced-strength titanium formulated to handle like zinc.

HINTS AND TIPS FOR ACRYLIC PAINTING

- Sinking paint Acrylic molecules are larger than oils so 'sinking' is less common. If your paint is dull it is more likely that it has been overthinned. You can correct it by applying medium thinly over the surface and continuing to paint. You should not leave the medium as the final layer as it is too soft and will pick up dirt.
- Overpainting with oils Acrylics should not be used over oils as they will not adhere.
- Removing dents from canvas
 See page 33.
- Using old canvases Although pentimento

and flexibility are not issues as with oils, residual texture is and you will risk producing your best work and then regretting your choice of support. It's not worth it.

- Resuming a picture when the paint is dry New acrylic paint will take over dry paint provided the old paint is washed clean first with a soft cloth, rinsed in clean, warm, soapy washing-up water and squeezed out. Follow this with a rinse of plain water. There should not be a residue of water on the painting. Washing is not necessary if the painting is only a few weeks old.
- Removing canvases from stretchers
 Acrylic paintings are less delicate than oil paintings and can withstand rolling better.
 However, this should still be avoided because of the tediousness of restretching the painting, and rolling it certainly won't be good for it. If you must roll it, with the picture on the outside, around a tube as large in diameter as possible. Any cracks will then fold in on themselves. An expandable stretcher will be necessary to stretch the canvas flat again.

EQUIPMENT

Dried acrylic emulsion is more or less ruinous to brushes. Be aware that paint can dry on brushes in only 10–15 minutes! Even when brushes are kept washed, dried paint can build up at the root of the brush after a while. If you need to remove it, try soaking the brush in methylated spirit (alcohol) or acetone.

A piece of formica or glass makes a good palette because dry paint can be soaked off with water or scraped off. Place a sheet of white paper under the glass if you want a white palette. Be careful to avoid breaking the glass.

CARE OF ACRYLIC PAINTINGS

Acrylic paintings absorb dirt, particularly in warm temperatures. If left unprotected, the dirt ingrains itself and dulls the picture irreversibly. If the picture is to be hung it should be varnished or hung in a glazed frame (see Appendix 1, page 176, for framing pictures).

VARNISHING ACRYLIC PAINTINGS

Allow the painting to dry thoroughly, a week for thin films, longer for impasto.

If the painting is underbound and absorbent, apply a thin film of medium and allow to dry before varnishing. Apply the varnish thinly with a soft brush as described for oil colour, see page 36.

TYPES OF VARNISH

Mediums should not be used as final coatings. They are not removable and will collect dirt quickly. Alkali-soluble varnishes are recommended as they are more safely removable (a proprietary remover is required) than white spirit-based varnishes. However, the latter may be used.

Matt and gloss varnishes are available and can be mixed to achieve various degrees of sheen. A thin wax picture varnish can also be applied to produce an even sheen.

CHAPTER THREE ENCAUSTIC PAINTING

Encaustic means 'burning in' and refers to pigment bound in wax being fused and driven into its ground or support by the use of heat. It is extremely durable. Encaustic can be translucent or opaque, used thinly or as an impasto/texturally, contains no extenders, and can be matt or semi-gloss. It is the only traditional thick paint medium which can be resumed at any time, as it can be made wet (or removed altogether) by the use of heat.

SUPPORTS

Encaustic is not destructive to its support but it has limited flexibility as a paint film.

CANVAS on open stretchers is not recommended for encaustic because the paint is not flexible enough to withstand any accidental knocks. Canvas should be stretched on a cradled board if you want to paint on it. Types of cloth recommended are the same as for oil (see pages 9-10) except if you are using acrylic gesso on polyester, in which case see the types of canvas recommended for acrylic painting (page 42).

CANVAS BOARDS

See page 42 and prime with acrylic gesso primer.

BOARDS such as MDF, hardboard and Sundeala are recommended as for gesso boards (see page 90). The disadvantage of plywood, blockboard and chipboard remain as for gesso boards (see page 91). Boards larger than 60 cm (24 in) square need to be mounted on a chassis (see page 92). Boards should be degreased and sanded before a ground is applied (see pages 92-93).

METALS Copper is a good support for encaustic because of its rigidity. It is far more expensive than wood-based boards. Plates should be degreased and sanded with coarse (page 120) wet-and-dry paper (also waterproof silicon carbide paper). Steel is not good because it rusts and zinc discolours the paint.

SCULPTURAL PIECES Encaustic is good for use on sculptural pieces because the paint structure is so simple and no varnish is necessary.

PAPER is not ideal for encaustic because the paint film is not flexible enough to withstand its movement, but if it is stored carefully you may like to use it on an open frame (see page 78) because it can so easily be kept hot hanging on a radiator.

GROUNDS

A ground allows the control of colour, absorbency or texture of the support. It also provides an extra layer for the painting to 'sit' on rather than just the support. Any of the grounds below are suitable, although you should bear in mind the heat involved in the encaustic process and not overheat any areas when 'burning in' (see page 55).

Unsized gesso See page 94.
Alkyd grounds See page 20.
Acrylic grounds See page 20.

ENCAUSTIC PAINT

Encaustic paint is available in a small range. The permanence of the pigments used should be confirmed by checking the CIGNs (see page 136) and checking with the list of pigments on pages 152-153. Encaustic is in fact the easiest paint to make, is very economical and gives you control over the pigments.

THE BINDER

The binder is beeswax or a mixture of waxes. Beeswax is best because it does not yellow or embrittle over time. Natural beeswax is to be

34. Clockwise: Natural beeswax pellets and lump, bleached beeswax, microcrystalline wax, natural yellow carnauba lump and flakes

preferred because it is more flexible than bleached beeswax (also called 'refined'), which reverts in colour over time anyway. Natural beeswax comes in pellets or lumps. Bleached beeswax can be used in part if you have some.

Carnauba wax is used to produce a harder paint and to make it less heat-sensitive. This is scraped from the leaves of a Brazilian palm tree. The yellow type is from the young leaves, while the grey is from the old leaves. Refined carnauba is filtered grey wax. The yellow type is best for encaustic because of its pale colour.

The melting point of the binder is raised by using part carnauba. The melting point of the paint can be important if you don't want the paint underneath to melt and lift off when you apply more hot paint.

Beeswax must not be overheated as it will turn brown, which will mask the colour of the paint and reduce its flexibility. Hot wax is a fire and fume hazard. A double boiler should always be used. You might like to keep a top part of a boiler exclusively for melting wax. This will save you having to clean it with solvent for other uses.

A total of 500 g (18 oz) of binder will make approximately six small pots of paint. Take 425 g (15 oz) of beeswax and 75g (3 oz) of carnauba wax, that is, 85 per cent beeswax to 15 per cent carnauba. Melt it in the top part of a double boiler for 5–10 minutes. Watch it to make sure the wax doesn't overheat and the water doesn't boil away.

If a softer paint is wanted, replace the carnauba with microcrystalline wax. This is also less sensitive to heat than beeswax. You can mix all three waxes, but keep the proportion of beeswax at approximately 70 per cent as it is the most durable component.

Dammar resin will also raise the melting point of the beeswax but will not combine as well as carnauba. Paraffin (kerosene) waxes are not recommended as they tend to be low quality.

Using oil is not generally recommended,

principally because the oil dries and prevents the studio-made paint being melted and used indefinitely. It also prevents unlimited reworking on the painting. These are two of the unique characteristics of encaustic which are too good to give up, so you may be better using wax in oil paint instead, see Impasto, page 29.

PIGMENTS

Any permanent pigment can be used (see page 135). Choose pigments according to whether you want a transparent or opaque or mixed palette. The transparency of the paint will not equal oil paint because the wax is far more

opaque than oil. Care should be taken with dry pigments, see page 171.

MAKING THE PAINT

The paint is made with the molten binder. It is made and kept on a hot plate because the binder sets in minutes when it is removed from the heat.

THE HOT PLATE

This can be a domestic hot tray or a photographic hot plate (if you are lucky enough to find one). If using a domestic hot tray do not reuse it for food. A metal plate over an electric ring

35. Tins of paint and binder on hot plate

makes an improvised hot plate – a double ring gives a good-sized palette. Stainless steel is ideal but steel will be fine if you keep water away from it. The plate should be at least 6 mm (1 /₄ in) thick and 50 mm (2 in) bigger than the top of the heat source in each direction. Paint the underside of the metal with a matt black paint to help it absorb the heat. Suspend the plate 50 mm (2 in) above the heat by standing it on bricks or by welding sides on it to keep the whole palette at an even temperature. Maintain the heat at the lowest setting to keep the colour molten and minimize the temperature hazard.

36. Metal plate suspended above electric ring: a. supported on bricks, and b. with metal sides

MIXING THE COLOURS

Empty, clean food tins are good containers. (Glass is an option but obviously may break.) With the empty tins on the hot plate, fill each one with molten binder then stir in the pigments well with a palette knife. You can use up to 40 per cent pigment in each colour. Too much pigment will make the colour set on the way to the canvas. The colour will however be very powerful with much less than 40 per cent pigment. Using less pigment will give a more transparent colour, even with an opaque pigment. There is no minimum amount structurally required – you can make it as you like it, but too little pigment will produce a softer

film. Keep the tins of colour on the hot plate or they will set.

Stir the paint before and during use to ensure the pigment is thoroughly suspended in the hot wax. If you experience any problems of pigment separation from the binder, try a different pigment.

THINNERS

There are no thinners for encaustic paint except for the binder itself. Keep a tin of this on the hot plate to thin the colours out — you can make a tin of strongly pigmented colour and then reduce it for transparency on the palette without having to make an extra tin of more transparent colour. There is only one basic consistency of paint in encaustic.

White spirit should not be used to thin hot paint because of the fire risk. White spirit in the paint can also cause separation of pigment and binder.

GRADATION OF LAYERS

Encaustic paint is more or less equal in strength and flexibility regardless of the pigment. Unlike oil, it is therefore possible for any colour to be used for underpainting or on top of one another.

MEDIUMS

The binder is the thinner and medium. You can use any variation of binder as a thinner, regardless of which one you made the paints with.

BRUSHES

You may find it practical to keep a brush for each colour. As the paint congeals at room temperature the brush becomes a hard lump of paint. The easiest thing to do is to leave it and re-melt the paint when you want that colour. This can be at any time (even years afterwards) because the paint does not dry or attract dirt like oil and acrylic. If you want to clean a brush, melt the colour by holding the brush down on the hot plate and wipe off all the paint with a rag. Then wash it with white spirit followed by soap and water. Do not use the white spirit near the hot plate as there is a fire risk.

PAINTING WITH ENCAUSTIC

Encaustic poses a practical challenge not found with oil or acrylic because the paint is only wet when it is hot.

Brushes can be stood in an empty tin on the hot plate to keep them from setting hard. Stand them up around the edge so the colours stay clean. When you have finished for the day, take them out of the tin, shape them with a rag and lay them flat so they set with the hairs straight.

To paint, either pour colours out on to the hot plate or straight on to the support, or use clean spoons/palette knives to remove paint from each tin as otherwise colours will contaminate each other. Don't leave utensils in the tins while the paint sets because you won't be able to pull them out!

Any heated tools can be used provided they don't burn the waxes, for example irons or soldering irons. Heated palette knives may be available.

The palette can be cleaned by wiping with a rag while it is still hot. If using an electric hot tray, avoid molten colour flowing under the edges in case it reaches the electrical connection.

Because the paint cools as soon as you take the brush off the heat, a thick layer of paint will be laid down on the support. Thin layers are obtained by using a hairdryer or infra-red lamp to heat the paint on the support. A hot-air gun is too hot. You may need to keep the support flat if painting wet on wet or the wax may run.

At the end of each painting session simply turn off the hot plate. When resuming, turn the hot plate on approximately 30 minutes in advance in order to melt the tins of colour. Any colours out on the hot plate will melt again too. The tins do not need lids, since any dust on the hard surface can be wiped off before melting the paint.

A characteristic unique to encaustic is that you can resume the painting at any time, even years afterwards. Layers of paint grip each other by the burning in process (see page 55); you won't find old paint resisting new. The painting can be melted at any time for you to paint wet into wet or wipe off entirely.

Encaustic paint can be used cold as wax pastels. A very thin layer of paint can be rubbed on the support with cold paint, see page 133. Scraping and incising techniques can also be used with encaustic. Pigmented oil pastels and some coloured pencils will also melt with heat.

37. Burning in

BURNING IN

When you have finished your painting the layers of paint are fused together and driven into the ground/support by the application of heat. The paint film will grip the ground/support.

Lay the painting flat and hold the infra-red lamp approximately 30 cm (12 in) above it. Move the lamp over the painting as the paint melts. If you over-melt, underlaying colours will seep through the top ones. Lightweight pigments particularly will float to the surface while heavyweight pigments will sink – for example, ivory black will rise up through cadmium red.

Painting can be resumed even after burning in. If you are working on an uncradled board or copper plate, apply a layer of paint on the reverse of the support to help prevent warping.

FINISH AND CARE OF AN ENCAUSTIC PAINTING

After heat treatment the painting will be matt. A gloss/semi-gloss is obtained by polishing the painting. Use a soft cloth and buff the painting or the parts of the painting you want to be glossy.

Encaustic paint does not attract dust as much as oil and acrylic. It cannot be varnished because it is solvent-sensitive. It may be hung on its own or kept in a glazed frame, see Appendix 1, page 176.

CHAPTER FOUR TEMPERA

Tempera is a paint which uses an emulsion as its vehicle. An emulsion is a stable mixture of an aqueous solution with an oily one (oil, wax or resin). Incidentally, this also includes acrylic paint. There are many tempera recipes, however, this chapter is mainly going to discuss two natural temperas; egg and gum. These best display the character of tempera, are the simplest to make, and have the added advantage of a greater choice of colours than the small ranges of manufactured egg/oil paints. Tempera made from natural emulsions is luminous, matt and at its most glowing when used translucently. Opaque layers tend to approximate gouache, which is much easier to use for the same effect. It dries quickly to a partly insoluble film, becoming practically insoluble after some months. Its glowing skin-like appearance is obtained by many superimposed layers of paint. It cannot be moved around on the support like other media. Subsequent painting can only be resumed within a certain period of time. Its strength is the unique appearance of the colours.

SUPPORTS

Tempera is not flexible enough to be used on canvas or paper and must be used on boards, see Chapter 6, page 89. Gesso on canvas which is mounted on board is structurally more acceptable than open stretched canvas, but the glowing nature of the paint will be reduced by the weave of the canvas. Tempera cannot be used on a board without genuine gesso because the board does not offer the right absorbency or colour.

GROUNDS

Genuine gesso is used as the ground for tempera painting because it has the right degree of absorbency which can be readily adjusted for this type of paint to grip the ground. See Chapter 6, page 99. It is also white.

Acrylic and alkyd grounds are not absorbent enough for tempera.

COLOURED GROUNDS

See Chapter 6, page 101.

TEMPERA PAINTS

There are manufactured ranges of tempera on the market which are all egg/oil emulsions. These are useful if you are going into tempera painting in a small way and are therefore less likely to produce a good standard of paint, or if you want to use

tempera to paint into wet oil paint. See
Using tempera over wet oil paint (page 68). Egg
or gum tempera is made in the studio.

EGG TEMPERA

Egg tempera is the best-known natural tempera. It is used thinly and does not offer any impasto effects; any thick layers tend to move before they dry and a thick layer will not adhere well to the gesso — it may peel or crack.

The binder is chicken egg yolk, which is an emulsion of egg oil particles suspended in albumen (aqueous solution). The eggs should be as fresh as possible; the paint will last longer and the paint film will be more durable.

GUM TEMPERA

Gum tempera offers minimal impasto effects as well as thin painting. It is slower drying than egg tempera, less transparent and blends more easily.

The binder is an emulsion of stand oil, dammar varnish and glycerine (oily) suspended in gum kordofan (aqueous solution). Gum kordofan is more flexible and less soluble than other acacia gums (see page 81).

PIGMENTS

Any permanent pigment can be used. See Chapter 9, page 135. Care should be taken with dry pigments (see *Health and safety*, page 171).

Pigments may of course be mixed dry or as water pastes to obtain different colours or shades as well as mixing at the paint stage.

Remember that opaque pigments appear more transparent because tempera is so thin.

38. Glass plate (slab) with sand-blasted surface – 46 cm (18 in) square is a good size. Left to right: paint scraper, palette knife and muller

WHITE IN TEMPERA

Flake white should be avoided because of its toxicity in dry form. Titanium tends to brush out better than zinc.

DE-IONIZED WATER

Only de-ionized/distilled water is used in tempera painting. Metals and salts in tap water can separate the pigments from the binder, leaving dusty pigment particles exposed on top of the gesso. 'Water' should be read as 'de-ionized water' throughout this chapter.

MAKING THE PAINT

Tempera will not keep in tubes without preservatives, humidifiers and possibly stabilizers. This makes recipes more complicated and consequently more likely to go wrong. Vinegar is often recommended for egg but can interfere with its binding strength and can affect some colours adversely. It is simpler if the paint is made as it is needed, thereby removing the need for any of the above.

Pigments must be mulled in order to be wetted, dispersed and suspended in binder to produce a

39. Pigment and water

40. Mixed paste

stable paint film. This is achieved by the friction between the surfaced muller and slab with the pigment paste in between. Mixing dry pigment and binder with a palette knife does not mull it and a weak film will be produced, often with dusty pigment deposits left on the gesso. The most efficient way of making tempera is in two stages: first, the pigment is mulled in water and stored in paste form, then the binder is added as and when paint is required.

MULLING THE PIGMENT

Place a pile of pigment on the plate, make a well in the centre and pour in some water, (fig.39). Mix this to a rough paste with a palette knife, adding more water if needed. Some pigments do not wet easily, but they can be persuaded by using some methylated spirits (alcohol) with the water (fig. 40).

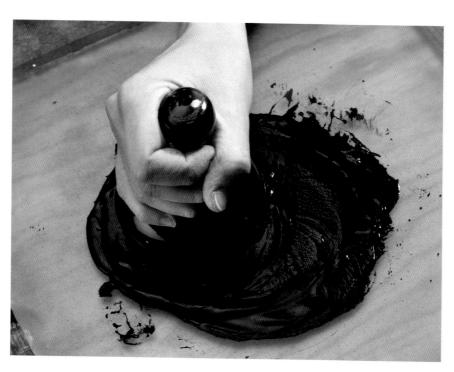

41. Mulling pigment

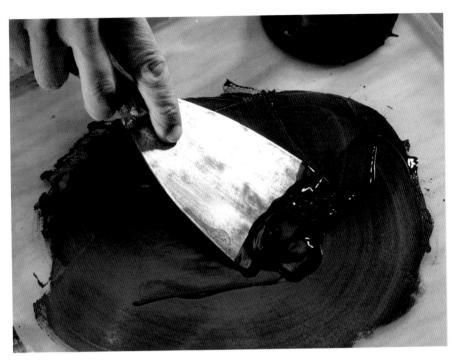

42. Gathering paste into middle of plate (slab)

43. Mulled pigment. Also see fig. 29

Once roughly mixed, move the muller across the plate, mulling the pigment until it is a smooth, creamy paste. Periodically stop and scrape the paste back into the middle of the slab and off the muller, using the large palette knife or paint scraper, (fig.42). Some pigments are initially very gritty and will require more work than others.

This pigment paste will mix with the binder to produce a properly dispersed paint. The paste can be kept in a lidded jar. If it begins to dry out pour a little distilled water on top. If it dries out completely it can be re-mulled with water and put back in the jar.

If you keep pigment pastes for a very long time you may find they go mouldy. If so, sterilize the jars before use (use sterilizing solution available from a chemist/drugstore). You should keep the

lids on during use, only decanting the paste you need. This will both prevent them from drying out and also reduce bacterial activity.

CLEANING THE MULLER AND PLATE

Place the muller and plate on newspaper and use rags or paper towel with water (or white/mineral spirits for oil, see page 38) to wipe them until there is only a trace of colour left. Wash the muller and plate in warm water and washing up liquid once or twice until clean. Dispose of the rags safely (see *Spontaneous combustion*, page 173).

MAINTAINING THE GRINDING SURFACE OF THE MULLER AND PLATE

As the muller and plate are used, the sandblasted surface of the glass is worn away. When it

44. Separating yolk and white

45. Picking up the yolk

is smooth, mulling will take longer because of reduced friction. The surface of the muller and plate can be re-cut by mulling with a teaspoon of pink-fused alumina (grade 54/70) and water for approximately 3 minutes. Wash it off thoroughly with water. Other abrasives, for example carborundum, are less effective at recutting a surface in the glass.

THE BINDER FOR EGG TEMPERA

When you are ready to paint, crack an egg and separate the yolk from the white. You can do this by tipping the yolk back and forth between two jars and letting the white fall out (fig. 44). The white is not used at all in the paint.

Once most of the white is gone, tip the yolk on to a piece of kitchen towel and roll it around. Any remaining white will come off. This will enable you to pick up the yolk between your thumb and forefinger (fig. 45).

46. Filled syringe

Have an empty, sterilized syringe ready and pierce the yolk sac with a point. The yolk will flow out into the syringe. To expel all the air, put the nozzle uppermost and wait for the egg to settle. Push the back further into the syringe until some egg yolk comes out the nozzle and no air remains in the cylinder. This is an excellent dispenser and will keep the egg usable for a number of days (fig. 46). Discard the empty sac. You can store the filled syringe in the refrigerator. Make sure the egg still smells fresh before you use it; if it doesn't, start again with a fresh yolk.

The colour of the yolk does not affect the paint because the paint film is so thin and the yolk colour will bleach out of the paint quickly anyway.

THE BINDER FOR GUM TEMPERA

The binder is made of the following ingredients:

- 5 parts gum solution
- I part stand oil mixed with I part dammar varnish
- 3/4 part glycerine

If you are buying gum arabic to use as your gum solution, confirm with the manufacturer that it is kordofan and about a 30 per cent solution. If you prefer, you can make the solution yourself.

Measure 56 g (2 oz) of kordofan gum, wrap it in a rag and crush it with a hammer. Pour 142 ml (5 fl oz) of hot water over it and leave it to dissolve for 3–12 hours. Strain the solution through a tea strainer to remove bits of bark.

If you are buying dammar varnish, confirm with

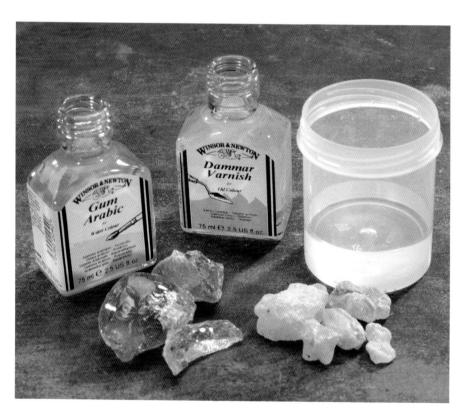

47. Gum Arabic solution, Gum kordofan, dammar varnish, dammar resin, glycerine

the manufacturer that it is a '5lb cut'. You can make the varnish yourself if you wish. Choose the pieces of dammar resin with the least colour and dirt. Tie 140 g (5oz) of dammar resin into a muslin bag and suspend it in a jar of 284 ml (10 fl oz) of turpentine. (Turpentine is a more thorough solvent for dammar than white spirit.) This produces a varnish of similar strength to the shop-bought ones.

Keep the lid on the jar to prevent turpentine evaporating. The resin will dissolve in 12–24 hours. Resist the temptation to dispense with the muslin bag. It can take up to a year for the resin to dissolve if it's not suspended in the solvent!

Dammar varnish should be used up while fresh because of the turpentine content. For full information on turpentine, see page 27.

Stand oil is used rather than any other linseed oil because of its flexibility and non-yellowing features.

48. Dammar bag in turpentine

Mixing the binder

Using a hand egg whisk or electric food mixer (employed in the studio only), add the stand oil/dammar mixture to the gum solution in a slow stream, mixing all the time. Continue mixing until a thick, white, homogenous liquid is produced (approximately 5 minutes). Add the glycerine last and mix well. Glycerine improves the brushability of the paint but increases solubility.

Although the gum solution would normally decompose, the binder can be kept for up to a year if retained in a sterilized jar which is full and

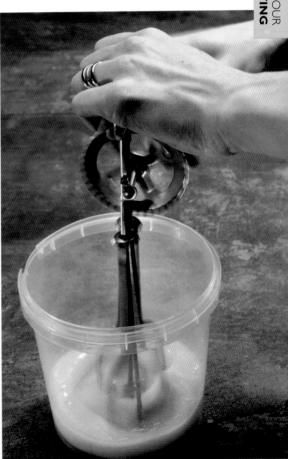

49. Whisking binder

sealed. A bought gum arabic solution is an advantage here, it will last longer as it contains preservatives.

Make sure the binder is fresh before use. If it is not, make a new batch. It will be watery and very smelly if it has gone off.

MIXING THE PAINT

Mix equal parts (by volume) of pigment paste with binder to make the paint. This can be done on the palette with a brush or, if you are using a lot of paint, you could put a yolk or an amount of gum in a cup and mix an equal volume of pigment paste with it using a palette knife.

ENSURING STABILITY

When you first make your paint, test each

colour to ascertain stability and which pigments may need a different amount of binder (for example blues may need a little more).

Brush out each colour on clear glass and allow to dry thoroughly, approximately 12 hours. Using a flexible razor blade, see if each paint film can be peeled off without splintering. The colours which splinter require more binder.

Too much binder will cause the paint to crack while too little will leave the pigment dry and underbound on the gesso. If the paint shows hair-line cracks, reduce the amount of binder or increase the amount of water.

Remember that in the actual painting, the absorbency of the gesso and the amount of thinners used will affect the paint film and must also be controlled. Having tested your paint as

50. Paint film peeled off glass

above and reduced the amount of thinners used, if the paint is still becoming dusty, the gesso is probably too absorbent. The gesso can be sized to control its absorbency (see page 99).

GRADATION OF LAYERS

Any cracking in the layers of colour may be the result of the top layer having more binder in it than the previous layer. The stronger paint layer contracts and cracks. If this problem arises, add more water to such pigments.

ACHIEVING DURABILITY

In order to produce a durable tempera painting you must strive to ensure the pigment is not left underbound. In total you must control the absorbency of the gesso, the amount of binder in each colour and the amount of thinners used. As with any studio-made material, the artist is committing themselves to the time-consuming task of experimenting, testing and documenting their formulations and the results. To achieve stable paintings you must methodically build your knowledge and competence.

STORING THE PAINT

Mixed colour can last up to a week in the refrigerator. It will need to be covered with protective food wrap. Keep it at its original consistency when you start painting again by adding water to the paint. Do not use any surface skin as paint. If you have the paint in cups during painting, a damp cotton wool pad in the top of each cup or damp sheet of blotting paper over a group of cups can act as a humidifier.

USING TEMPERA

There is no medium for tempera, and only one thinner – de-ionized water. Before use, the paint is thinned just enough to enable it to be brushed out. The paint should not be viscous, particularly egg tempera. Too thick a layer of egg tempera will crack, but too much water will produce an underbound paint film. There is only one basic consistency of paint in tempera.

A tempera painting is made by the superimposition of paint layers. Like water colour, everything remains visible so it is not always very forgiving!

The most important part of tempera painting is not to paint in a back and forth motion as is the habit in all other media. This muddies the paint on the gesso. Lay the colour on by one brushstroke only, lift the brush and wait for the paint to dry before the next layer. This takes only a minute.

In order to build up optimum translucency the amount of paint on the brush also needs to be controlled. A full brush will deposit thick edges and a blob at the end of the stroke. This will show through to the next layer and the translucency will be reduced. Wiping the brush on a rag between the palette and the painting will remove excess paint and result in an even brushstroke being made.

Even when dry, the tempera is susceptible to being lifted or muddied by the subsequent layer. Gum tempera is particularly re-soluble. The painting cannot be built up if the underneath layers are constantly being picked up. Excluding glycerine from the gum tempera will reduce solubility. However, a complete absence may

make it difficult to brush the paint out. Painters should adjust the recipe according to their needs.

Colours cannot be mixed on the gesso board. They have to be mixed on the palette or laid, wet on dry, on top of one another on the gesso.

The painting can be resumed up to approximately eight months after the last layer was applied.

After that the new paint does not seem to join with the previous layers but rather floats on top.

If you are going to overpaint with oil you need to wait until the original oil layer is touch dry or the tempera may be picked up as the brush moves the original oil layer. If the tempera itself tends to be soluble when further oil paint is applied, try using a binder without dammar in it (dammar remains soluble in turpentine, although it should be somewhat protected by the stand oil and egg), for example:

- I part stand oil
- I part turpentine
- 2 parts whole beaten egg
- 2 parts de-ionized water

DRYING TIME

A tempera painting is surface-dry within hours. However, the longer the painting is left (up to about a year) the harder, less absorbent and more insoluble the paint film becomes.

USING TEMPERA OVER WET OIL PAINT

Tempera can be used over wet or tacky oil paint for crisp textural and visual effects, unlike those made by painting wet into wet with oil paint. A blob or line of tempera does not merge with oil paint, thus producing the crisp effect. The tempera cannot be worked on the canvas; you can only lay the paint on and leave it, or completely remove it again.

This method of painting can be difficult as the tempera layer is apt to crack where wide brush-strokes are used, or if the oil layer is too wet or too thick, or if the tempera dries too quickly. Use this method only when you occasionally need the crisp effect. An egg/oil tempera is recommended for maximum adhesion of the two media, particularly if the tempera is subsequently covered by more oil paint, for example glazing the tempera with oil paint. See the egg/oil recipe, page 69, or buy ready made egg/oil tempera.

CARE OF A TEMPERA PAINTING

A tempera painting can be given a satiny gloss by polishing/buffing it with a soft cloth – silk is good. Buffing should only be done after the paint has hardened. The painting can be kept clean in a glazed frame.

If your painting is in any way dusty or fragile when buffed, this indicates a faulty paint film. Try to identify your faults and correct them for the next painting. See Ensuring stability, page 66.

A fragile tempera painting must be kept under glass because a varnish would not be removable without taking some of the paint with it. A thin wax picture varnish can be applied to produce an even sheen.

VARNISHING

An absorbent or weak paint film will allow the varnish to sink into the painting, making it very difficult to remove without damaging the painting. Varnishing should only be done once the paint has thoroughly dried and hardened and if the paint film is sound. Buffing the surface may also make it less absorbent. Varnish as for oil painting (see page 35).

OTHER TEMPERA RECIPES

EGG EMULSION

Whole egg does not cause any structural problem in a binder but the resultant paint is more awkward than an egg-yolk binder as it dries very quickly and is more difficult to brush out.

EGG/OIL EMULSION

An egg/oil emulsion gives results tending towards a gum emulsion but to a lesser extent. Egg/oil recipes are more likely to go wrong than gum tempera; they can produce paint which cracks or won't dry. Its best use is for overpainting into wet oil paint (see page 68). A reliable recipe is:

- *2 parts whole beaten egg
- •2 parts de-ionized water
- I part stand oil
- I part dammar varnish

Mix the egg and water together, then strain through a tea strainer to remove the yolk sac and clots. Mix the stand oil and dammar varnish together. Combine the two mixtures with a beater until they emulsify.

The dammar varnish is desirable because the turpentine in it helps the whole mixture emulsify and the dammar seems to have a preserving effect on the binder. The stand oil is better than other linseed oils because of its flexibility and non-yellowing features. Defects in egg/oil emulsions seem less likely to occur when the whole egg is used rather than just the yolk.

There are plenty of recipes in other books for various egg/oil emulsions but be careful as it's easy to go wrong! Start by purchasing readymade tube colour and only make your own if and when your needs expand.

OTHER POSSIBLE EMULSIONS

Egg/oil emulsions can also be made so that they are soluble in turpentine instead of water: Beeswax emulsions offer similar effects to gum tempera. Drying oils should not be combined with wax emulsions because the resulting binder would yellow badly; wax/glue and wax/casein emulsions are recommended instead. Casein and drying oil emulsions are not recommended as they turn yellow/brown. Glue/oil and egg/gum emulsions are also possible. See Bibliography for further information sources on tempera (page 183).

WATER COLOUR AND GOUACHE PAINTING

Water colour is transparent, matt, re-soluble and used thinly. It has a jewel-like quality in its thin translucent stains, but as every mark is visible it is not very forgiving.

Gouache is opaque water colour. It is also matt and re-soluble. Although it can be layered, colours will cover each other as they are so opaque. It is used more thickly than water colour but it is the combined mattness and opacity which produces the body effect of the paint, hence the term 'body' colour.

SUPPORTS AND GROUNDS

Water colour and gouache paint are used directly on paper as both the support and the ground. The paper fibre catches the pigment particles. Rag paper is recommended (see page 110).

A painting will appear brighter if it is executed on a Rough or Not sheet as opposed to an HP (hot-pressed) sheet. Rough and Not surfaces have a greater surface area resulting in more pigment particles being deposited and more colour reflected back through them. For an explanation of paper surfaces, see page 114.

51. Water colour coastline on two different coloured backgrounds

52. Cross-sections of paper showing greater surface area of Rough or Not paper (top) versus HP (bottom)

The paper used for water colour is usually white so that the maximum amount of light is reflected back and the painting appears, and remains, as bright as possible. However, the pale-tinted water colour papers can give some very interesting tonal results. See fig.51, also Coloured pastel paper and Colouring papers (pages 125-126).

Because gouache is opaque, it is not necessary for the ground to be white as the light will not travel through the paint layer. The brightness of the paint comes only from the reflection of light through the pigment itself. Lightfast papers should be used if the paper is to be left exposed. See Coloured pastel paper and Colouring papers, (pages 125-126).

OTHER SUPPORTS AND GROUNDS

Canvas is not suitable for water colour and gouache because the weave interferes visually and gouache cannot withstand canvas movement.

Boards are not suitable as they are not white or absorbent.

Acrylic primer is too non-absorbent for water colour or gouache.

Genuine gesso on board can be used but it should be sized to prevent sinking. See Chapter 6, page 99, for sizing of the board.

Designers may use gouache on various supports for model making. However, if the model is to be kept as a work of art, paper and gouache should be used or alternatively opaque acrylics, which are more flexible.

PREPARATION OF PAPER

A heavyweight (200–300lb/425–640gsm) paper will need no preparation provided the painting is executed with a moderate amount of water. If any excess of water is used or several layers are applied in quick succession the paper will need to be restrained (stretched) or it will cockle. Lightweight papers (approximately 90lb/190gsm) will also need restraining. Cockling paper reduces the amount of water you can use, makes the picture

awkward to keep or frame and can be offputting visually.

Some water colour paper is sold in blocks, as an attempt to keep the paper from cockling. These blocks are simply sheets of paper glued together around the edges, leaving a gap unglued so you can peel the top sheet off. These will remain flatter but will still show cockling if a lot of water is used. A water colour board is rag paper stuck to a board; these are relatively expensive and are probably the nearest to stretched paper. The quality of the board and glue is important as they should be acid-free and non-yellowing. Specific enquiry should be made to the manufacturer.

STRETCHING PAPER

This takes only about 15 minutes and presents a surface which stays flat regardless of the amount of water, the length of time it is worked on or the weight of the sheet. It also allows you to save a lot of money by using lightweight paper. It keeps the paper still and makes it easier to work on.

Paper from any size up to approximately 150 \times 250 cm (59 \times 98 in) can be stretched. The tension built up in sizes beyond that tends to split the paper. There are two ways of stretching paper: on a flat board, or on a flat open frame. A flat board gives a hard paper surface to paint on, while the open frame gives a more sensitive, springy surface.

Don't be tempted to lightly wet the paper, or use masking tape or drawing pins to 'stretch' the paper. These methods do not keep the paper flat when water is subsequently applied.

The painting area is inside the gumstrip on a board and inside the chassis on an open frame, see fig. 62.

53. Spruce boards

STRETCHING ON A FLAT BOARD

The best drawing boards are those made of spruce wood. These are rare as they stopped being made for artists about 40 years ago. One-sided wooden boards for draughtsmen are also spruce. Spruce withstands hundreds of cuts from a Stanley knife when the paper is cut off. Spruce-veneered boards were made and sold in art shops after this but were very expensive.

If you are not lucky enough to have a spruce board, a man-made one will stretch the paper just as well; it will just wear out more quickly. Chipboard is the cheapest but if you find it too heavy, try Sundeala, which is lighter. Use a board at least a 12 mm (1 / 2 in) thick. Thinner ones cannot withstand the tension of the stretched paper and will buckle. Hardboard is useless! If you are stretching on a 244 × 122 cm (8 × 4 ft) board use as thick a board as possible, for example 38 mm (1 / 1 / 2 in) chipboard. Alternatively, you could brace a thinner board with a frame (see page 92) but this will mean only one side is available for stretching. Spruce boards need no preparation but manmade boards are initially too absorbent – the glue from the gumstrip sinks into the board instead of sticking down the paper. They can be

54. Applying diluted French polish to an MDF board

sized with dilute shellac. Sizing is only repeated when you get a new board. Buy French polish and dilute it with approximately 40 per cent methylated spirit (alcohol). Paint on to both sides of the board and leave to dry overnight.

Soaking the paper

Paper expands when soaked in water. It is then restrained by sticking it down by the edges while it is in an expanded state. Further application of water will not cockle the paper.

55. Paper on board showing space for gumstrip

Cut your paper to size. Make it at least 25 mm (1 in) smaller than the board all the way round. Submerge the paper either flat or rolled in a sink or bath of water. A heavy paper (300lb/640gsm) will need approximately 30 minutes, while a lighter weight paper (90lb/190gsm) needs only approximately 5 minutes.

If a sink or bath is not available the paper can be soaked by sponging (fig. 56). This method needs approximately 15–25 minutes on either side of the paper and repeated sponging to ensure it is wet. Be careful not to rub the paper vigorously with the sponge because it will come off in little rolls and will look skinned when dry. If you are very rough you can make holes in it.

56. Paper soaking on board

57. Wet paper disintegrating from rubbing

Insufficient soaking is one of the principle causes of failure in stretching paper. A sheet which is taped down when not fully expanded will not stretch flat and will cockle when painted on.

If you are using surface-sized paper (see page I I2), use cold water and don't oversoak or the glue may dissolve into the water.

Once it is soaked, drain the paper. Either sponge off the excess or, if the paper is strong enough and not too large, hold it vertically over the sink. A piece of Formica mounted vertically over the studio sink is excellent for draining (fig. 58). The wet paper will cling on to it and the water will run off. A clean, tiled wall in a bathroom can also be used.

58. Paper draining on Formica over sink

Attaching paper to board

Lay the paper flat on the board. Pat out any large air bubbles but do not worry about little undulations, which will flatten out as the paper dries.

59. Gumstrip

Gumstrip is used to tape down the expanded sheet. It can be washed off the board with water afterwards. Keep your hands dry when touching the gumstrip roll – any water across the diameter of the roll will stick the whole roll together. Cut the gumstrip to length with dry hands while the paper is soaking.

Wet the gumstrip with a moist sponge, brush or plant mister. Make sure you don't wipe off the gum – it should feel sticky to your fingers. No glue left on the tape is another cause of failure.

Overlap the paper with approximately half the width of gumstrip. Press down firmly, being careful not to rub and damage the wet paper (fig. 57).

Leave the paper to dry in a horizontal position.

The paper will dry naturally in 4–12 hours. Leaving it to dry upright or attempting to stretch paper on walls is a recipe for failure as the water drains by gravity, the top part of the paper dries faster than the rest and then splits from the resultant tension. If you have to attempt it, try to dry the paper evenly with a hair dryer.

If you want to paint into wet paper, take the precaution of leaving the stretched paper to dry thoroughly beforehand in case it fails. Once you know it's successful you can wet it again with a sponge or plant mister:

Stretch paper on both sides of the board. Preparation is always quicker in multiples. Having stretched one side, turn the board over and stand it on four film canisters, ink bottles or something similar at the four corners (not on the paper), so the board has air circulating round it. Both sides can then dry normally. Stretch the second sheet as before.

60. Board standing on canisters

STRETCHING ON AN OPEN FRAME

Paper can be stretched on an open frame up to approximately 150×150 cm $(5 \times 5 \text{ ft})$ before the tension becomes too great and the paper splits. Make a well-jointed and well-glued chassis using approximately 57×16 mm $(2^{-1}/_{4} \times {}^{5}/_{8}$ in) wood for small sizes, increasing the dimensions

of the wood with the size of the chassis and adding crossbars if necessary. Use a waterproof glue for the joints.

An oily wood such as teak will not need sizing but any other wood will require a coat of shellac on the side used when it is new in order to prevent the glue sinking in (see page 75). It is a little awkward, though not impossible, to use both sides of the chassis at the same time.

The paper is attached by means of glue with this method instead of gumstrip, unless you have a wide enough frame for the gumstrip to fit on. Scotch glue (also Pearl glue) is used because it can be washed off the frame with water afterwards. Any water-soluble glue will do the job, for example vegetarians may prefer to use starch.

Scotch glue is a very cheap animal glue. Soak 5 g in 56 ml (2 fl oz) of water for approximately 3 hours, until the granules have absorbed as much water as they can. They will be the same pale colour all the way through. Melt the mixture in a

61. Scotch glue granules

62. Stretched paper: Left: on open frame (painting area within pencilled keyline) Right: on board (painting area within gumstrip). Also showing a heavy metal straight edge

double boiler without boiling. See page 16 for a full explanation of using and heating animal glue. This is enough glue for a frame measuring 100×100 cm (39 \times 39 in).

Cut the paper to the outside dimensions of the chassis. Soak and drain it as described on pages 75-77, fig. 58. Meanwhile, paint the sized side of the chassis with the melted glue.

Place the drained paper over the glued chassis and press down well (without rubbing) all the way round. Try to get it as flat as possible, particularly

on larger chassis. For large chassis this can be done if you clamp it in a forward-tilting easel. Attach the top edge first and as the paper hangs flat, press down the sides and bottom edge; success depends on your glue staying put on the chassis. Remove the chassis from the easel and leave to dry flat.

CUTTING OFF THE WORK

Use a sharp craft knife and a heavy metal straight edge. Lay the straight edge on the work side of the gumstrip or glued edge, so that any slips don't slice into the work. If the picture is to be

63. Paint scraper lifting off wet gumstrip

framed, cut off part of the gumstrip margin so you won't lose any of the painting under the edge of the frame.

On large works, particularly on open frames, cut two opposite sides first, followed by the next two. This reduces the risk of the paper splitting diagonally as the tension is released.

CLEANING THE BOARD/CHASSIS

Cover the gumstrip or glued paper edge in water for approximately 20 minutes, using a sponge or a plant mister. (Heavy paper may take longer.) It will then lift off in seconds with a paint scraper. Don't bother picking at the half-soaked gumstrip/paper edge because it lifts off so easily when fully soaked. Rinse over the board or chassis with a clean sponge and you're ready to start again.

RECYCLING FAILED STRETCHED PAPER

If you have a failure, you can reuse the paper. From a board, cut off the paper including the gumstrip. The gumstrip will come off when you soak the paper, leaving you with the original-size sheet. Only the paper on the inside of a chassis can be saved.

WATER **COLOUR AND GOUACHE PAINT**

which makes it more suitable for water colour and gum tempera.

Gum arabic is a type of gum acacia. It is a loose name for any gum acacia. Dextrin is used for colours which react with gum arabic.

WATER COLOUR PAINTS

Water colour relies heavily on the character of each pigment and its relationship with the paper to produce a surface of varying hue and textural washes. The choice of pigment is likely to be as much for its texture on the paper as it is for its colour. Artists' quality water colour will provide a much greater variation in pigment properties and is recommended in preference to students' colours. Properties such as granulation should be highlighted on manufacturers' colour charts along with transparency, series and so on. Remember that opaque pigments appear more transparent because they are applied in thin films. See also Artists' vs. students (page 26).

Although pigments have slightly reduced lightfastness in water colour because the paint film is so thin, in the 21st century we are hugely lucky to have the very best pigments in water colour. These are now so permanent that despite the thin paint film they are not expected to change. See Chapter 9, page 137 for further information.

Making your own water colour paint is possible, but tricky. Studio-made water colours are apt to be gritty and become insoluble in the pan very quickly. It can be difficult to prevent them from becoming mouldy too. See Bibliography (page 182) for sources for recipes.

WHITE IN WATER COLOUR

Some argue that white should not exist in water colour because the paper can supply it. However, others believe there is a place for both the skill of the artist in using the white of the paper and

the use of white pigments. Chinese white is the most popular as it is only semi-opaque. Titanium is excellent for highlights or covering minor mistakes.

GOUACHE PAINTS

Because gouache (often called 'designers' colours) is popular with designers and graphic artists whose work is generally of a temporary nature, some fugitive colours are used for their short-lived brilliance. These are marked by the manufacturers as poor in lightfastness.

Many gouache ranges are manufactured opaque by the mixing of white pigment into each dry colour. The best ranges however achieve their opacity by loading the binder with the maximum amount of pure pigment.

WHITE GOUACHE

White gouache can be used in water colour to produce 'body colour', but such tints will not have the brilliance of colour of the pure gouache paints. This technique, also called gouache, pre-dates the availability of an actual gouache paint.

USING WATER COLOUR AND GOUACHE PAINTS

WATER COLOUR

Water colour paint comes in pans and tubes. Millilitre for millilitre, tube colours are cheaper than pan colours but you will use tube more quickly and inevitably waste some.

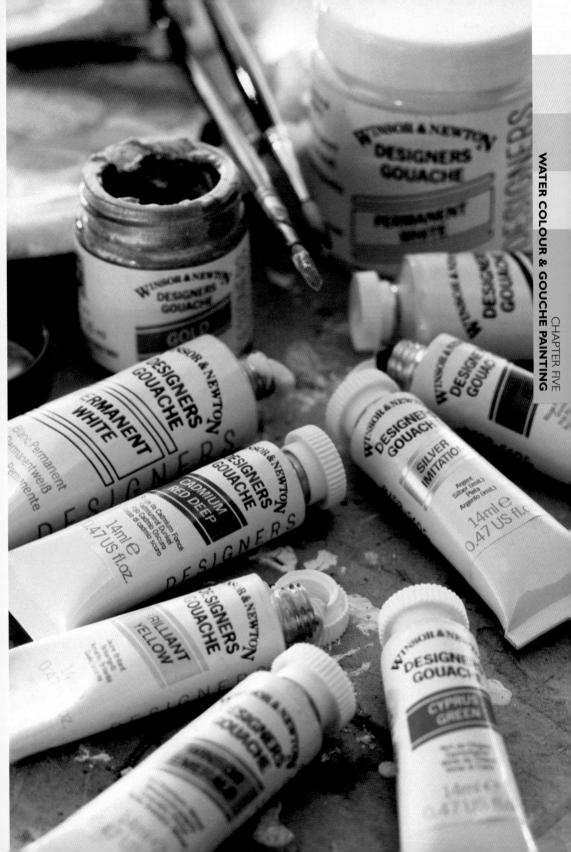

64. Water colour paint in half pan and tube

Tube paint makes strong washes quickly and provides volume, while pan is portable and can be worked up to equal strength washes if you wish.

Pan colours from different manufacturers vary in their solubility or 'pick up'. Although colours which pick up very easily with a wet brush are strong, more like tube colours, the disadvantage is that they will also pick up too easily from the paper, resulting in muddy layers. Pans which require a little more working will provide cleaner, more transparent layers on the paper.

It is not advisable to squeeze tube colours into empty pans as they are likely either to remain sticky or dry out and crack. Buy the pan colour instead, which will release colour as it should.

Washes can be left to dry on the palette and this can be useful when you resume painting, as you don't have to start from scratch again.

Lumps of tube colour can be left to dry on the palette but these do not always redissolve with a wet brush and never behave like wet tube colour again.

For initial sketching, use a light pencil (F, HB) as the water colour will not cover the graphite well and an eraser will not remove the graphite once the wash is dry.

LOOKING AFTER METAL BOXES

Metal paintboxes provide perfect palettes for mixing washes but they will rust if too much free water is about. After a painting session, mop up any excess water and leave the box open to dry. Do not close the box for any period of time with wet colours in it or you may find they stick to the lid of the box and even pull the white paint off the palette.

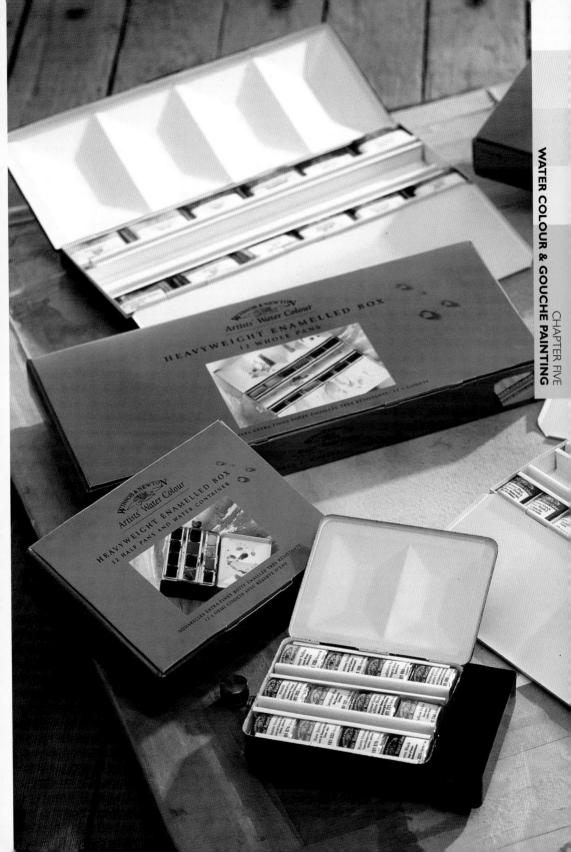

THINNERS

The thinner for water colour and gouache is water. You can use de-ionized water if you find your tap water causing the pigments to separate.

GRADATION OF LAYERS

Water colour is little more than a stain and layers may be continually applied. Gouache colours are very heavily pigmented and can verge on cracking with superimposed layers. Gum arabic should be added to such layers. Don't use too much or the colours will become streaky and glossy. Because of the risk of cracking, gouache should not be used for a real

impasto effect; its characteristic opacity and mattness provides an illusion of body.

MEDIUMS

Gum arabic solution is available as a medium for water colour and gouache. It increases gloss and transparency. It should not be used in heavy layers as it will crack.

You can make your own gum solution if you are using a large volume or want a gum of different strength. Wrap 28 g (1 oz) of gum kordofan in a cloth and crush with a hammer. Combine the gum with 84 ml (3 fl oz) of hot distilled water in

a jar and leave it to dissolve for 3–12 hours. Strain the solution through a tea strainer to remove unwanted bits of bark. Sterilize the jar before use to help prevent mould.

Ox gall is a wetting agent which helps colours flow over hard sized papers. Art Masking Fluid is a latex resist which is very popular for retaining the white of the paper. Care should be taken as it can be difficult to remove from the paper and is best applied with a disposable stick.

There is also a selection of specialized mediums to increase granulation, texture, blending, lifting, resist, iridescence and reduce flow. These extend your possibilities with the colour without any risk to the permanence of the paintings.

CARE OF YOUR PAINTING

Water colours and gouaches should not be varnished. The varnish will yellow and collect dirt and will not be removable from the paper fibre. Gouache will absorb the resin instantly and your matt picture will deepen in tone unrecognizably.

Water colours and gouaches should be either stored away, laid flat rather than rolled, or hung in glazed frames. See Appendix I (page 175) for information on the necessary type of storage or frame.

CHAPTER SIX GESSO GROUNDS

Genuine gesso offers an alternative ground for oil painting and is the ground used for tempera painting. It can also be used for any of the other media. Gesso boards can be bought but are expensive. You can make them cheaply and one of the advantages of gesso is that it is so adjustable to personal needs.

SUPPORTS

Gesso needs a rigid support as it is not flexible enough for use on canvas. Canvas mounted on board is a possibility but the glowing surface of tempera would be reduced by the canvas weave.

Originally, hardwoods were used to make panels (see Bibliography, page 182, for sources on their preparation). These have been superseded by machine-made boards because of greater stability and savings in timber costs and preparation time of hardwood panels. A board provides a rigid, keyed surface for the gesso to grip.

TYPES OF BOARD

MDF (Medium density fibreboard) is

made from pressed wood fibre. It cannot split down the grain as it has none. It comes in thicknesses from 2–30 mm ($^{1}/_{16}$ –1 $^{1}/_{4}$ in) and has two smooth sides. The corners of the thicker boards, 9 mm ($^{3}/_{8}$ in) or more, will not dent easily. MDF is cheaper than plywood and slightly more expensive than blockboard. Exterior MDF is the best but is more expensive. It takes screws well.

There has been some concern with the use of formaldehyde in MDF boards. This is unlikely to be a problem if your boards are stored in ventilated conditions, but if you use a large

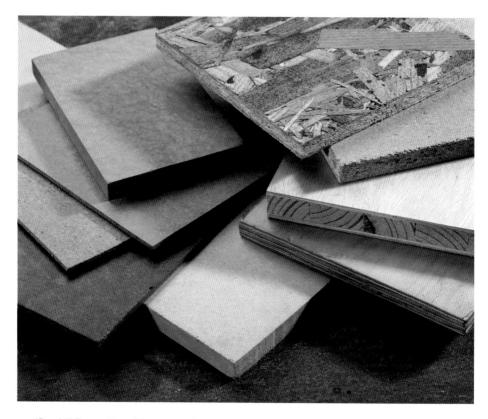

65 and 66. Types of board from centre bottom, clockwise: MDF, tempered hardboard, two untempered hardboards, Sundeala A, sterlingboard, chipboard, blockboard, plywood

quantity of MDF you may wish to source ZF (zero formaldehyde) boards.

Hardboard (masonite) is also pressed wood fibre. Details are the same as for MDF but it only comes in thicknesses of 2-6 mm ($\frac{1}{16} - \frac{1}{4}$ in) and has one smooth side only. The wired/patterned reverse can be used but can appear rather mechanical. The corners are susceptible to denting if the board is dropped. There are two types of hardboard, tempered and untempered. Tempered has been prepared with oil. Provided it is prepared as advised, tempered hardboard appears to be more durable in the long run. It is only slightly more expensive than untempered. Hardboard is the cheapest board, partly because it is so thin. It is best used for gesso boards which are less than 60 cm (2 ft) square. See page 92.

Sundeala A This is also pressed wood fibre. Details are the same as for MDF but it only comes in thickness of 6–12 mm ($^{1}/_{4}$ – $^{1}/_{2}$ in) and has one smooth side only. Sundeala A is 'sheltered exterior' quality and is recommended for artists because Sundeala K (interior quality) is too absorbent. Corners are less likely to be dented than hardboard, but Sundeala is softer than the other boards of the same thickness. It is more expensive than MDF but is lighter in weight.

Insulation board (Softboard) is a weak wood fibre board which is not recommended for artists.

Plywood is made of various numbers of thin layers of wood and/or veneers (plys), the grain of each lying at right angles to one another. Over a period of time, the outer veneer sometimes splits in fine lines down the grain which show as cracks in the painting, particularly through alkyd grounds and gesso. The corners of the thicker boards, 9 mm ($^{3}/_{8}$ in) or more, will not dent

easily. It can be susceptible to slight warping. It comes in a large number of thicknesses depending on the number of plys and has two smooth sides. WBP (weather and boil proof) or marine quality are the types recommended.

Blockboard is made of small lengths of wood sandwiched between two outer skins of wood veneer or plywood. The top veneer can split like plywood. The corners will not dent easily and blockboard is unlikely to warp. It comes in thicknesses of 13–26 mm (1/2–1 in) and has two smooth sides. The quality of blockboard varies a lot, and a poor-quality board will show gaps in its edge where the inside structure should be. Well structured five-ply is recommended if you do use blockboard.

Chipboard (particleboard) is made of pressed wood chips. It does not have any grain. It is liable to break or chip rather than dent, particularly around the edges. It comes in thicknesses of 6–38 mm ($^{1}/_{4}$ –1 $^{1}/_{2}$ in) and various densities of 600–720 (kg per cubic metre) and up. Heavier densities are recommended if you are going to use it. It has the poorest surface stability out of all the boards – particles can come away from the front and the colour of the wood chips can seep through into the ground – but it is the cheapest thick board. It does not take screws well.

Sterling board (Aspenite) has similar disadvantages to chipboard.

All the boards are likely to bend from their own weight in large sheets, that is 244×122 cm (8 \times 4 ft).

CONSTRUCTION AND PREPARATION OF SUPPORT

BOARDS

Man-made boards will warp, particularly when being prepared with water-based size or primer. If the board is smaller than 60×60 cm $(2 \times 2$ ft) both sides are prepared in the same manner. This equal tension on both sides will help keep the board flat. Use 3 mm ($^{1}/_{8}$ in) hardboard for these smaller boards because it is the cheapest.

Larger sizes will need to be braced by attaching them to independent frames. This is a type of cradled board. Make a well-jointed and glued frame using approximately 57×16 mm ($2^{-1}/_4 \times 5^{-1}/_8$ in) wood for small sizes, increasing the dimensions of wood with the size of the chassis. Use square-edged wood so the board has the maximum amount of frame to join to (fig. 68). Add a crossbar for sizes bigger than approximately 71×91 cm (28×36 in) and multiple crossbars as the size of chassis increases.

Cut the board to fit the outside dimensions of the chassis. Use a proprietary wood glue and glue and screw the chassis and board together. Any fuzzy edges on the board from the saw can be neatened with a coarse file. Either side of any board can be used.

Thin boards, for example 3 mm ($^{1}/_{8}$ in) hardboard, should not be attached from the front using panel pins. The ground never takes over the pins, even when they have been punched below the surface and filled. Using cocktail sticks instead of panel pins may be better, but a thick board eliminates the problem. Use a board which is at least 9 mm ($^{3}/_{8}$ in) thick in order for the screw to get enough grip from the back, (fig.68 and 69).

67. Chassis with crossbars

68. Cross-section of chassis and board showing screw and square-edged wood for maximum attachment

Using plywood and blockboard

To prevent the hair-line cracks in the wood-grain from showing through, a layer of muslin can be glued on to the board with the size. The gesso will cover the muslin. This does not always work however and the cracks can still manage to transfer themselves through to the gesso and the painting. Any cloth on the board is an extra element in the ground which can go wrong, so avoiding plywood and blockboard would seem more sensible than trying to offset the transference of hair-line cracks by using muslin.

Degreasing boards

Once constructed, the side to be gessoed and edges of the board should be scrubbed with a clean rag and methylated spirits (alcohol) to

69. Cradled boards, front and back

degrease them as a greasy board can resist the gesso and cause pin-holes. Wear rubber gloves because methylated spirits may be absorbed through your skin. If it's an uncradled board, scrub both sides and the edges; doing the back as well means you can't transfer the grease from there to the front. Leave to dry thoroughly overnight.

Tempered hardboard must be degreased very thoroughly, so no greasy patches are left.

Sanding boards

Boards should be sanded using a medium-fine abrasive paper to provide a key for the gesso to grip. Be careful to sand the surface evenly or the board will absorb size or gesso unevenly.

CANVAS ON BOARD

See oil painting chapter for types of canvas and mounting canvas on board (pages 9, 18). A cradled board is best because it will withstand better the tension from the cloth on the front. If using an uncradled board, do apply a coat of gesso to the reverse, otherwise the board will warp. Canvas on board should only be used if you need the weave of the canvas with gesso.

USING MUSLIN ON BOARD

Muslin is sometimes recommended to give the gesso something extra to grip, but properly made gesso can grip a degreased and sanded board quite well enough without this extra element. Try chipping some gesso off your board; you will see its grip is quite sufficient. It should pull away some of the wood fibre with it.

GROUND

Gesso is made of animal glue and an inert pigment or a mixture of white pigment and inert pigments. See also alternative binders and pigments (pages 103-104). Care should be taken with dry pigments, see Health & Safety (page 171).

MAKING THE GLUE

As when rabbit-skin glue is prepared for sizing canvas, the measurements of glue and water can only be approximate (see Sizing canvas, page 16, for extra explanation on using and understanding rabbit-skin glue). The glue must be made in a double boiler, and its set must be tested.

The measurements will probably be 70–85 g (2 $^{1/}2$ –3 oz) of glue to 1.1 litres (2 pt) of water. This will be enough gesso to complete a $^{1}22 \times ^{1}52$ cm (4 × 5 ft) board. If the glue is made too weak the gesso will be too soft and powder off the board; if it is too strong it will be too hard and brittle and will chip and crack off the board.

As a starting point, put 80 g (3 oz) of glue with 1.1 litres (2 pt) of water in the top part of a clean double boiler. Leave to swell for approximately 2 hours until it is a uniform beige colour. Keep the lid on the double boiler.

Melt the glue and leave to set in a cool place with the lid on. Test it when it is at room temperature, otherwise it might appear stronger than it really is. The set glue should look and feel like

70. Split glue for gesso

fruit jelly except a split in it made with your finger should be firm and rough rather than smooth and tough. If the jelly is too strong it needs more water. If it resembles size, then it is too weak and needs some more glue. Add more glue or water if necessary and repeat the process until the right set is obtained. Note the proportions so you can make the glue in one go next time.

Make up several boards at a time. Depending on the size of the board, of course, four or five boards will take about the same time as one!

SIZING THE BOARD

The board needs sizing in order to reduce its absorbency. (The exception to this is tempered hardboard, which does not need sizing because it is not absorbent.) Without size the glue in the gesso would sink into the board and leave a weak layer of pigment on top. The edges of man-made boards are often more susceptible to moisture than the faces. An initial sizing helps to equalize this difference and make for a more stable board. Sizing may also help to isolate any greasiness still on the board and prevent pin-holes.

If using part of the glue made for the gesso it will need to be diluted with 50 per cent hot water to make it size strength (see page 16). Some sources claim boards need a stronger size solution. If you find your gesso sinking into the board, increase the strength of the size used.

Heat the glue in the double boiler until it feels hot to your finger; do not boil. Hot glue will size the board most efficiently by penetrating it more.

Use a 7 cm ($2^{3}/_{4}$ in) varnishing brush and put the size on sparingly. A flood will have the same defects as too strong a size. Size one side and the edges first and leave the board to dry flat. Once it is dry enough to turn over; size the

other side and leave to dry thoroughly, which will take 3–12 hours. If the board is cradled the back does not need to be sized.

MAKING GESSO

Gesso needs to be white in order for the painting on it to be as bright as possible and remain so. Gesso does not need to be mulled because the pigments chosen disperse well in the glue on their own.

White pigment alone does not disperse well in the glue and is relatively expensive. Whiting forms a good dispersion, dries to a fairly white finish and is relatively cheap. See page 104 for functions of different pigments.

71. Gesso at thin single cream consistency

Replacing 10 per cent of the whiting with titanium white will improve the whiteness and opacity of the gesso without affecting its structure. Start with approximately 450 g (1 lb) of whiting and 56 g (2 oz) of titanium. Mix these together while dry to disperse the titanium. This will make enough gesso for 3–4 coats on a 152 \times 122 cm (5 \times 4 ft) board.

Heat the glue until hot. Transfer it to a spare pan and put the pigment mixture in the top half of

72. (i) First coat of gesso on board (ii) fully coated gesso board

the double boiler. Keep the double boiler on the lowest heat setting. With no heat at all or a lack of it the gesso will harden; but you mustn't let it boil either! Pour enough glue into the mixed pigment to stir it into a lump-free paste. Make sure the pigment is thoroughly wet and mixed. Dilute with the glue until the gesso is the consistency of a very thin single cream. Keep the lid on from now on or the gesso will thicken up and skin over from water evaporation.

USING GESSO

Gesso is used by building up layers, usually about five and not less than three, to obtain a structure of decent thickness. Several thin layers are more stable than one thick one. Make the gesso in the moming so you can complete the boards in one day. The gesso is bound to skin if you keep it

overnight and there is better adhesion between layers if they are done in succession. Pin-holes can develop if new gesso is added over a dry coat.

If the gesso thickens during the day because of evaporation of water from the glue, add a little hot or warm water to keep it at a very thin single cream consistency otherwise the glue, and hence the gesso, will become too strong. It is important to keep the gesso the same strength (or if anything weaker) because stronger layers applied over weaker ones may cause them to crack and pull the gesso off the board.

Stir the gesso before applying another layer to prevent the pigment settling at the bottom of the pan. Try not to whip air bubbles in, as pin-holes can result (see page 105).

73. Gesso on canvas board

A 7 cm (2 $^{3}I_{4}$ in) varnishing brush gives a good even layer with minimum brushmarks. Brush on the first coat, including the edges (do not do this vigorously or the size will lift up) then go over it with your fingers, rubbing it into the board. This makes a good bond and helps to prevent pin-holes. See fig. 72 (i).

If the board is uncradled, turn it over and repeat on the reverse. Apply an even number of coats on both sides; missing out just one from one side can make the board warp. Only do the edges when you do a coat on the front or they'll be double thickness! Just build the layers up one by one, including the edges, on a cradled board.

For the second coat just brush on and leave to touch dry. Drying time can get a bit longer as the layers build up. Brush the third and subsequent coats on at right angles to the previous coat. This helps to produce a level gesso ground.

Rinse the brush out between each coat or it will set hard before the next one. The gesso will dry to the touch in 10–20 minutes.

Keep going until the gesso is I-2 mm ($^{I}/_{16}$ in) thick or more, so that the dry gesso is thick enough to sand. Leave to dry thoroughly for I2-24 hours, see fig.72 (ii).

APPLYING GESSO TO CANVAS ON BOARD

Apply the gesso as thinly as possible. A wavy mottler is good. Thick layers are more brittle and will fill in the weave of the canvas and cover it up. This would counteract the point of gluing the canvas on in the first place.

SURFACED (OR TOOTHED) GESSO

Surfaced gesso is used for pastels, charcoal and other drawing materials. The surface can be created by adding one of the inert pigments which imparts tooth to the last one or two coats of gesso. (See the list on page 104). Keep this addition to no more than 10 per cent to keep the structural advantages of the whiting gesso.

Mix the extra pigment with some glue before adding it to the main batch as the new pigment will not disperse well on its own and will make lumps in the gesso, see fig.74 (ii).

Don't sand the board as you'll remove the surface. Any size required is applied over the toothed surface.

To make a smoother surfaced gesso, soak a pumice stone in warm water for approximately 15 minutes. Use the wet stone to rub over the gesso board. The gesso board will partly dissolve and some pumice will be deposited in it. Leave to dry, see fig.74 (i).

STIPPLED, PATTERNED OR SPRIGGED GESSO

For a randomly modelled gesso the last couple of coats can be applied by stippling them on vertically with a wavy mottler. See fig. 25 and fig. 74 (iii). For patterned gesso the last coat can be surfaced by pressing a piece of cloth/canvas or a sheet of glasspaper into the soft but not wet gesso, see fig. 74 (iv).

Sprigged gesso is patterned gesso in positive relief. A cast is made from your desired mould using enough whiting in the glue to make a 'putty'. This 'sprig' is then attached to the board with wet gesso, see fig. 74 (vi), (see opposite under Incised, carved and sanded gesso).

INCISED, CARVED AND SANDED GESSO

A wet gesso board can be incised or embossed with any number of tools in order to model it, see fig. 74 (v). A dry gesso board can be carved and engraved. Sanding is another way of modelling it.

A good thickness of gesso on the board will prevent you from going through to the board. If the gesso needs sizing for the medium you are using, either do this after you have modelled the surface or, if you remodel the gesso when painting, carefully resize any areas you need to. See page 99 for sizing gesso, and Chapter 2, page 43.

You can increase the quantity of whiting to produce a thicker gesso for modelling but you need to do this with caution as there will come a point when the glue is in too low a proportion to bind the whiting.

FINISHING THE BOARD

Tempera painting needs a flat ivory-like finish if the paint is to optimize its glowing skin-like quality. There is no structural objection to an unsanded or textured board if you want that effect.

Once dry, the front of the gesso board can be sanded to remove brushmarks. Use a medium-fine abrasive paper wrapped round a block if you want a dead flat surface. Dispense with the block if you want slight undulations. Keep going until all the brushmarks have gone. Sand the edges too if you want them neatened up and round them slightly to prevent chips on the sharp edge.

To produce the ivory-like effect get a clean damp lint-free rag (the cloth must not deposit any fluff into the gesso) and wrap it into a smooth pad. A piece of worn cotton sheeting is good. Rub over the board in a light circular

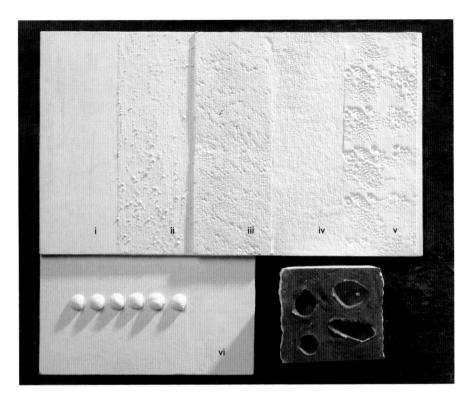

74. Types of gesso surface, from left: (i) smooth surfaced gesso, (ii) added pumice to gesso, (iii) stippled gesso, (iv) patterned gesso, (v) incised/embossed gesso, (vi) sprigged gesso with cast

motion. This polishes the gesso by dissolving the top layer and spreading it out to fill in any scratches. Keep going until a sheen is built up, see fig. 76 (v).

This method of finishing is also suitable for encaustic and silverpoint.

SIZING GESSO

For tempera With experience you may want or need to reduce the absorbency of the gesso. Use a gelatin size (see page 100). Keep notes on the number of layers or strength of size so you can repeat or change the effect.

For silverpoint, charcoal or graphite

Sizing can be done after a preliminary drawing.

For acrylics See page 43 for sizing gesso.

For oil and water colour painting The board may be left as it is after its final coat of gesso or can be sanded and/or polished as for tempera. At this point the gesso is too absorbent for oil paint; the oil would continue to sink into the gesso while the paint was drying, leaving the pigment insufficiently bound on the surface. The gesso needs to be sized to achieve just the right slight absorbency for oil or water colour paint.

Gesso on canvas on board also needs sizing for oil or acrylic painting.

GELATIN SIZE

Gelatin does not interfere structurally and is transparent, so the whiteness of the gesso will not be impaired. Technical gelatin is easier to use than food gelatin, which is weaker. Technical gelatin may sometimes be in capsules or powder as well as in sheet form.

A weak gelatin size is used. If the size is too strong the paint will slip over the surface and not grip the ground. However, if the size is too weak the paint will sink into the gesso.

Measure 14 g (1 /₂ oz) gelatin and soak it in 568 ml (1 pint) of water in the top of a double boiler for approximately 2 hours. This will be enough size for the number of boards made from 1.1 litres (2 pt) of gesso, that is, the measurements in this chapter.

Melt the gelatine in the double boiler and leave

until it is cool but not set; although the size is most evenly distributed while it is hot, it cannot be used hot as it would dissolve the top layer of gesso. Brush it on using a 7 cm ($2^{-3}/_4$ in) varnishing brush. Do the edges as well to give the same surface to paint on right up to and over the edge if required, see fig.76 (ii) and (iv). Leave to dry, usually 2–6 hours.

The gelatin size will not last more than a week in the fridge before it starts to decompose. Throw away what you don't use and make fresh next time.

If the paint seems to be sinking when using the board with oil paint, see Oiling out and controlling sinking (page 33). For the next panel either put two coats of size on, letting the first dry, or increase the strength of the size by 5 g of gelatin. Alternatively, you could reduce the absorbency of the gesso by using Lifting

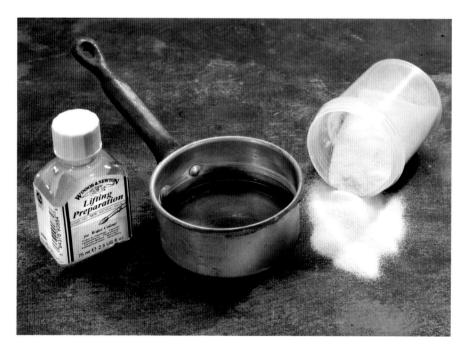

75. Lifting preparation, cool but not set gelatin and technical gelatine

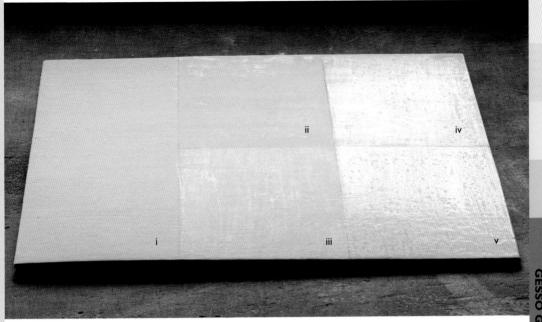

76. Finishing and sizing gesso examples, from left: (i) gesso, (ii) size on sanded surface, (iii) sanded gesso, (iv) size on polished surface, (v) polished gesso

Preparation by Winsor & Newton. This is painted on straight from the jar or warmed prior to use to dilute it by standing the bottle in some hot water.

USING SHELLAC FOR SIZING

Shellac is not recommended because it darkens and embrittles.

BRACING UNCRADLED BOARDS

For the ultimate in bracing uncradled boards you can size the final coat on the back with gelatin and then put on a layer of paint, that is, the medium used for the painting on the front. Any movement will then affect both sides in the same way.

COLOURED GROUNDS

There is no structural objection to coloured grounds – the effects are optical only. Any transparent media needs to be used on a white ground so that the maximum amount of light is reflected back and the painting will appear and remain as bright as possible. In fact an oil painting will get brighter on a white ground, whilst a pale beige opaque, coloured ground is the most suitable colour if you do not want this to happen.

Opaque media do not need to be used on a white ground because the light doesn't travel beyond the pigment layer. The brightness of the media comes from the reflection of light from the pigments themselves.

TRANSPARENT VEILS

In order to colour gesso for a transparent technique, a veil is applied using a transparent pigment in a second coat of gelatin size. If you colour the first coat of size the colour will sink too deeply into the gesso. This will negate the white ground.

Having chosen the colour you want, mull the pigments with water until you have a smooth paste. (See Chapter 4 for photographs and extra explanation (figs. 39–43).) Any additional water used in mulling the pigment will weaken the size. The first coat has already sized the board sufficiently and it is safer to have a weaker layer than a stronger one.

Mix the pigment paste into the cool but not set size and brush on a second coat quickly. Then wipe the board over with a cloth to even up the colour. Leave to dry 6–12 hours.

In the photograph (fig. 77) a more pigmented size was used on the darker middle section (ii), which had been only lightly sanded. A less pigmented size was used on the lighter left hand section (i).

OPAQUE COLOURED GESSO

An opaque coloured ground can be made by mixing any pigment of your choice (transparent

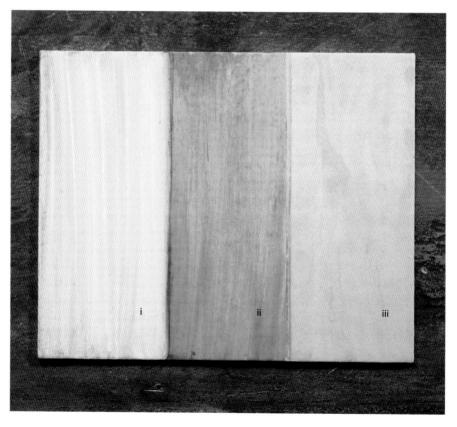

77. Coloured gesso grounds, (i) lightly pigmented veil, (ii) more strongly pigmented veil, (iii) opaque coloured gesso

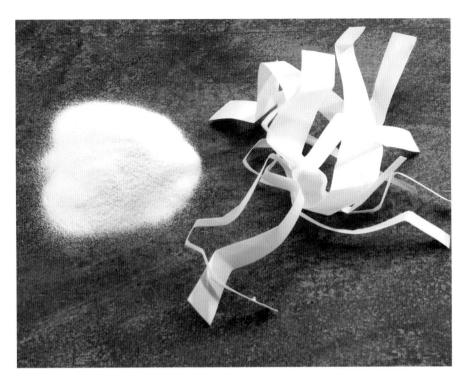

78. Casein and parchment clippings

or opaque) into the gesso for the last one or two coats. Mix the extra pigment with some glue before adding it to the main batch as the new pigment will not disperse well on its own. Try to use only about 10 per cent coloured pigment so as not to interfere with the sound structure of the whiting gesso. If the board is to be sanded apply three or four coats to ensure you don't sand back to the white, or use coloured gesso from the start, see fig. 77 (iii).

Gesso can be coloured, toothed, patterned, incised and so forth by any combination of the methods detailed in this chapter:

OTHER BINDERS FOR GESSO

Calf-skin glue is a rabbit-skin glue type but it is not readily available.

Blended glues (a mixture of more than one type) are also rabbit-skin glue types.

Gelatin produces a weaker gesso than rabbitskin glue.

Parchment clippings can be used to make a glue (fig.78).

Casein produces a more brittle gesso but is

made and applied without heat, which may be an advantage. See fig.78 and Bibliography for sources on preparation (page 181).

Glycerine or honey should not be used in gesso in an effort to increase flexibility. Their hygroscopicity can damage the gesso structurally.

Synthetic resins have definite scope for use in gesso but we await any research on the subject.

Manufactured gesso powders tend to produce a rather splintery gesso and do not offer the control that studio-made gesso does.

OTHER PIGMENTS USED IN GESSO

Other inert pigments can be used in gesso to impart extra tooth, texture, smoothness or absorbency. Unless the list below states that whiting can be replaced, it is suggested you use approximately 10 per cent of the said pigment because they do not disperse as well as whiting (or the pigments which can replace whiting). Only replace more than 10 per cent of the whiting if you need to and certainly don't go beyond 40 per cent.

You could use one or more of the pigments from below throughout the whole gesso batch, or you could use them in the gesso for the last couple of coats. If doing the latter, mix the pigment/s with some glue before adding to the main gesso as the new pigment will not disperse well on its own.

The pigments are listed alphabetically in the pigment list (page 141). Their uses in gesso are:

- Barium sulphate Gives tooth.
- Blanc fixe Gives tooth.
- China clay Very smooth gesso.
- Flake white Not suitable for use in gesso due to its toxicity.
- Gypsum Produces an all-round poorer gesso than whiting.
- Magnesium calcium carbonate Can be used but not recommended.
- Marble Gives tooth and a white gesso.
- Mica Does not produce a stable gesso.
- Plaster of Paris Used slaked and replacing whiting, this produces a very smooth, fine-grained gesso called gesso sottile. See Bibliography for sources on preparation (on page 182).
- Precipitated chalk Finer grain gesso than whiting, which it can replace. It is more expensive. It is not recommended for gelatin gesso as the combination of fine particles and weak size prevents the gesso forming.
- Pumice Gives tooth and off-white gesso.
- Red bole Very smooth, opaque red gesso.
- Silica Gives tooth to gesso if using a coarse grade. Not recommended as continued use could lead to silicosis.
- Talc Does not produce a structurally sound gesso.

- Whiting On its own will be less white than with some titanium or zinc added. Recommended for gelatin gesso as its coarser particles help form the gesso.
- Zinc white Can be used instead of titanium but is neither so white nor so opaque.

PROBLEMS WITH GESSO GROUNDS

Damp or excessively cold rooms can cause all sorts of problems and so can the wrong strength of glue.

PIN-HOLES

These tiny pinpricks in the surface of the gesso can prevent you from getting a smooth ground for tempera paint. They cannot always be removed by sanding.

Air bubbles within the gesso can cause pin-holes when the gesso is brushed on. This can result from tipping the pigment into the glue and stirring in too much air. Bubbling gesso from too much heat will also trap air bubbles but the gesso should never be that near boiling point.

Pin-holes can also be caused by applying new gesso to thoroughly dry or dusty gesso. Try to complete the gessoing in one day.

Pin holes are most likely to occur when there are pigment particles which have not been wetted. If you have this problem, try mixing the whiting into a small amount of glue first.

79. Pin-holes in gesso

GESSO IS TOO GRITTY

Gesso can be gritty or granular if the pigment is too coarse or is not suspended evenly in the glue. Sanding the gesso board may just leave a minutely pitted surface which will interfere visually with tempera.

This can be avoided by mulling the pigment with water (see page 60) until you have a smooth paste before mixing it into the gesso. Try to offset this added water by using a proportionately smaller amount of water to make the glue with. This is obviously fiddly because of not necessarily using all the glue mixture for your mulled pigment. Alternatively, if you leave the mixture on the plate (for a few days) to evaporate off, you will have a finer ground pigment which will not be gritty and should disperse better:

TOP LAYERS OF GESSO CRACKING

This is due to the glue being stronger in the top coats compared to the previous ones. See Using the gesso (page 96) for full explanation.

GESSO CRACKING THROUGHOUT

This can happen if one of the layers of gesso was too thick or if the room was too cold and damp. Cracks occurring once the gesso is over a year old are probably caused by the support moving.

HALF CHALK OR EMULSION GROUNDS

In an effort to adapt gesso for canvas on open stretchers and principally oil paint, a half-chalk ground has been developed. This consists of mixing oil into gesso, which increases its flexibility but does not make it as flexible as an alkyd ground. It also reduces the absorbency of the ground. The whiteness of the ground is less than gesso. Any flexibility decreases rapidly. A half-chalk ground becomes almost as brittle as a gesso ground after a few years. The ground is much more hygroscopic than an alkyd ground on an open stretcher. This also encourages the ground to crack.

The absorbency is apt to vary from batch to batch even when using the same recipe and problems with sinking are frequent. In other words, there is a very narrow margin for success.

The half-chalk ground yellows more than an alkyd ground. Its faults would be minimized if it were to be used on board with an opaque palette, that is, the yellowing of the ground would show less if the oil painting were opaque. Canvas mounted on board would be better than canvas on an open stretcher. Unless you specifically need this ground to paint on, the alkyd ground or gesso already described are quicker to make, allow much more room for error and offer a wider scope.

GENERAL RECIPE FOR HALF-CHALK GROUND OR EMULSION

Size the canvas or board as usual (see pages 16, 18, 95) or mount the canvas on board as for an alkyd ground.

Make the gesso (see *Making the gesso*, page 95) with titanium or zinc and whiting in a 1:1 proportion, for example 56 g (2 oz) titanium and 56 g (2 oz) whiting if using a total of 100 g (4 oz) of pigment. This is to try to offset the yellowing effect of the oil.

The oil content can be between 20–30 per cent in liquid volume of the gesso. Some recipes use boiled oil, but this will make the ground yellow and brittle. It is used because it is quicker drying than other linseed oils. Thickened linseed oil will not embrittle as much as boiled oil, will dry at approximately the same rate, but may darken like boiled oil. Stand oil will have the least yellowing effect, will remain the most flexible, but is slow to dry.

Add the oil in a slow stream to the hot gesso and stir it continuously until there are no oil droplets visible, that is, until it emulsifies. Apply one coat as thinly as possible, using a wavy mottler (fig. 25) to push the ground into the weave of the canvas. A thin coat is much less likely to crack.

Leave to dry. Thickened oil emulsion should be left to dry for a week, while stand oil emulsion may take up to three. A second coat will take 2–3 times longer to dry than the first coat and will also make the ground less flexible. If the ground is painted on before it's dry, it will crack the painting as it dries. It may also be overabsorbent until it is dry. Leaving the ground to dry for six months would eliminate the risk of such problems.

CHAPTER SEVEN PAPER

Paper is made from the interlocking of fibres, usually plant fibre (cellulose). There are many makes of artists' paper, all of high quality. Full information is very good through retailers. See Bibliography (on page 182). This chapter will explain terminology and give notes on uses and using paper. Artists need strong paper to withstand sustained working and to resist deterioration. There are many factors determining the strength and character of paper. Aside from the manipulations possible in the papermaking, strong paper is produced from long, acid-free fibres. Each plant produces a fibre of different length. Longer fibres make the strongest paper because they interlock better. Artists' paper should not discolour. Acidity in paper causes it to embrittle. This can happen in less than a year with newspaper. Acidity can come from the fibre or from the sizing. See Types of fibre (page 110) and Rosin size (page 112).

TYPES OF FIBRE

Wood fibres of different lengths are mixed to produce strong paper. Two types of paper are produced from trees: mechanical woodpulp, and woodfree.

Mechanical woodpulp paper is made simply by pulping the wood. This fibre is very acidic, which leads to the quick deterioration and yellowing of the paper. Examples are newspaper and sugar paper:

Woodfree paper is made from chemical woodpulp, where the fibre has been separated and cleaned. The lignin which is the acidic and yellowing component has been removed. Some

artists' papers, including some cartridges, are made from woodfree fibre. In tests it does resist decay.

Cotton fibre direct from the plant is used for artists' paper. It is called cotton linter. The fibre used to come from old cotton and linen clothes or clippings, hence the term 'rag' for artists' paper. Cotton is strong and non-acidic.

Linen fibres make very strong, non-acidic paper but the cost of the raw material means it is rarely made. See Bibliography (on page 182).

Other fibres such as manilla, esparto, glass, nylon and polyester are used in various commercial papers and sometimes for handmade artists' papers.

Oriental fibres: There are several plant fibres

80. Paper with four deckle edges

81. Cylinder mould showing where torn and deckle edges are formed (six sheets of paper)

used in Japan, Korea and China to make strong, non-acidic paper. Batches of paper can vary in acidity. Retailers should be consulted to establish which papers are non-acidic.

PAPER PRODUCTION

Handmade paper is strong in all directions because the fibres are meshed absolutely at random. This gives handmade sheets their surface character and makes them very stable and probably the most hard-wearing and longest surviving. Handmade paper has four deckle edges as a result of being formed by hand on a mould and deckle.

Machine-made paper is made on a Fourdrinier machine which mimics the original paper-making process but on one continuous machine. The paper is rather characterless, is directional (the fibres run in the direction of the movement of the machine) and is markedly two-sided. The rapid and strong drainage of the pulp on the mould produces a different density of fibre on each side of the paper. These two factors make it weaker (it will tear easily in one direction) and less dimensionally stable, making it cockle when in contact with moisture.

Mould-made paper is made on a cylinder-mould machine which orientates the fibres more randomly than a Fourdrinier machine. Its strength and character is therefore somewhere between handmade and machine-made paper. Mould-made paper has two deckle edges along the long sides of the sheet. These are formed at the ends and centre of the cylinder. The other two shorter edges are made when the sheet is torn to size. This has come to be described as having 'four deckle edges'.

SIZING OF PAPER

The strength of a sheet of paper is improved by sizing, but the real strength is in the structure of the interwoven fibres. These fibres are very absorbent, and this absorbency has to be reduced or paint will sink straight in; it will look dull, the pigment will be left unbound on the paper surface, and the paint will be very difficult to work with. Blotting paper is an example of unsized paper.

Artists' paper for painting and drawing is sized **Internally.** A synthetic size is used in the pulp. It joins to the fibre, resulting in a paper which, even if the surface is rubbed away, will have the same absorbency all the way through.

Artists' papers may also be **Surface-sized,** where the paper can be sized in two ways. Firstly, with starch in the paper machine, which has no sizing effect but smooths the fibre down to improve the paper surface; and secondly, with gelatin in the cylinder mould machine or on the dry sheet. This is called tub sizing. If a paper description states the paper is surface-sized without the word gelatin, you can deduce that the surface-sizing is starch.

Tub sizing gives an extra glow to the paint because the paint sits on the surface more, that is, the absorbency of the paper is reduced. Water-soluble paint is also easier to remove when it is only sitting on the surface. This method of sizing also toughens the surface somewhat, giving it more resilience for a heavily worked drawing.

Unlike internal sizing, vigorous painting will remove either type of surface-sizing.

ROSIN SIZE

Prior to synthetic size, rosin and alum were used at the pulp stage for internal sizing. The rosin had a yellowing and embrittling effect on the paper and the alum caused acidity. This method of sizing is no longer used for artists' paper, but may still be used for other papers.

WATERLEAF AND SOFT SIZING

Papers for intaglio printmaking need to be soft so that the paper can take a true cast of the plate. A surface-sized paper would interfere with this, so requires soaking in warm or hot water for at least 30 minutes to dissolve the glue. A heavily sized sheet may need to be soaked for up to 12 hours. Pouring off the water and glue solution and replacing it with fresh water hastens the process.

Soft-sized paper has a low level of internal sizing to retain the softness of the paper fibre. Waterleaf has no sizing at all for the same reason. Waterleaf gives a glowing, detailed appearance to a print because it is so soft.

Soft-sized and waterleaf papers became popular in the 20th century when the availability of old rag water colour paper declined. An old piece of paper (that is, tub-sized paper, approximately 20 years old) gives an excellent cast of a plate because the surface-sizing has broken down, softening the paper. This cannot be mimicked by the soaking of a new sheet of surface-sized paper. As internal sizing on mould- and machinemade paper became more common, the old papers ran out and soft-sized papers have taken their place.

Because soft-sized papers are not surface-sized they do not require long soaking. A medium weight paper (250 gsm) will need only approximately 5 minutes to soften the fibre for a good cast.

Soft-sized and waterleaf papers are rather limited for painting because the paint sinks into them rather quickly, and can leave a weak film of underbound pigment on the paper surface.

process is not disclosed. Any buffering in that case would only be to counteract atmospheric acidity. Buffered paper is sometimes called calcium carbonate buffered.

BUFFERED PAPER

Gelatin is traditionally used in conjunction with an acidic substance called alum which emphasizes (hardens) the gelatin effects on the paper. However, alum makes the paper acidic, so this acidity is successfully counteracted by buffering the paper with an alkaline buffer, for example calcium carbonate. A small amount is incorporated into the paper at the pulp stage. Gelatin can be fixed without using any acidic substance but that

WOVE AND LAID PAPER

Wove paper is formed on a woven mesh. Laid paper made by hand or on a cylinder-mould is formed on a mesh made of wires laid over each other at right angles. A greater proportion of pulp is deposited on the lower wires of the cylinder-mould. Laid paper made by a Fourdrinier machine is wove paper which has been embossed with a laid pattern. On the Fourdrinier machine the paper fibre is displaced and produces

82. Laid (Fourdinnier) paper, left, and wove paper, right

83. Cross-section of laid mould showing more pulp on lower wires during production of laid handmade or mould-made sheet

higher density lines of pulp. When either paper is pressed and dry, a lined pattern results.

A watermark is made in the same way as laid paper either by stitching/brazing the design on to the mould or on the Fourdrinier machine by embossing it into the wet sheet.

Laid paper can be used to effect in drawings, where charcoal/pastel take more to the thicker stripes in the paper, giving a ribbed effect. Some printmaking papers are very subtly laid and can be used to good effect in a print, in either the inked or border area.

THE SURFACE OF THE PAPER

Water colour paper is produced with three surfaces (see fig.84):

Rough paper reflects the rough surface of the blanket between which the formed sheet is pressed.

Not stands for not hot-pressed. Otherwise known as cold-pressed, it is rough paper which has

been pressed again (cold) without the blanket, the pattern of the blanket being flattened.

Hot-pressed (HP) paper is Not paper which has had a hot pressing. This smooths the paper considerably by ironing down the fibres.

These surfaces are relative to each make of paper – one maker's Rough is another one's Not. When choosing a paper, artists should look at all the makes in order to get the right surface for the cheapest price.

THE RIGHT SIDE OF THE PAPER

The right side is that side which shows the watermark the right way round. It is often the smoother side. Machine-made paper is markedly two-sided; mould-made may be perceptibly two-sided, while handmade paper is not. Although these technical differences exist, artists should use the side which suits the work in hand as they often offer different effects.

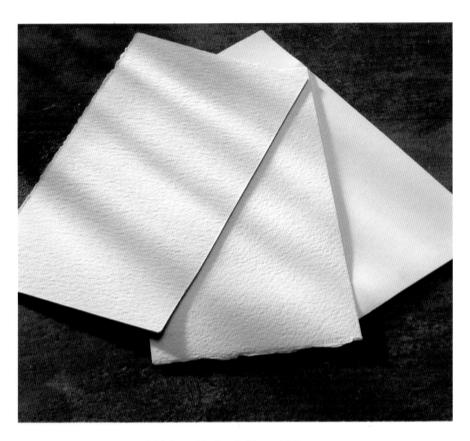

84. Left to right: Rough, Not, and HP paper

WEIGHT OF PAPERS

Papers are weighed in metric and imperial measurements. A heavy paper is thick and a light paper is thin. If you execute a painting on paper with a sparing amount of water, it will remain reasonably flat, particularly if it is a heavy piece of paper. A handmade sheet will also tend to dry flatter than a mould-made or machine-made piece, in that order. The random orientation of fibres in a handmade sheet produces a more dimensionally stable sheet.

However, for a water-rich method or sustained painting, any paper will cockle as it absorbs water. This can be avoided by stretching the paper in the first place (see page 74). You can then also save money by using lighter weight papers.

Heavyweight papers are not categorically better than lighter ones. It is from the point of view of long-term stability and age that this loose condemnation of lightweight paper stems. A heavier paper is more resistant to tearing and rough storage and is stronger simply because there is more interwoven fibre. This must be taken in context, however, as any cotton paper will last indefinitely if kept as recommended.

CHAPTER EIGHT DRAWING MATERIALS

Any of the materials mentioned in this chapter can be mixed. Some materials will not adhere well to each other, for example chalk pastel over wax pastel or pastel and charcoal over graphite, but you will be able to see and feel this when using those materials.

Drawings can be resumed at any time either by removing the charcoal, pastel, pencil and so forth, or by adding to the original.

SUPPORTS AND GROUNDS

Charcoal, graphite, coloured pencils and chalk pastels are suited to work on paper because the paper acts as a file, removing particles from the drawing tool and holding them in the interstices and the paper fibres. The paper is both the support and ground. Rag or acid-free paper is recommended (see page 110).

85. Pigment particles in interstices of paper

Pencil or charcoal can be used on canvas or canvas board when sketching in a composition. Boards can also be used.

Genuine gesso is suitable. See page 89 for preparation of gesso boards and page 95 for sizing if necessary. Acrylic gesso primer will also file off particles and can be useful for coloured grounds, see page 124. Clear Gesso Base on its own will give an excellent surface for charcoal and pastels and can also be coloured, see also page 124.

SILVERPOINT AND OTHER METALS

Metals are too hard to be filed off by paper fibres alone. The paper needs a coating of pigment particles to catch the metal.

Stretch the paper of your choice (see page 74) – smooth paper is often chosen for realistic work. To have plain white paper, paint on a layer of titanium white water colour. This will be more or less imperceptible but renders the paper hard enough to pick up the metal. White gouache or acrylic gesso primer can be used if you want a more dominant primer/less dominant paper surface. A coloured water colour or gouache will give you a coloured paper ground.

Gesso does not need to be sized for metal drawings. See page 89, 101 for making and colouring gesso boards.

USING METALS

Metals produce light and airy drawings.

Silver produces a grey line which tarnishes to brown.

Gold gives a brown/grey line very similar to silver which also tarnishes.

Platinum gives a grey line which does not tarnish.

Plumber's and tinman solder (60 per cent lead) gives a dark grey line, more dense and like pencil than the other metals. It can tarnish to a brown

86. Clockwise from top left: (i) plumber's solder, (ii) tinman solder, (iii) platinum, (iv) gold, (v) two thicknesses of silver, (vi) proprietary holder with thin and thick silver

Wire can be held in a clutch pencil if it's tight enough, or just pushed into a piece of wooden dowling. However, a proprietary holder is not expensive, grips the silver well and has ends of four different sizes to hold a variety of metal thicknesses (each end can be unscrewed and reversed).

New pieces of wire can have sharp burrs at the end. Roll the new wire end on some fine emery paper to remove any sharpness which could cut the paper.

Metal marks cannot be removed from paper without removing the paper surface as well; nor

can they be removed from acrylic primer.

Although gesso takes longer to prepare, its advantage for sustained metal drawings is that marks can be removed by sanding down the gesso (see page 98). A smooth support will allow continuous lines to be drawn while on a rough support the stylus will bounce over the high spots, giving a broken line effect.

Silverpoint can be useful instead of pencil or charcoal for under-drawings because it shows far less through thin paint, especially for tempera and water colour. Gesso boards can be sized for water colour and oil painting after the silverpoint drawing is complete. See page 99.

87. (i) Compressed charcoal (Fusain), (ii) charcoal pencil, (iii) medium, thick and thin willow charcoal, (iv) vine charcoal, extra soft and hard, (v) triangular poplar charcoal, (vi) white eraser, (vii) conté carré, original and Large, (viii) black crayon, (ix) Pierre Noir crayon, (x) square graphite pencil, (xi) soluble graphite pencil, (xii) graphite without wooden casing (x 3)

SCRAPER BOARD

A scraperboard is a board coated with a white ground and surfaced with black ink which can be scraped away to produce a white on black drawing.

Scraping techniques can also be used with encaustic and oil pastels. See Bibliography (on page 183) for sources on preparing traditional scraperboards.

GRAPHITES AND CHARCOALS

Lead pencils are made of graphite and clay. The harder the pencil (H = hard) the more clay in the mixture; the softer the pencil (B = black) the more graphite in the mixture. F (firm) is between H and HB.

The same scale of hardness is also used for

graphite sticks and compressed charcoal, although different companies' scales may not correlate, that is, one company's 2B may be equivalent to another's 4B.

Graphite also comes in sticks of various sizes without wooden casing and in soluble pencil form.

Charcoal comes in a variety of sizes and densities, according to the common wood in the country of origin. Willow is common in the UK, vine in the US and poplar in Europe. It is good to have as many as possible to add variety to your drawings.

Charcoal and graphite in general are cheap to produce and completely lightfast. Each brand can be quite different so choose the brand which you like or which is cheapest. The photograph (fig. 87) shows a range of these materials.

Any type of eraser can be used. For complete removal of marks, a white plastic eraser is excellent.

For surfaced papers, see Chalk pastels (page 124) and Fixatives (page 127).

Oil charcoal To give effects similar to oily crayons, charcoal can be oiled. Stand sticks of charcoal in a jar and fill the jar with refined linseed oil. Keep the jar topped up with oil for 24 hours. Then remove the charcoal, wipe off excess oil and wrap the sticks individually in aluminium foil to slow the drying. Oil charcoal will go hard as the oil dries, so make it when it is required. It should be used on gelatin surface-sized paper in order to reduce the absorption of oil by the paper. You may find acrylic gesso primer more suitable.

COLOURED PENCILS

Coloured pencils for artists come in three basic types: conventional, charcoal/pastel and water-soluble. The vehicle in coloured pencils is based upon a blend of waxes.

Coloured pencils were not originally conceived as a medium for fine artists but, as with any material, some artists will exploit them. During the last decade some ranges have been made with higher lightfast pigments and manufacturers have published the pigments used. A prospective ASTM standard on coloured pencils has helped raise the bar.

If you experience any dustiness or separation with water-soluble pencils, using de-ionized water may help (see page 59).

White spirit or turpentine can be used with some pencils but the solvents are likely to stain the paper. Some coloured pencils can be moved with heat, similar to encaustic.

Paper may be best stretched for ease of use if you intend an extended working time on one piece. White plastic erasers are recommended for maximum removal of marks.

COMMERCIAL PENS

There are many black pens which are made either for writing or, more specifically, drawing. Unfortunately, permanent markers refer more to the water/bleedproof binder rather than the lightfastness of the colour.

The main concern is to establish the light-fastness of any you use. Contact the manufacturers and ask for pigmentation or Blue Wool Scale ratings. (see page 137). If there is any doubt regarding permanence a dip pen and black Indian ink should be used.

NIBS, QUILLS, REED AND BAMBOO PENS

Apart from the many types of metal nibs, quills and reed pens offer unique types of marks and are all worth considering.

Quills Goose and turkey are mostly used, although crow, sea-gull and swan have been used, particularly in the past. It is probably the resilience which promotes these types of quill. Of course you can try any feather. See Cutting a nib.

Reed pens are made from the common reed plant, Phragmites communis (syn. Phragmites australis). The reeds are harvested in late autumn and dried before cutting a nib. Here again you can try any hollow plant stalk.

Bamboo pens are the toughest natural pens.

88. From left: Bamboo and reed pens, turkey and goose quills

89. a. Steps in cutting a nib. b. Nib designs for right-handed people

CUTTING A NIB

Nibs can be cut in any of the ways shown in fig. 89 or you can invent your own method. Use a new blade in a scalpel or craft knife and always cut away from you. Nibs can continue to be cut from a length of reed or bamboo as each nib wears down, until there is not enough pen left to hold.

COLOURED INKS

Inks stem primarily from the graphics area of painting, where work may be produced for its illustrative function only rather than for permanent display. Brilliance therefore may precede permanence. There are many ranges and names on the market but we can divide inks into three types.

Shellac binder with dyes are bright and transparent and lovely to paint with but they are unfortunately not permanent. For fine art work they can only really be used in sketch books which remain closed. They are water resistant on drying.

Acrylic binder with dyes are bright and transparent and may be called Brilliant Watercolour. These are not particularly widely available since the demise of the graphic illustrator. They are not lightfast or water resistant.

Acrylic binder with pigment were initially called Liquid Acrylics and were primarily developed for airbrush. They may be called other names but the important thing is that they are made with pigments. Check the pigments with the manufacturer to ensure permanence. If you like shellac-based inks but want permanence, these are your option. They are usually water resistant on drying.

Indian ink is a pigmented shellac-based black ink. It is permanent and water resistant and is used in pen and wash techniques. Black ink also comes in

the form of sticks from China. This is made from pigment and natural glue. It is made liquid by rubbing it with water on to an ink stone or a piece of Formica and this is not water resistant when dry. Coloured ink sticks are probably best avoided as the pigments may not be lightfast.

90. Chinese ink stick, ink stone

For use with inks, paper should be stretched (see page 74) to prevent cockling. Genuine gesso should be sized. See Chapter 6 (page 89) and Sizing gesso (page 99). Acrylic gesso primer is not absorbent enough for ink.

Inks can be thinned with water. De-ionized water is recommended.

CHALK PASTELS

One of the main attractions of chalk pastels is the pure colour at your fingertips. Paper does not have to be prepared for pastel. However, the nature of pastel, charcoal and graphite is the textural relationship between the pigment particles and the paper. This is obscured if the picture is fixed. Fixative can also darken the colour and make it more transparent. So, the more the paper grips the pastel the less it will need fixing. Using a Rough or Not sheet of gelatin surface-sized paper rather than an HP one will help (see page 114). The pastel is held in the undulations of the paper.

91. Cross-section of Rough and Not papers showing trapped pastel

For heavy work, pastel and charcoals are really improved by using a surfaced paper or board. Fine abrasive or flour paper can be used but it traps the pigment very much which can be over dominating and the paper backing is not rag (see page 110). To obtain a modest surfaced rag paper you must prepare your own.

Flocked (velour) paper is paper coated with powdered cotton. The backing is not rag and the colours tend to be rather bright and not particularly lightfast.

MAKING SURFACED PASTEL PAPER

For a white ground, this can be done by using acrylic gesso primer (see page 22). Stretch the paper of your choice (see page 74). Paint on a layer of acrylic gesso primer and leave to dry for I-3 hours to make sure the surface is dry and hard, (fig. 92 i). An even toothier surface can be obtained by using natural texture gels added to the primer, (fig. 92 ii). Do not add more than 20 per cent of texture gel and do not overbrush when applying or the texture will get dragged out. For a coloured surfaced paper you can tint acrylic gesso primer, (fig. 92 iii).

For a translucent texture use clear gesso base (fig. 92 iv) and apply as for acrylic gesso primer. A transparent colour can be added to clear gesso base, (fig.92 v) or for a more strongly coloured surface use an opaque colour such as red iron oxide, (fig. 92 vi), (see also Coloured grounds, page 23).

Genuine gesso can also be surfaced for drawings and coloured (see pages 98 and 101).

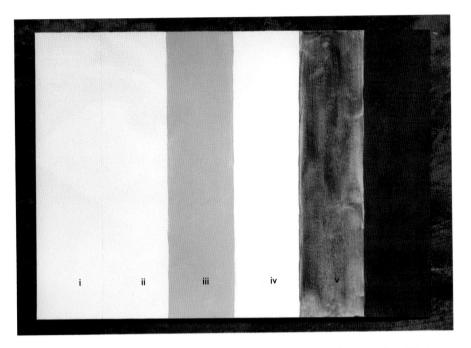

92. (i) acrylic gesso primer, (ii) acrylic primer and texture gel, (iii) tinted acrylic gesso primer, (iv) clear gesso base, (v) clear gesso base with transparent acrylic hue, (vi) clear gesso base with opaque acrylic hue

COLOURED PASTEL PAPERS

Pastel is an opaque medium and does not therefore rely on a white ground. The brightness of the pastel comes from the reflection of light through the pigment itself. Coloured papers will have no effect on the stability of colour in the pastel.

Coloured backgrounds can be very useful in unifying the image rather than having white flecks showing through the pastel. They are also attractive by providing contrast in studies or portraits where the image is central, leaving the outer paper uncovered. Unfortunately, however, such strongly coloured papers often need dyes which are inferior in lightfastness to artists' colours and papers which are exposed are likely to fade. For permanent work it is therefore recommended to wet or dry tint your own paper as fig.93 or, better still, as fig.92 which can include extra tooth too.

COLOURING PAPER

Wet tinting To approximate internally coloured paper, water colour and Method A should be used. Gouache can be used for a heavier effect.

Stretch the paper of your choice (see page 74).

Method A. Wet the stretched paper using a sponge or garden spray and leave for the water to soak in for a few minutes. Then paint on the colour of your choice and leave to dry. Use a large wash brush to produce an even wash.

Method B. Paint the colour of your choice on to dry stretched paper and leave to dry.

Dry tinting Internally coloured paper can also be approximated by using the dry pigment of your choice. This method does not need stretched paper in itself but if the paper is going

93. Dry tinting paper with pigment

to be painted on then stretch it before colouring it, as the pigmented paper can be blotchy after soaking. Use a dry toothbrush to rub the dry pigment well into the paper fibre. Care should be taken when handling dry pigments (see Health & Safety, page 171).

USING PASTELS

The binder for chalk pastels is usually a weak gum, just sufficient to hold the pigment together. The colours in pastels cannot be mixed on the palette like paint, so an individual stick for each colour and tint required must be bought. Opaque tints of colours are made by mixing the full strength wet colour batch with more and more white, making some pastels at each stage of reduction. Because of the large amounts of white pigment used in producing the paler shades of pastels and the lack of binder

protection only those pigments with high lightfastness should be used (see Chapter 9 and relevant manufacturers' catalogues).

Pastels containing high quality pigments can be expensive, especially for large ones. However, pastels can be made economically in the studio – see Making chalk pastels recipe (page 127).

Some brands are less dusty than others but dusts are potential hazards and you should work to minimize the dust in your workspace. Brush dust away rather than blow it and vacuum the edge of your easel or table when you've finished.

Dust will also be controlled if you keep all your pastel pieces in boxes or trays of rice or ground rice. This also keeps them clean and you can see what they are. Many artists keep separate airtight containers for each part of the spectrum.

FIXATIVES

Fixatives are made from synthetic resin. They negate the textural quality of pastels and darken and translucify the colours. They do, however, improve the lightfastness of the pastels as they offer some protection to the exposed pigments. Fixative can be invisibly employed in between layers to enable you to work over and into areas without the pastel or charcoal lifting up.

If the picture really needs a final protective layer, the finer it is the more subtle any change will be. Three thin layers of fixative are more stable than one thick one. A fine layer can be applied using an aerosol or a laboratory atomizer (fig. 94). To avoid splattering your picture, test the aerosol away from the painting prior to use. Do not use it in cold conditions and start and finish beyond the picture surface. Make sure the can is full enough to coat the picture and follow any instructions on the can.

Unless you already have a spray gun, the alternative is an atomizer. This apparatus enables you to produce a very fine even spray without drips or sudden splodges and you can fix with the picture horizontal if you wish. The atomizer is used by pumping the rubber bulb with your hand. Care should also be taken not to get liquid into the rubber hose, because the valve at the end of the rubber bulb will rust. Any build-up of limescale can be removed by standing the atomizer, nozzle-end up, in a glass jar with a proprietary de-scaling product.

If you have a delicate mixed-media picture, fixing with diluted acrylic emulsion can be useful because it glues down any loose particles more successfully than fixative. If the work is on paper, however, it will need to be stretched beforehand. Dilute the emulsion with 10 per cent water.

94. Atomizer with hand pump

Acrylic emulsion comes in matt or gloss and can be used in a spray gun or atomizer. Clean the gun or atomizer with water and pump through to clean the nozzle thoroughly. Dried acrylic within the nozzle is very difficult to remove. PVA is not recommended as a substitute as it is lower in quality than acrylic emulsion.

Ensure fixatives are only used in well-ventilated conditions.

MAKING CHALK PASTELS

If you use a lot of pastels it may be worthwhile investing the time in making some in the studio. As with any studio-made material, time is required to experiment and build your knowledge and formulations. Care should be taken when handling dry pigments. See Health and safety (page 171).

95. Gum tragacanth

THE BINDER

Gum tragacanth produces relatively soft pastels. See also Alternative binders (page 131). Aim to use up all the gum solution you can to avoid the need for preservatives. Any unused gum solution can be kept in tightly sealed, full, sterilized bottles. Check before use that it has not gone off (if so, it will have become watery and very smelly when you open the bottle).

Soak 28 g (1 oz) of powdered gum tragacanth in 1.3 litres (48 fl oz) of cold water and stand it in a warm place overnight. If the gum is not powdered, place it in a plastic bag and crush it with a glass jar, this increases the surface area for wetting. The gum does not dissolve but swells. Make sure the gum doesn't stick together in lumps, or there will still be dry gum in the water in the morning. See fig. 96. Once swollen, whisk the glue to a uniform consistency (fig. 97). This will be Binder A.

Each pigment and even different batches of the same pigment can require a different strength of binder to produce a range of pastels of similar softness. You can choose the hardness or softness of your pastels by using a stronger or weaker binder respectively. Of course you can have some soft and some hard if you want. They just need to be hard enough to hold together in

96. Swollen gum tragacanth

97. Binder of uniform consistency

stick form. If they are too hard the pigment won't come off on to the paper.

The other binders are made as follows.

Binder B

Mix 227 ml (8 fl oz) of Binder A with 227 ml (8 fl oz) water (1 part A : 1 part water).

Binder C

Mix 114 ml (4 fl oz) of Binder A with 341 ml (12 fl oz) water (1 part A : 3 parts water).

Binder D

Mix 85 ml (3 fl oz) of Binder A with 426 ml (15 fl oz) water (1 part A:5 parts water).

Binder E

Mix 56 ml (2 fl oz) of Binder A with 568 ml (20 fl oz) water (1 part A : 10 parts water).

One ounce of tragacanth can result in over 200 pastels, approximately 89×12 mm (3 $^{1}/_{2} \times ^{1}/_{2}$ in) each, but it does depend on the pigments used. Make a smaller amount of Binder A to start with if you need fewer pastels.

PIGMENTS

High lightfast pigments should be used. In a very pale tint of a pastel there is only a small amount of coloured pigment in relation to white pigment and any light-sensitive colour will not stand up well to daylight.

The following list gives you a starting guide for the strength of binder needed for some pigments. Apart from the white for producing the tints, pigments are noted in alphabetical order followed by the approximate binder.

Note A/B means *Binder* A tending towards *Binder* B. It is suggested you start with the first binder. *E/Water* means start with *Binder* E, but you may find the pigment binds together with water alone.

White for tints: Precipitated chalk and whiting mixed 1:1 - A/B. Precipitated chalk offers whiteness. Pricewise it is between chalk and a coloured pigment, but on its own with tragacanth produces splintery pastels. Whiting is creamy white, is very cheap and binds the pigment better. See page 132 for other whites.

Alizarin crimson - B

Alizarin/phthalocyanine blue - C

Arylamide yellow - D/E

Bismuth yellow - C

Burnt sienna - D

Burnt umber - B

Chromium oxide green - B/C

Diarylide yellow - D/E

Dioxazine violet - C/D

Graphite - B

Indanthrone blue - E/water

Indian red - E/water

Ivory black - C/D

Lamp black - C/D

Light red - E/water

Mars black - B

Mars red - B

Mars violet - C/D

Mars yellow - A/B

Phthalocyanine blue - E/D. Approximately

80 per cent white needed to make first shade

Phthalocyanine green - E/D. Approximately

80 per cent white needed to make first shade

Pyrroles - D/E

Ouinacridones - D/E

Raw sienna - E

Raw umber - E

Titanium White - B

Ultramarines - B

Viridian - E/water

Yellow ochre - D/E

Zinc white - B

If using a pigment which is not on the list, take a calculated guess for the strength of the binders and make test pastels and notes.

MAKING THE PASTELS

First, make the full-strength colour pastels. The tints are then made by successively reducing the colour batch with white. Full-strength colours may be mixed before starting to produce different colours, for example a violet from alizarin and phthalocyanine blue.

Using a glass plate (slab) and palette knife (fig. 38), make a small (approximately 30×6 mm ($1^{1}/_{4} \times {}^{1}/_{4}$ in) white pastel by mixing a spoonful of pigment (precipitated chalk and whiting, 1:1) with enough Binder A to produce a pastry-like paste that is not too sticky (fig. 98).

Roll it out inside two sheets of newsprint (that is, newspaper without ink on). This stops you getting your hands filthy and the absorption of the paper also dries the pastel off a bit, making it easier to roll. Hold your fingers parallel to the pastel stick - having the pastel stick at right angles to your fingers will produce thin uneven sausages of pastel (see fig.99).

Put the pastel in a container of some sort so you can dry it with a hairdryer without it being blown off the table. Once it is absolutely dry, approximately 5-10 minutes, test the pastel on paper for hardness/softness. If you test a half-dry pastel it will appear softer than it really is. If it's not right, make another one with stronger or weaker binder, whichever is necessary.

Once you've got it right, make a good-sized batch of white with approximately 284 g (10 oz) of pigment. Pile the pigment on the slab, make a well in the centre and pour in the binder. Mix it to a paste consistency with the palette knife.

Choose a colour for your first pastels, for example, yellow othre. Make a sample pastel with it, dry and test it. Once it is correct make a batch using approximately 100 g (3 $\frac{1}{2}$ oz) of pigment.

Take half the ochre paste and roll it into pastels of the size you want. Very large pastels, 3 cm

98. White paste on plate (slab)

99. Rolling pastel

 $(1\ //_4\ in)$ diameter and more, take a long time to dry thoroughly and are therefore more likely to crack than smaller ones. This doesn't matter as long as they are usable. Leave the pastels to dry naturally, which will take 12-48 hours. Avoid force drying them as this will encourage cracking.

To make the next tint, make up the remaining half of yellow ochre paste with at least an equal amount of white paste. You can use more or less white to get the tint you want. Some pigments, for example, phthalocyanines, are so strong that more than double the white paste is needed in relation to the coloured paste to produce another tint sufficiently different from the last.

Mix the two pastes together on the plate (slab) until the colour is uniform (although you could have two-tone/streaky pastels if you want). Cut the paste in half, make pastels out of one half and use the second half for the next tint.

As you continue in this fashion you build up a range of the tints you want. Of course you don't have to take half the batch every time; you might make just one pastel and then make another tint or you might use all the paste up and have only

one colour. Using half the batch every time will systematically spread the range of tints.

Some pigments do not wet easily. They can be persuaded by mixing in some methylated spirits (alcohol) with the pigment and binder on the plate. The alcohol evaporates off without affecting the pastels.

ALTERNATIVE BINDERS

Any of the following gums, glues and resins can be used for binding pastels. The binders made from the standard solutions are so weak that their relative flexibilities are of less concern than they are in other media. It would seem sensible to use only one binder so that you can build up a knowledge of the strength of binder needed for the various pigments. Alternative binders could perhaps be tried with problem pigments.

Gum acacia produces harder pastels. See fig. 47.

Methyl cellulose is a synthetic thickener. (See fig 100).

Gelatin produces crumbly pastels. (fig. 75).

Casein produces crumbly pastels. (fig. 78).

Starch glue, for example Arrowroot (fig. 100).

Dammar varnish (fig 47).

100. Arrowroot and methyl cellulose

ALTERNATIVE WHITE PIGMENTS FOR TINTS

Using precipitated chalk and whiting 1:1 may produce a white which is rather creamy. Reduce the amount of whiting if you want the white to be whiter. The less whiting, the weaker the binder will need to be

Talc produces a slippery texture which can be pleasing to work with but the pastels will break less easily.

China clay produces a smoother pastel and needs a weaker binder than 1:1, whiting: precipitated chalk. Pastels break less easily, especially with Bentonite.

Titanium and zinc are generally not used because they overpower the coloured pigments in the paler tints.

OIL AND WAX PASTELS

Gelatin surface-sized paper is recommended as a support for oil and wax pastels because the paper surface will absorb less oil. Better still, surfaced paper can be used if desired, see page 124. Gesso will stain less if it is sized. If you have a favourite paper which is not gelatine surface-sized you can reduce its absorbency by applying one or two coats of Lifting Preparation (Winsor & Newton). Thin papers may need to be stretched beforehand.

Canvas is not a suitable support for these pastels because they lack the necessary flexibility. Canvas can be used on board if wished. See pages 18, 42, 97.

OIL PASTELS

Oil pastels are also bound with mixtures of waxes. The quality of the waxes and pigments should be higher than in childrens' wax pastels. Ask the manufacturer for the C.I. Numbers of the pigments used, (see Chapter 9, page 135). White spirit or turpentine can be used with oil pastels but the solvents are likely to stain the paper.

Oil pastels can be moved with heat, similar to encaustic paint. A hairdryer or infra-red lamp will make the colours fluid. Oil pastels could be combined with encaustic paint. Use pastels with lightfast pigments if you want to retain the lightfast quality of the painting. Good-quality pigments in the pastels indicate as far as possible that good-quality waxes have also been used.

WAX PASTELS

The binder for these is usually a mixture of

101. Wax pastel cast in half section of metal tubing, such as copper pipe cut into semi circular section

waxes and fats. The very cheapest wax crayons are usually in this category. The pigments are not usually lightfast. Cheap waxes can yellow and embrittle.

MAKING WAX PASTELS

Cold encaustic paint can be used to make wax pastels. The use of wax such as beeswax and lightfast pigments offer a reliable pastel compared to the wax crayons mentioned previously. These pastels are very much harder than oil pastels.

The various binders mentioned in Chapter 3 can be used according to the hardness or softness of pastel required. Some experimentation will be needed to get a usable pastel. Use at least 20 per cent pigment for a well coloured pastel. See Making the paint (page 52) for a full explanation.

Pastels are best cast in metal to ensure easy release. Remove the hot paint from the heat and

stir it to distribute the pigment evenly throughout the wax. Watch the wax as it cools for a few minutes and just as the top is setting, pour it into the mould. Leave until cold and then tap it out. If you pour the coloured wax into the mould straight from the heat it will stick and is impossible to get out when cold.

CARE OF DRAWINGS

Drawings should be kept in portfolios or in glazed frames as they are impractical to clean and gather dirt readily. See Appendix I for storing and framing work.

Do not varnish drawings. The varnish will yellow and collect dirt and will not be removable from the paper fibre.

CHAPTER NINE PIGMENTS

Pigments are solids which by definition do not dissolve when mixed with a vehicle. Dyes will generally only stain a vehicle and the majority of them are not lightfast. Any lightfast ones are included in the pigment list. Although generally pigments are more lightfast, not all pigments are permanent.

THE CONTENTS OF THE PIGMENT LIST

Many new pigments were introduced into artists' colours in the 1990s, mostly higher lightfast organics but also highly transparent iron oxides and some new inorganic colours too.

This chapter details the properties of pigments used in artists' materials for reference purposes. It gives the following information: Names (including Colour Index Generic Name), Lightfastness, Type, Opacity, and Toxicity. Explanatory notes follow below.

HUE

The colour chips are printed in fig. 102 as a guide but are subject to the limitations of the printing process. One of the very best investments you can make is to buy a hand-painted colour chart of the range you use. The best ones are graded

washes showing both top and undertone and are an excellent tool for learning about relative colour values and hue. They also take the guesswork out of trying new colours.

There will be variations of hue within pigment families and only some are printed here.

NAMES

Pigments are entered under their common names or pigment types, obsolete names, some trade names (indicated by ® after the pigment name) and their Colour Index Generic Name. The latter refers to the chemical classification compiled and published in the Colour Index International by the Society of Dyers and Colourists and the American Association of Textile Chemists and Colorists. A Colour Index Generic Name is a pigment colour followed by a number, for example Alizarin Crimson is C. I. Pigment Red 83.

There can be a number of different names for the same chemical type, generally for historic or geographical reasons. The Colour Index Generic Name will identify each pigment by chemical type – for example *lvory black*, the common name used for artists' paints, is entered as *Bone black* and other trade names in the Colour Index International. Its Colour Index Generic Name is C. I. Pigment Black 9.

Pigments which are chemically identical are grouped under one Colour Index Generic Name, even though they are different colours, for example *Cadmium Scarlet* and *Cadmium Maroon*, or have different physical properties, for example *Ivory black* and *Heavy French black*. There are also a number of pigment 'families' for example Benzimidazolone and Arylamide, where there are a number of different C. I. Names. These are mostly grouped together.

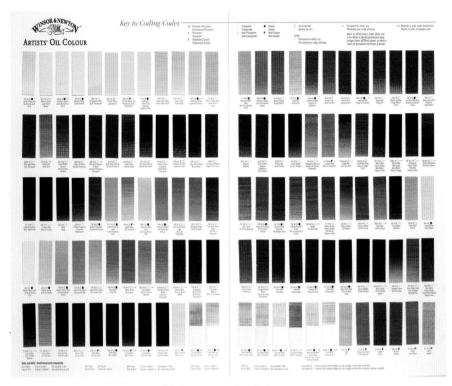

102. Spectrum order of pigments

It must be noted that the correct terminology is *C. I. Pigment (colour) (number)* and must be quoted as such when using it, therefore, for the purposes of this book only, the Colour Index Generic Names in the pigment lists have been abbreviated to the following:

X = a number

C. I. Natural Black X	$NBk \times$
C. I. Pigment Black X	PBk X
C. I. Pigment Blue X	$PB \times$
C. I. Natural Brown X	NBrX
C. I. Pigment Brown X	$\operatorname{PBr} X$
C. I. Pigment Green X	PG X
C. I. Pigment Orange X	PO X
C. I. Natural Red X	NRX
C. I. Pigment Red X	$PR \times$
C. I. Pigment Violet X	PV X
C. I. Pigment White X	PW X
C. I. Natural Yellow X	NY X
C. I. Pigment Yellow X	PY X

LIGHTFASTNESS/ PERMANENCE

The lightfastness of a pigment is dependent on amount and quality of light; length of exposure; extent of mixing with other colours, particularly white; amount of extender; type of binder; thickness of film; pigment particle size; amount of pigment in binder; type of support; and reaction to atmosphere and pollution. Colloquially, artists think of lightfastness as permanence.

BLUE WOOL SCALE

The lightfastness of specific pigments in specific conditions is rated on the Blue Wool Scale (British Standard 1006) by numbers 1-8. The 8 rating is excellent lightfastness. The degree of lightfastness is rapidly reduced at each move down the scale, so that 7 fades twice as fast as a number 8, 6 twice as fast as 7, and so on. The Blue Wool Scale is used universally by pigment suppliers.

The Blue Wool Scale (BWS) numbers in this book have been compiled from a variety of sources and are used here to provide a guide to lightfastness for artists. Use them in combination with information from your artists' materials manufacturer: Where no Blue Wool Scale number can be found, any known information will be stated.

Pigments with ratings of 7 or 8 are classed as absolutely lightfast for fine art materials. The term 'permanent' as part of a manufacturer's name does not necessarily correspond to a 7 or 8 on the Blue Wool Scale. 'Permanent' was first used in the 1920s when pigments were first improving. Check the permanence of colours by the Colour Index to be sure.

Where pigments are significantly less lightfast when mixed with other colours, especially white, a second BWS number is given with the words 'in tint', for example a coloured pigment reduced with a percentage of white pigment. Try to use these colours in reasonably thick films at full strength only.

In some cases where a colour cannot be replaced, lower ratings will have to be accepted – Aureolin for example. Pigments rated as 5 and below should be avoided if possible.

ASTM

ASTM stands for the American Society for Testing and Materials. This organization has set standards for the performance of art materials including the lightfastness of colour. Lightfastness is tested in both sunlight and accelerated conditions by reducing each pigment to 40 per cent reflectance with Titanium White (or the paper in water colour). Ratings I and II are classed as 'permanent for artists' use'. Pigments are tested in some or all media and ratings may differ between media. In this book A = Acrylic, AI = Alkyd, G = Gouache, O = Oil, and W =

Water colour. Results are given by media. For example ASTM I (A, O) means the pigment gets a I rating in acrylic and oil. There are prospective Pencil and Pastel standards but no pigments have yet been tested and published.

Unfortunately there are many pigments as yet not rated by ASTM. This simply means they have yet to be tested and does not ordinarily reflect a lack of lightfastness. BWS numbers therefore give a better reference indication as they are more widely used by the pigment manufacturers.

There are lower ASTM ratings for some pigments but as these are not classed as permanent they are not listed here.

Manufacturers' permanence ratings

The best artists' materials manufacturers combine the pigment suppliers' information with ASTM ratings and their own accelerated and natural light testing to arrive at their ratings. At this level, the manufacturer's ratings of their actual colours are undoubtedly the best guide to permanence.

TYPE

Broadly speaking, pigments can be divided into two groups: inorganic and organic. This is a chemical classification. Inorganic pigments do not contain carbon, whereas organic pigments contain carbon, being derived from living substances or substances which were once part of living things. These are then subdivided into natural and synthetic (see fig. 103).

As artists we tend to recognize three pigment types: **earth**, **traditional** and **modern**. **Earths** include ochres, siennas, umbers, Mars colours (synthetic iron oxides) and transparent iron oxides (for example burnt sienna). **Traditional** pigments include cadmiums, cobalts, titanium, ultramarine but also some of the newer

103. PIGMENT CLASSIFICATION TABLE

INORGANIC	
NATURAL	SYNTHETIC
EARTHS (e.g. ochres, umbers)	CADMIUMS
	COBALTS
	IRON OXIDES (e.g. Mars)
	OTHER METAL OXIDES (other than iron and cobalt): e.g. Viridian, Chromium Oxide, Nickel Titanate, Bismuth Yellow, Titanium
	MISCELLANEOUS INORGANICS: e.g. Prussian Blue, Manganese Violet, Ultramarine, Minerals (e.g. Davy's Gray).

ORGANIC		
NATURAL	SYNTHETIC	
MISC.: e.g. Rose Madder, Bone Black, Carbon Black	QUINACRIDONES	
	PHTHALOCYANINES	
	PERYLENES	
	PYRROLES	
	ARYLAMIDES	
	BENZIMIDAZOLONES	
	METAL COMPLEXES: e.g. Nickel Azo, Nickel Dioxzine	
	MISC: e.g. Dioxazine, Indanthrone	

pigments like bismuth and magnesium brown. Generally, inorganic pigments have moderate tinting strength.

Modern pigments are complex chemical structures derived from petroleum. Their chemistry results in suitably complex names – phthalocyanine, benzimidazolone, and so on. Modern pigments generally tend to have high tinting strength and are often transparent.

OPACITY

The opacity of a pigment depends on the physical size and shape of the particles and their chemical nature. It can also vary according to the processing of the pigment particles. Pigments are

generally noted in this book as Transparent,

Opaque or Variable opacity. Opacity will normally
be on the colour chart or tube labels.

A transparent colour allows previous paint layers to show through while an opaque colour covers up previous layers, for example a violet can be obtained by placing a transparent red over a transparent blue, or vice versa. Opaque pigments will appear more transparent when used thinly, especially in water colour or tempera.

TOXICITY

All dry pigments are potential irritants like any other type of dust. Once incorporated into colour however and used in the expected manner most colours are non-hazardous. Any which are potentially hazardous will be listed with 'Caution'. Some pigments are classified as toxic. These are listed.

Please refer to Health & Safety, page 171 for a full discussion on toxicity, labelling and recommended studio practice.

INERT PIGMENTS

Extenders, stabilizers and pigments used for grounds are listed in the same way as the other pigments, followed by their most common uses. They are called inert pigments because they are inactive in artists' paint and do not retain their white colour in all media, compared to the white pigments flake, titanium dioxide and zinc oxide. Some can remain white in water-based media but become transparent in oil.

The names of these pigments are grouped here for reference. The individual entries include their other names: Aluminium hydrate, barium sulphate, blanc fixe, China clay, gypsum, magnesium calcium carbonate, marble dust, mica, plaster of Paris, precipitated chalk, pumice, silica, talc, whiting.

HOW TO USE THE PIGMENT LIST

A colour such as Cobalt Blue can simply be looked up in the alphabetical list. If you want to check, however, that a manufacturer is using Cobalt Blue pigment and not just that name, then obtain the Colour Index Generic Name from their catalogue or from the company if they are not yet publishing Colour Index Generic Names. You can then either obtain the pigment name from the Pigments by numbers

list (page 152), for example Pigment Blue 28 (abbreviated to PB28 in this book) is Cobalt Blue; or if the manufacturers say they use Pigment Blue 15 you can look up PB15 and obtain its pigment name. This can then be looked up in the alphabetical list. However, many pigments have more than one name, that is, you may be checking to see if Thénard's Blue in a certain brand is PB28. Therefore when you find PB28 is Cobalt Blue in the Pigments by Numbers list you will have to look up Cobalt Blue in the alphabetical list to see if Thénard's Blue is another name for PB28.

Some colours, such as Indian Yellow, Indigo and Sepia, were originally natural pigments which are fugitive and should be replaced by the manufacturers with more lightfast pigments. Colours such as Hooker's Green, Olive Green or Sap Green are mixtures of pigments which were popular in the past but commonly fugitive. These, too, should be replaced by a mixture of more lightfast pigments. You can check the lightfastness and other characteristics of these colours in the same way as for Cobalt Blue above, that is, obtain the Colour Index Generic Names for the pigments used, look them up in the Pigments by Numbers list, then look them up by name in the alphabetical list to ascertain the characteristics of the pigments being used. Each brand you use will have to be checked, because different manufacturers probably use different pigments for their own Indian Yellow, for example.

Sometimes manufacturers use names which are not in the alphabetical list, for example Purple Lake. Again the Colour Index Generic Names should be obtained and the Pigments by Numbers list followed by the alphabetical list should be employed to establish the qualities of the pigments being used. If there are any pigments which are not in the list then you should ask the manufacturer for the BWS or ASTM figures to determine lightfastness.

THE PIGMENT LIST

See page 137 for abbreviations of Colour Index Generic Names.

ACETYLENE BLACK See CARBON BLACK.

ALIZARIN CRIMSON Also MADDER LAKE. PR83. BWS 6-7. In tint BWS 5. Organic lake. Transparent.

ALUMINA WHITE See ALUMINIUM HYDRATE.

ALUMINIUM HYDRATE Also ALUMINA, ALUMINIUM HYDROXIDE, ALUMINA WHITE. PW24. Permanent. Inorganic. Inert pigment. Transparent in oils. Used as extender and stabilizer and for smoothness in paints.

ALUMINIUM HYDROXIDE See ALUMINIUM HYDRATE.

ANILINE BLACK PBk1. BWS 7-8. In tint BWS 6. ASTM I (G). Organic. Transparent. **Caution.**

ANILINE COLOURS Obsolete term for synthetic organic pigments.

ANTHRAQUINONE RED PR177. BWS 7-8. ASTM I (O). Organic. Transparent.

ANTIMONY YELLOW See NAPLES YELLOW.

ANTWERP BLUE See PRUSSIAN BLUE.

ANTWERP RED PRIOI or PRIO2. See MARS RED or RED OCHRE.

ARYLAMIDE YELLOWS Also LEMON YELLOW HUE. PY I. BWS 7. In tint BWS 4. / PY3. BWS 7. In tint BWS 6-4. ASTM I (G) ASTM II (A,AI,O,W) / PY65. BWS 7. ASTM I (A,O) ASTM II (G,W) / PY73 (ASTM I (A,O)), PY74 (ASTM I (A,O) ASTM II (G)). BWS 8. In tint BWS 6. / PY97. BWS 8. ASTM I (A,O) ASTM II (W)/ PY98. BWS 6-4. Organic. Variable opacity.

ASBESTINE See TALC. Caution.

ASPHALTUM Also BITUMEN. NBk6. Natural organic. Fugitive colour derived from tar. Very destructive in paint films, causing wide splits and blisters etc. in oil paint. Should be replaced by a mixture of permanent colours. **Caution.**

AUREOLIN Also COBALT YELLOW. PY40. BWS 7. Reduced in tint. ASTM II (O,W). Inorganic. Transparent. *Caution*.

AZO CONDENSATION BROWN

PBr23. BWS 7-8. Organic. Transparent.

AZO CONDENSATION RED PR166. BWS 7-8. Organic. Opaque. Also PR144. BWS 7-8. Semi-transparent.

AZO CONDENSATION YELLOW

PY128. BWS 7-8. Organic. Transparent.

AZOMETHINE COPPER COMPLEX

PY129. BWS 7-8. ASTM I (O). Organic. Transparent. Replaces PG10. *Caution*.

BARITE see BARIUM SULPHATE. Caution.

BARIUM CHROMATE See BARIUM YELLOW.

BARIUM SULPHATE Also BARITE, BARYTES. PW22. Unaffected by light. Inorganic. Inert pigment. Transparent in oil. Used as extender in paints, tooth in grounds (especially PW22) and for opacity in gouache.

BARIUM WHITE See BLANC FIXE.

BARIUM YELLOW Also BARIUM CHROMATE, LEMON YELLOW. PY3 I. BWS 8. Inorganic. Opaque. *Toxic*.

BARYTES See BARIUM SULPHATE.

BASIC DYE TONER BLUE PB1. BWS 6-4. Organic. Transparent.

BASIC DYE TONER RED PR169. BWS 5. Reduced in tint. Organic. Transparent.

BASIC DYE TONER VIOLET PVI. BWS 6-4. PV2, PV3. BWS 4. Organic. Transparent. *Caution.*

BENTONITE White American Clay. PW 19. Earth. Inert pigment. Used as a thickener.

BENZIDINE ORANGE See PYRAZOLONE ORANGE.

BENZIDINE YELLOW See DIARYLIDE YELLOW.

BENZIMIDAZOLONE MAROON

PBr25. BWS 7-8. ASTM I (G). Organic. Transparent.

BENZIMIDAZOLONE ORANGE PO36. BWS 6-8. ASTM I (A,G,O,W). / PO62. BWS 8. ASTM I (A,O) ASTM II (W). Organic. Transparent.

BENZIMIDAZOLONE RED PR175. (ASTM I (A,O)). PR176. BWS 7-8. Organic. Transparent.

BENZIMIDAZOLONE YELLOW PY120. PY151 (ASTM I (A,O)). PY154 (ASTM I (A,O,W)). PY155. PY175 (ASTM I (A,O)). BWS 7-8. Organic. Variable opacity.

BERLIN BLUE See PRUSSIAN BLUE.

BISMUTH YELLOW PY 184. BWS 8. ASTM I (A). Inorganic. Opaque.

BISTRE NBr II. Not permanent. Natural organic. Should be replaced by a mixture of permanent colours. RAW UMBER is a good match.

BITUMEN See ASPHALTUM.

BLACK IRON OXIDE See MARS BLACK.

BLANC FIXE Also BARIUM WHITE.

Precipitated Barium sulphate. PW21. Unaffected by light. Inorganic. Inert pigment. Transparent in oil. For uses see BARIUM SULPHATE.

BLUE BLACK See VINE BLACK.

BOLE See RED BOLE and WHITE BOLE.

BON ARYLAMIDE See NAPHTHOL RED.

BONE BLACK See IVORY BLACK.

BROMINATED ANTHRANTHRONE

See DIBROMOANTHRANTHRONE.

BRONZE BLUE See PRUSSIAN BLUE.

BROWN IRON OXIDES See MARS

BROWN.

BROWN MADDER Often a mixture.

Check C. I. Names.

BROWN OCHRE Type of UMBER.

BURNT GREEN EARTH Also VERONA

BROWN. See GREEN EARTH.

BURNT GYPSUM See PLASTER OF PARIS.

BURNT OCHRE PBr7. Also PR I 02. BWS 8.

Earth. Variable opacity.

BURNT SIENNA PBr7. BWS 8. Earth.

Transparent. Best grades came from Italy. May be replaced by transparent PRIOI.

BURNT UMBER Also RAW UMBER. PBr7.

BWS 8. ASTM I (A,AI,G,O,W). Earth.

Transparent. Used to be used in toned oil grounds. Best grades come from Cyprus, called

TURKEY UMBER. Good grades from Italy.

CADMIUM GREEN A mixture, check C. I. Names. *Caution*.

CADMIUM ORANGE PO20. BWS 7.

ASTM I (A.Al,G,O,W). Inorganic. Opaque. Cannot be relied upon to withstand damp.

Caution.

CADMIUM REDS PRIO8. BWS 7. ASTM

(A,AI,G,O,W). Inorganic. Opaque. Cannot be

relied upon to withstand damp. Caution.

CADMIUM YELLOWS PY35 (ASTM I

(A,G,O,W)). PY37, (ASTM I (A,AI,G,O,W). BWS 7. Inorganic. Opaque. Cannot be relied upon to

withstand damp. Caution.

CALCIUM CARBONATE See WHITING.

CAPUT MORTUUM See MARS RED.

CARBAZOLE VIOLET See DIOXAZINE

VIOLET.

CARBON BLACK Also ACETYLENE

 ${\tt BLACK, FRANKFORT\ BLACK, LAMP\ BLACK,}$

VEGETABLE BLACK. PBk6/7. BWS 8. ASTM I (A,AI,G,O,W). Inorganic. Opaque. *Caution*.

CARMINE Also SCARLET LAKE, NR4, Not

permanent. Natural organic. Transparent.

ALIZARIN is more permanent.

CASSEL EARTH See VANDYKE BROWN.

CERULEAN BLUE PB35. BWS 7-8. ASTM I

(A,G,O,W). Inorganic. Opaque. Caution.

CERULEAN BLUE CHROMIUM See

COBALT TURQUOISE.

CERUSE See FLAKE WHITE.

CHALK See PRECIPITATED CHALK and

WHITING.

CHARCOAL BLACK See VINE BLACK.

CHINA CLAY Also BOLE, KAOLIN, WHITE

BOLE. PW19. Earth. Semi-transparent. Inert pigment. Transparent in oil. Sometimes used as a

stabilizer or thickener in paints, for white in

pastels and can be used in gesso.

CHINESE WHITE See ZINC WHITE.

CHLORINATED PARA RED PR4. BWS

6. In tint BWS 4. Organic. Semi-opaque.

CHROME ORANGE See CHROME YELLOWS and ORANGES.

CHROME TITANATE PBr24. BWS 8. ASTM I (G,W). Inorganic. Opaque.

CHROMEYELLOWS and ORANGES

Also LEAD CHROME. PY34. PO21. BWS 6-8. Inorganic. Opaque. **Toxic.** Tends to brown and darken from atmospheric pollution. Obsolete due to toxicity. Replaced by CADMIUMS.

CHROMIUM OXIDE GREEN Also
OXIDE OF CHROMIUM. PG 17. BWS 8. ASTM 1
(A,G,O,W). Inorganic. Opaque.

CINNABAR Obsolete mineral. Not permanent. Replaced by VERMILION. *Toxic*.

COBALT BLUE Also KING'S BLUE, THÉNARD'S BLUE. PB28. BWS 7-8. ASTM I (A,AI,G,O,W). Inorganic. Semi-transparent. **Caution.**

COBALT BLUE DEEP PB73. PB74. BWS 7-8. Inorganic. Semi-transparent. *Caution*.

COBALT CHROMITE GREEN PG26. BWS 7-8. ASTM I (A). Inorganic. Opaque. *Caution.*

COBALT GREEN Also LIGHT GREEN OXIDE. PG19. Also PG50 BWS 7-8. ASTM I (A,G,O,W). Inorganic. Opaque. *Caution*.

COBALT TITANATE GREEN See LIGHT GREEN OXIDE.

COBALT TURQUOISE Also CERULEAN BLUE CHROMIUM, TURKISH GREEN. PB36. BWS 7-8. ASTM I (A,O,W). Inorganic. Semitransparent. *Caution*.

COBALT TURQUOISE LIGHT See LIGHT GREEN OXIDE.

COBALT VIOLET PV14 (ASTM I (G,O,W)). PV49. BWS 7-8. Inorganic. Semi-opaque. *Caution*.

COBALT YELLOW See AUREOLIN.

COERULEUM See CERULEAN.

COLOGNE EARTH See VANDYKE BROWN.

CREMNITZ WHITE See FLAKE WHITE.

CYAN Primary blue used for four-colour printing. Check C. I. Names, may be PB15:3.

DAVY'S GRAY PBk19. BWS 8. ASTM I (W). Mineral. Semi-transparent.

DIARYLIDE ORANGE See PYRAZOLONE ORANGE.

DIARYLIDE YELLOW Also BENZIDINE YELLOW. PY12, PY14. BWS 4. In tint BWS 4-2. / PY13, PY17. BWS 5-6. / PY83. BWS 7. ASTM I (A,O). Organic. Variable opacity.

DIBROMOANTHRANTHRONE Also BROMINATED ANTHRANTHRONE. PR I 68. BWS 7-8. ASTM I (A) ASTM II (O). Organic. Semi-transparent.

DIOXAZINE PURPLE See DIOXAZINE VIOLET.

DIOXAZINE VIOLET Also CARBAZOLE VIOLET, DIOXAZINE PURPLE. PV23. BWS 7-8. ASTM I (A,AI) ASTM II (G,O). Organic. Transparent.

DOLOMITE See MAGNESIUM CALCIUM CARBONATE.

DRAGON'S BLOOD NR31. Not permanent. Natural organic resin. ALIZARIN is more permanent.

DROP BLACK See IVORY BLACK.

ENGLISH RED See LIGHT RED.

FERROUS NITROSO-BETA NAPHTHOL LAKE PG12. BWS 6. In tint
BWS 4-5. Organic. Transparent.

FLAKE WHITE Also CERUSE, CREMNITZ WHITE, LEAD WHITE, SILVER WHITE, WHITE LEAD. PW I. BWS 7. ASTM I (Al,O). Inorganic. Opaque. *Toxic*. May brown and darken from atmospheric pollution; can be reinstated by cleaning.

FRANKFORT BLACK See LAMP BLACK.

FRENCH CHALK See TALC.

FRENCH ULTRAMARINE See ULTRAMARINE BLUE.

GAMBOGE NY24. Not permanent. Natural organic. Transparent. PY150 is an excellent light-fast replacement. *Caution*.

GENUINE ULTRAMARINE See LAPIS LAZULI.

GERMAN BLACK See VINE BLACK.

GILDERS' WHITING See WHITING.

GOLDEN OCHRE See MARS YELLOW. Should be genuine type of ochre or synthetic iron oxide, not a mixture containing chromes.

GRAPE BLACK See VINE BLACK. **GRAPHITE** PBk10. Permanent. ASTM I (A).

Mineral. Opaque.

GREEN EARTH Also TERRE VERTE, VERONA GREEN. PG23. BWS 7-8. ASTM I (A,AI,G,O,W). Earth. Transparent.

GREEN GOLD PG10. BWS 7-8. ASTM I (A,O). Superseded by PY129.

GUIGNET'S GREEN see VIRIDIAN.

GYPSUM PW25. Earth. Semi-opaque. Inert pigment. Can be used for gesso or in white for pastels.

HEAVY FRENCH BLACK See IVORY BLACK.

HOOKER'S GREEN Check C. I. Names to ensure a mixture of permanent colours.

HYDRATED CHROMIUM OXIDE See VIRIDIAN.

INDANTHRONE BLUE PB60. BWS 7-8. ASTM I (A,O). Organic. Transparent. Good replacement for Prussian Blue.

INDIAN RED See RED OCHRE and MARS RED.

INDIAN YELLOW (imitation) Can be a number of pigments, check C. I. Names.

INDIGO NB I. Not permanent. Natural organic. Should be replaced by a mixture of permanent colours. PHTHALOCYANINE BLUE, ULTRAMARINE and a black are a good match. Check C. I. Names.

IRON BLUE See PRUSSIAN BLUE.

IRON OXIDE BLACK See MARS BLACK.

ISOINDOLINONE YELLOW Also TETRACHLOROISOINDOLINONE. PY 109.

PY110. BWS 7-8. ASTM I (A,G,O) ASTM II (W). Semi-transparent. / PY137, PY139. BWS 7-8. Organic. Opaque.

IVORY BLACK Also BONE BLACK, DROP BLACK, HEAVY FRENCH BLACK, PBk9. BWS 8. ASTM I (A,AI,G,Q,W). Inorganic. Opaque.

KAOLIN See CHINA CLAY.

KING'S BLUE See COBALT BLUE.

LAMP BLACK See CARBON BLACK.

LAPIS LAZULI Also GENUINE ULTRAMARINE. PB29. Mineral. Transparent. Matched by FRENCH ULTRAMARINE. Very expensive. May bleach in acidic atmospheres. Replaced by FRENCH ULTRAMARINE.

LEAD ANTIMONIATE See NAPLES YELLOW.

LEAD CHROME See CHROME YELLOWS and ORANGES.

LEAD SALT OF EOSINE PR90. BWS 3. Organic. Transparent. *Caution*.

LEAD WHITE See FLAKE WHITE.

LEMON YELLOW See BARIUM YELLOW, NICKEL TITANATE, ARYLAMIDE YELLOW.

LEMON YELLOW HUE See NICKEL TITANATE, ARYLAMIDE YELLOW.

LIGHT GREEN OXIDE: Also COBALT TITANATE GREEN, COBALT TURQUOISE LIGHT. PG50. BWS 8. ASTM I (A,O). Inorganic. Opaque. *Caution*.

LIGHT RED PRIO2 or PRIO1. See RED OCHRE or MARS RED

LITHOL is a registered trademark of Bayer.

LITHOL® RED PR49. BWS 5. Organic. Semi-opaque.

LITHOL® RUBINE PR57:1. BWS 5, reduced in tint. Organic. Transparent. May be Magenta in four-colour printing.

LITHOPONE PW5. BWS 8. ASTM I (G). Inorganic. Transparent. Opaque in water colour. Used in grounds and as an extender in paints.

LUSTRE See PEARL LUSTRE.

MADDER LAKE See ALIZARIN CRIMSON and ROSE MADDER.

MAGENTA Primary red used in four-colour printing. Check C. I. Names in fine art ranges. See LITHOL RUBINE.

MAGNESIUM BROWN PY119, BWS 7-8. Inorganic. Semi-opaque.

MAGNESIUM CALCIUM
CARBONATE Also DOLOMITE. Similar to
Whiting (PW18). Inert pigment. Sometimes used
as extender in paints rather than whiting and
could be used in gesso.

MALACHITE Mineral. Not permanent. Should be replaced by a mixture of permanent colours.

MANGANESE BLUE PB33. Pigment discontinued. Replaced by Manganese Blue Hue, based on phthalocyanine.

MANGANESE VIOLET Also MINERAL VIOLET. PVI 6. BWS 7. ASTM I (O,W). Inorganic. Semi-transparent.

MARBLE DUST PW18. Permanent. Mineral.

Inert pigment. Good tooth and whitener for grounds. *Caution*.

MARS BLACK Also BLACK IRON OXIDE, IRON OXIDE BLACK, PBk. I I. BWS 8. ASTM I (A,O), Inorganic, Semi-opaque.

MARS BROWN Also BROWN IRON OXIDES. PBr6. BWS 8. ASTM I (A,O). Inorganic. Semi-opaque.

MARS COLOURS Also SYNTHETIC IRON OXIDES. See individual MARS entries.

MARS RED Also BURNT SIENNA, CAPUT MORTUUM, INDIAN RED, LIGHT RED, MARS VIOLET, RED IRON OXIDE, TRANSPARENT OXIDES, VENETIAN RED. PRIOI. BWS 8. ASTM I (A,AI,G,O,W). Inorganic. Variable opacity.

MARS VIOLET See MARS RED.

MARS YELLOW Also GOLDEN OCHRE, RAW SIENNA, YELLOW IRON OXIDE. PY42. BWS 8. ASTM I (A,G,O,W). Inorganic. Variable opacity.

MICA PW20. Unaffected by light. Mineral. Used to import lustre.

MILORI BLUE See PRUSSIAN BLUE.

MINERAL BLUE See PRUSSIAN BLUE.

MINERAL BROWN PBr33. BWS 7-8. Inorganic. Semi-opaque.

MINERAL VIOLET See MANGANESE VIOLET.

MIXING WHITE See TITANIUM WHITE.

MONASTRAL® is a trade name of Avecia.

MONASTRAL® BLUE See PHTHALO-CYANINE BLUE.

MONASTRAL® GREEN See PHTHALOCYANINE GREEN.

MONESTIAL BLUE See PHTHALOCYANINE BLUE.

MONESTIAL GREEN See PHTHALOCYANINE GREEN.

NAPHTHOL CRIMSON See NAPHTHOL RED.

NAPHTHOL GREEN PG8. BWS 7-8. In tint BWS 5-6. Organic. Semi-opaque.

NAPHTHOL RED Also BON ARYLAMIDE

NAPHTHOL CRIMSON. PR7, (ASTM I (A,O)), PR12, PR170, (ASTM II (A,G,O,W)). BWS 6-7. / PR9, (ASTM I (A) ASTM II (G)). PR188. BWS 7. (ASTM I (A,G,O) ASTM II (W)). / PR146. BWS 5-6. / PR112. BWS 7-8. ASTM II (A,O). Organic. Variable opacity.

NAPLES YELLOW Also ANTIMONY YELLOW, LEAD ANTIMONIATE. PY41. BWS 7-8. Inorganic. Opaque. *Toxic*. May brown and darken from atmospheric pollution but can be cleaned. Obsolete due to toxicity. Replaced by a number of pigments, check C.I. Names.

NATURAL IRON OXIDES See RED OCHRE and YELLOW OCHRE.

NICKEL AZO YELLOW PY 150. BWS 8. ASTM I (A,O,W). Organic. Transparent. Caution.

NICKEL DIOXINE PY153. BWS 7-8.ASTM I (A,O) ASTM II (W). Organic. Transparent.

Caution.

NICKEL TITANATE Also LEMON YELLOW HUE, TITANIUM YELLOW. PY53. BWS 8. ASTM I (A,G,O,W). Inorganic. Opaque. Caution.

OCHRE See RED OCHRE and YELLOW OCHRE.

OLIVE GREEN Check C. I. Names to ensure a mixture of permanent colours.

OXIDE OF CHROMIUM See CHROMIUM OXIDE GREEN.

PARIS BLUE See PRUSSIAN BLUE.

PARIS WHITE See WHITING

PAYNE'S GRAY A mixture of pigments, check C. I. Names.

PEACH BLACK May be a mixture, check C. l. Names.

PEARL LUSTRE Also LUSTRE. Colours with mother-of-pearl lustre. Can be from the addition of MICA. No Colour Index Generic Names. Lightfastness should be checked with manufacturer:

PERINONE ORANGE PO43. BWS 7-8. ASTM I (A,G,O). Organic. Semi-opaque.

PERSIAN RED See RED OCHRE.

PERYLENE BLACK PBk31. BWS 7-8. Organic. Semi-transparent.

PERYLENE GREEN See PERYLENE BLACK.

PERYLENE RED PR149, (ASTM I (A,O)). BWS 7-8./ PR178 (ASTM I (O)/ PR179 (ASTM I (A,O,W)). PR224 is similar. Organic. Transparent. **PERYLENE VIOLET** PV29. BWS 7-8. Organic. Transparent.

PHTHALOCYANINE BLUE Also MONASTRAL, MONESTIAL BLUE, WINSOR BLUE. PB15, PB15:1, PB15:3, PB15:4, PB15:6, PB16. BWS 7-8. ASTM I (A,AI,G,O) ASTM II (W). Organic. Transparent.

PHTHALOCYANINE GREEN Also MONASTRAL, MONESTIAL GREEN and WINSOR GREEN. PG7, PG36 (yellow shade). BWS 7-8. ASTM I (A,AI,G,O,W). Organic. Transparent.

PHTHALOCYANINE TURQUOISE
PB16. BWS 7-8. ASTM (A,O). Organic.
Transparent.

PLASTER OF PARIS Also BURNT GYPSUM. Mineral. Inert Pigment. When slaked can be used in gesso.

POTTER'S PINK PR233. BWS 7-8. Inorganic. Semi-opaque.

PRASEODYMIUM YELLOW PY 159. BWS 7-8. Inorganic. Opaque.

PRECIPITATED CHALK Also CHALK. PW18. Mineral. Inert pigment. Finer particle chalk than whiting. Used in white for pastels, opacity for gouache and can be used in gesso. Muddy in oil.

PRUSSIAN BLUE Also BERLIN BLUE, BRONZE BLUE, IRON BLUE, MILORI BLUE, MINERAL BLUE, PARIS BLUE. ANTWERP BLUE is a less pure form. PB27. BWS 7. ASTM I (AI, G,O,W) ASTM II (A). Inorganic. Transparent. Can fade in daylight but regain its colour in darkness. Replaced by INDANTHRONE BLUE.

PTMA VIOLET PV4. BWS 2. Organic. Semi-

transparent. Caution.

PUMICE PW20 and PW26. Unaffected by light. Inorganic. Powdered volcanic rock. Inert pigment. Good tooth for grounds, including surfaced pastel paper. Grey in colour. **Caution**.

PYRAZOLONE ORANGE Also BENZI-DINE ORANGE, DIARYLIDE ORANGE. PO13. BWS 6.Transparent. / PO34. BWS 6-8. In tint BWS 4. Organic. Variable opacity.

PYRAZOLOQUINAZOLONE ORANGE PO67. BWS 7-8. Organic. Semiopaque.

PYRAZOLOQUINAZOLONE RED

PR251. BWS 7-8. Organic. Semi-opaque.

PYRROLE ORANGE PO71. BWS 7-8./ PO73. BWS 7-8. ASTM II (G). Organic. Variable opacity.

PYRROLE RED PR254 (ASTM I (A)). PR255 (ASTM I (A,W)). PR264. PR270. BWS 7-8. Organic. Variable opacity.

QUINACRIDONE GOLD PO48 (ASTM I (A,O) ASTM II (W)). PO49 (ASTM I (A,O)). BWS 7-8. Organic. Transparent.

QUINACRIDONE MAGENTA PR122 (ASTM I (A,AI,O) ASTM II (G)). PR202 (ASTM I (A)). BWS 7-8. Organic. Semi-transparent.

QUINACRIDONE MAROON PR206. BWS 7-8. ASTM I (A). Organic. Transparent.

QUINACRIDONE PYRROLIDONE No

C. I. Name. BWS 7-8. Organic. Transparent.

QUINACRIDONE RED See QUINACRIDONE VIOLET.

QUINACRIDONE SCARLET PR207 (ASTM | (A,O)). PR209 (ASTM | (A) ASTM || (W)). BWS 8. Organic. Transparent.

QUINACRIDONE VIOLET Also QUINACRIDONE RED. PV 19. BWS 8. ASTM 1 (A,AI,G,O,W). Organic. Semi-transparent.

QUINOPHTHALONE YELLOW PY 138. BWS 7-8, ASTM I (A,O) ASTM II (W). Organic. Transparent.

RAW SIENNA See YELLOW OCHRE. May be replaced by transparent PY42.

RAW UMBER See BURNT UMBER.

RED BOLE Also BOLE. See RED OCHRE. Used as a ground for gold leaf and can be used in gesso. Formerly used in toned oil grounds.

RED EARTH See RED OCHRE.

RED IRON OXIDE PRIOI OR PRIO2. See MARS RED or RED OCHRE.

RED OCHRE Also ENGLISH RED, INDIAN RED, LIGHT RED, NATURAL IRON OXIDE, PERSIAN RED, RED EARTH, TERRA DI POZZUOLI, TERRA ROSA, PR 102. BWS 8. ASTM I (A,O). Earth. Variable opacity.

RHODAMINE PR81 BWS 4-6. / PR173 BWS 5. Organic. Transparent. *Caution*.

ROSE DORÉ NR9. BWS 6. Natural organic lake. Transparent. Can also be a mixture of pigments.

ROSE MADDER Also MADDER LAKE. NR9. BWS 6. ASTM I (AI) ASTM II (O). Natural organic lake. Transparent.

SANGUINE Red colour for pencil/pastel made of earths/iron oxides.

SAP GREEN Organic. Not permanent. Should be replaced by a mixture of permanent colours. Check C. I. Names.

SCARLET LAKE Used to be based on Carmine. A variety of pigments used, check C. I. Names.

SEPIA Natural organic. Not permanent. Semitransparent. Should be replaced by a mixture of permanent colours, check C. I. Names. BURNT UMBER is a good match.

SIENNAS See BURNT SIENNA and RAW SIENNA.

SILEX See SILICA.

SILICA Also SILEX. PW27. Unaffected by light. Mineral. Semi-opaque. Inert pigment. Matting agent in varnishes. *Caution* (crystalline silica).

SILVER WHITE See FLAKE WHITE.

STRONTIUM SALT PR48:3. BWS 6-7. Reduced in tint. Organic. Transparent.

SYNTHETIC IRON OXIDES See MARS COLOURS.

TALC Also ASBESTINE, FRENCH CHALK. PW26. Unaffected by light. Mineral. Inert pigment. Used in white for pastels.

TARTRAZINE YELLOW PY100. BWS 1-2. Organic. Transparent. *Caution*.

TERRA DI POZZUOLI See RED OCHRE.

TERRA ROSA See RED OCHRE.
TERRE VERTE See GREEN EARTH.

TETRACHLOROISOINDOLINONE

See ISOINDOLINONEYELLOW.

THÉNARD'S BLUE See COBALT BLUE.

THIOINDIGO PR88. BWS 7-8. Organic. Semi-opaque. Obsolete.

TITANIUM DIOXIDE See TITANIUM WHITE.

TITANIUM, TIN, ZINC, ANTIMONY OXIDE PY126. BWS 7-8. Inorganic. Opaque.

TITANIUM WHITE PW6. BWS 8. ASTM I (A,AI,G,O,W). Inorganic. Opaque. MIXING WHITE is a reduced strength Titanium White.

TITANIUM YELLOW See NICKEL TITANATE.

TOLUIDINE RED PR3. BWS 7. In tint BWS 4. Organic. Variable opacity.

TRANSPARENT IRON OXIDES See MARS RED.

TURKEY UMBER See BURNT UMBER.

TURKISH GREEN See COBALT TURQUOISE.

ULTRAMARINE ASH Poor-quality LAPIS LAZULI.

ULTRAMARINE BLUE Also FRENCH ULTRAMARINE. PB29. BWS 8. ASTM I (A.AI,G,O,W). Inorganic. Semi-transparent. Can bleach in acidic atmospheres. See also LAPIS LAZULI.

ULTRAMARINE PINK See ULTRAMARINE VIOLET.

ULTRAMARINE RED See ULTRAMARINE VIOLET.

ULTRAMARINE VIOLET Also

ULTRAMARINE PINK, ULTRAMARINE RED. PV15. BWS 7-8. ASTM I (A,O,W). Inorganic. Semi-transparent. Can bleach in acidic atmospheres.

UMBERS See BURNT UMBER.

VANDYKE BROWN Also CASSEL EARTH,

COLOGNE EARTH, NBr8. BWS 7-8. Earth. Transparent. A poor reputation but no defects can be found under testing by Winsor & Newton.

VEGETABLE BLACK See CARBON BLACK.

VENETIAN RED See MARS RED.

VERMILION PR106. BWS 7-8. Inorganic. Opaque. Can turn black in daylight. Obsolete. Replaced by CADMIUM REDS. *Caution*.

VERONA BROWN See BURNT GREEN EARTH.

VERONA GREEN See GREEN EARTH.

VINE BLACK Also BLUE BLACK, CHARCOAL BLACK, GERMAN BLACK, GRAPE BLACK, PBk8. BWS 8. ASTM I (O,W). Inorganic. Semi-transparent.

VIRIDIAN Also GUIGNET'S GREEN, HYDRATED CHROMIUM OXIDE. PG18. BWS 7. ASTM I (AI, G,O,W). Inorganic. Transparent.

WINSOR BLUE See PHTHALOCYANINE BLUE.

WINSOR GREEN See PHTHALOCYANINE GREEN.

WHITE BOLE See CHINA CLAY.

WHITE LEAD See FLAKE WHITE.

WHITING Also CALCIUM CARBONATE, CHALK, PARIS WHITE. PW18. Permanent. Earth. Inert pigment. Quite absorbent. Most used in gesso, in white for pastels and for buffering paper. GILDERS'WHITING rather than builders' whiting (which is very dirty and sandy) should be used by artists.

YELLOW EARTH See YELLOW OCHRE.

YELLOW IRON OXIDE PY42 or PY43. See MARS YELLOW and YELLOW OCHRE.

YELLOW OCHRE Also NATURAL IRON OXIDE, RAW SIENNA, YELLOW EARTH, YELLOW IRON OXIDE. PY43, BWS 8, ASTM I (A,AI,G,O,W). Earth. Variable opacity.

ZINC CHROMATE See ZINC YELLOW.

ZINC OXIDE See ZINC WHITE.

ZINC WHITE Also CHINESE WHITE, ZINC OXIDE, PW4, BWS 8, ASTM I (A,G,O,W). Inorganic, Semi-opaque.

ZINC YELLOW Also ZINC CHROMATE. PY36. BWS 8. Inorganic. Semi-transparent. *Toxic.* Obsolete.

PIGMENTS BY NUMBERS

Abbreviated Colour Index Generic Names

BLUES

NBI	Indigo		
PBI	Basic dye toner blue		
PB15, PI	315:1, PB15:3, PB15:4, PB15:6		
	Phthalocyanine blue		
PB16	Phthalocyanine blue		
	and phthalocyanine turquoise		
PB27	Prussian blue		
PB28	Cobalt blue		
PB29	Ultramarine blue and lapis lazuli		
PB33	Manganese blue		
PB35	Cerulean blue		
PB36	Cobalt turquoise		
PB60	Indanthrone blue		
PB73	Cobalt blue deep		
PB74	Cobalt blue deep		

BLACKS

NBk6	Bitumen	
PBkI	Aniline black	
PBk6	Carbon black	
PBk7	Carbon black	
PBk8	Vine black	
PBk9	Ivory black	
PBk10	Graphite	
PBkII	Mars black	
PBk19	Davy's gray	
PBk31	Perylene black	

BROWNS

Vandyke brown		
rll Bistre		
Mars brown		
Burnt ochre and burnt umber		
Azo condensation brown		
24 Chrome titanate		
PBr25 Benzimidazolone maroon		
Mineral Brown		

GREENS

PG7	Phthalocyanine green		
PG8	Naphthol green		
PG10	Green gold		
PG12	Ferrous nitroso-beta naphthol lake		
PG17	Chromium oxide green		
PG18	Viridian		
PG19	Cobalt green		
PG23	Green earth		
PG26	Cobalt chromite green		
PG36	Phthalocyanine green (yellow shade)		
PG50	Light green oxide		

ORANGES

Pyrazolone orange			
Cadmium orange			
Chrome orange			
Pyrazolone orange			
D36 Benzimidazolone orange			
Perinone orange			
PO48 Quinacridone gold			
49 Quinacridone gold			
Benzimidazolone orange			
PO67 Pyrazoloquinazolone orange			
Pyrrole orange			
Pyrrole orange			

REDS

NR4	Carmine			
NR9	Rose madder			
NR31	Dragon's blood			
PR3	Toluidine red			
PR4	Chlorinated para red			
PR7	Naphthol red			
PR9	Naphthol red			
PR12	Naphthol red			
PR48:3	Strontium salt			
PR49	Lithol red			
PR57:1	Lithol rubine			
PR81	Rhodamine			
PR83	Alizarin crimson			
PR88	Thioindigo			
PR90	Lead salt of eosine			
PRIOI	Mars red and burnt sienna.			
PR102	Red ochre, light red and burnt ochre			
PR 106	Vermilion			
PR 108	Cadmium red			
PRII2	Naphthol red			
PR122	Quinacridone magenta			

PR I 44	Azo condensation red	PW22	Barium sulphate
PR146	Naphthol red	PW24	Aluminium hydrate
PR 149	Perylene red	PW25	Gypsum
PR 166	Azo condensation red	PW26	Talc
PR168	Dibromoanthranthrone	PW27	Silica
PR169	Basic dye toner red		
PR 170	Naphthol red	YELL	.ows
PR 173	Rhodamine	NY24	Gamboge
PR 175	Benzimidazolone red	PYI	Arylamide yellow
PR 176	Benzimidazolone red	PY3	Arylamide yellow
PR 177	Anthraquinonone red	PY12	Diarylide yellow
PR 178	Perylene red	PY13	Diarylide yellow
PR179	Perylene red	PY14	Diarylide yellow
PR 188	Naphthol red	PY17	Diarylide yellow
PR202	Quinacridone magenta	PY31	Barium yellow
PR206	Quinacridone maroon	PY32	Strontium yellow
PR207	Quinacridone scarlet	PY34	Chrome yellow
PR209	Quinacridone scarlet	PY35	Cadmium yellow
PR224	Perylene red	PY36	Zinc yellow
PR233	Potter's pink	PY37	Cadmium yellow
PR251	Pyrazoloquinazolone red	PY40	Aureolin
PR254	Pyrrole red	PY41	Naples yellow
PR255	Pyrrole red	PY42	Mars yellow
PR264	Pyrrole red	PY43	Yellow ochre and raw sienna
PR270	Pyrrole red	PY53	Nickel titanate
		PY65	Arylamide yellow
VIOL	.ETS	PY73	Arylamide yellow
PVI	Basic dye toner violet	PY74	Arylamide yellow
PV2	Basic dye toner violet	PY83	Diarylide yellow
PV3	Basic dye toner violet	PY97	Arylamide yellow
PV4	PTMA violet	PY100	Tartrazine yellow
PV14	Cobalt violet	PY109	Isoindolinone yellow
PV15	Ultramarine violet	PYII0	Isoindolinone yellow
PV16	Manganese violet	PYII9	Magnesium brown
PV19	Quinacridone violet and	PY120	Benzimidazolone yellow
	quinacridone red	PY128	Azo condensation yellow
PV23	Dioxazine violet	PY129	Azomethine copper complex
PV29	Perylene violet	PY137	Isoindolinone yellow
PV49	Cobalt violet	PY138	Quinophthalone yellow
NA71 11	TEC	PY139	Isoindolinone yellow
WHI		PY150	Nickel azo yellow
PWI	Flake white	PY151	Benzimidazolone yellow Nickel dioxine
PW4	Zinc white	PY153	Benzimidazolone yellow
PW5	Lithopone	PY154	Benzimidazolone yellow
PW6	Titanium white	PY155 PY159	Praseodymium yellow
PW18	Whiting	PY175	Benzimidazolone yellow
PW19	China clay	PY184	Bismuth yellow
PW20	Mica	PY216	Titanium, tin, zinc, antimony oxide
PW21	Blanc fixe		

It is useful to understand some colour theory as it can go a long way towards helping your choice of colour on both the painting and the mixtures required on the palette. OCHETTE PAPIER AQUAREITE MOULD MADE: GRAIN TORCHON 300 Sm.
100% COTON FORMATE & LA GELATINE TENUE D'ARCHIVE SOBRE PARA ACUARRIAS APRESTADO CON GELATINA PERMANENCIA DE CONSERVACION 100% Cotton × 12 in (406 × 305 mg

THE TERMINOLOGY OF COLOUR THEORY

Hue Colour, for example red, blue or yellow.

Chroma The purity, saturation or intensity of a hue.

Tint Hue mixed with white.

Shade Hue mixed with black.

Tone Hue mixed with grey.

Value The extent to which a colour reflects or absorbs light. Cadmium yellow reflects a significant amount of light to give a high value, while yellow ochre absorbs more light to give a lower value.

Undertone: The colour of a pigment as it appears in a thin film, as opposed to its TOP or MASSTONE straight from the tube.

oil

water colour

104. Masstone and undertone of oil and water colour

Tinting strength A measure of the ability of a pigment to tint a white.

Transparency The ability of the pigment to transmit light and allow previous colour layers to show, for example a violet can be obtained by placing a transparent red over a transparent blue, or vice versa.

Opacity Opposite to transparency, for example an opaque red will cover up any previous colour layers. (NB opacity in water colour is low due to thinness of film)

Temperature A colloquial term used by artists to indicate the colour relative to red (warm) and blue (cold).

Primary colour In paints: red, blue and yellow, or more correctly, magenta, cyan and yellow.

Secondary colour A secondary colour is the result of mixing two primary colours, not necessarily in equal proportions.

Complementary The complementary of a primary colour is the combination of the two remaining primaries, for example in paints, blue and yellow mixed gives green, which is the complementary of red. Mixing complementaries, for example red and green, makes deep intense darks (blacks, browns and greys).

Spectrum order The spectrum order used by artistists is; yellow, orange, red, crimson, violet, blue, green, yellow earth, red earth, brown earth, black and white. See fig. 102 on page 137.

Additive colour mixing The mixing of coloured light is ADDITIVE. Secondary colours are purer, that is, away from black. This is the opposite to what happens when artists' colours are mixed and is the reason for much of the confusion regarding colour mixing.

Subtractive colour mixing The mixing of pigments is SUBTRACTIVE. Secondary colours become less pure, that is, towards black. This is the opposite to what happens when coloured light is mixed.

105. Additive (top) and subtractive (bottom) diagrams

THE OBJECTIVES OF COLOUR MIXING

The objectives of colour mixing in painting are to create the largest number of options from the minimum number of colours and to be able to mix the colour you want. The ability to succeed depends initially on the quality of the colour (see Artists' vs. student colours, page 26).

BASIC COLOUR THEORY

For reasons of simplicity, we are taught when young that the three primary colours - red, blue and yellow - are all that are required for colour mixing. In fact, in pigment form every colour has both a masstone and an undertone which is ifferent to the next colour. For example, a blue pigment will have either a red undertone or a green undertone in comparison to another blue pigment. French ultramarine is a red shade blue while Prussian blue is a green shade blue. This in turn is affected by which two you are comparing. For example, indanthrene blue is red shade in comparison to Prussian blue, but both would be classed as green shade blues. The colour bias is often most easily seen in a tint.

So, red, blue and yellow alone are not the whole story and in fact six colours provide a wider base for colour mixing: a red with a yellow bias, a red with a blue bias, a blue with a green bias, a blue with a red bias, a yellow with a red bias and a yellow with a green bias.

Blue Red Green Yellow

106. B,Y,R,G diagram

The hue and undertone of each colour are best seen on hand-painted colour charts which show graded washes. Printed tint cards can only indicate hue and undertone as closely as is possible within the limitations of the printing process, see fig. 102.

In practice: if an artist wants to mix green, blue and yellow are used. The cleanest green is made by using a green shade blue and a green shade yellow – for example, ultramarine (green shade) and cadmium lemon. If a red shade blue (French ultramarine) and a red shade yellow (cadmium yellow deep) were used instead, a dirty green would result.

THREE PRIMARY COLOURS

Of course, the use of three primary colours alone remains a good learning exercise. In this case, it is necessary to choose the red, blue and yellow which are the purest, for example the red which is as far as possible mid way between a blue shade and yellow shade. This ensures the cleanest violets and the cleanest oranges when using only one red.

Theoretically, the three primaries are magenta, cyan and yellow. However, remember that each artists' colour has a masstone and an undertone, that artists require a package of handling properties and that permanence is also important. Whichever range you use, look at the manufacturer's literature and web site or contact the manufacturer direct and ask them to recommend their choice of three primaries.

COLOUR PROPERTIES AFFECTING MIXING

An artist may already have Winsor blue (green shade), yet might use another green shade blue, Prussian blue, for its lower tinting strength. Additional colours within the same hue may also be used because of variations in opacity, tinting strength, drying rate, granulation and so on. Manganese blue hue may be used for its transparency and cerulean for its opacity, although they are both light blues.

SINGLE PIGMENTS

The common understanding that mixing too many colours together results in muddy browns is due to the subtractive nature of colour mixing with paints (see page 157). The use of single pigments is therefore an important benefit. The choice of two distinct colour positions in the red area, for example, will produce a wider range of mixtures, each being clean and bright.

The same principle applies to single pigments in the green, orange and violet areas of the spectrum. A single pigment green will provide a more intense (that is, further away from black) colour than if the artist were to try to mix that same green made from blue and yellow.

107. French ultramarine (top left) and Winsor blue (top right) with their reductions below them

TINTING STRENGTH

Every pigment varies in strength. Winsor blue, for example, has a high tinting strength while French ultramarine has a lower tinting strength. In other words, Winsor blue will have a dominant effect on any mixtures while ultramarine will have a moderate effect in mixtures. The illustration here shows each colour reduced by 1:5 with white.

Care is required in colour mixing to avoid the strong colours over-dominating the paint surface. Strong colours can be controlled by adding small amounts to the mixture repeatedly until the required hue is reached. Alternatively, some artists may choose colours with lower tinting

strength, for example, ultramarine (green shade) in preference to Winsor blue (green shade) as it has a lower tinting strength.

High tinting strength colours are often high key while low tinting strength colours are often low key.

As a general guide the following colours tend to have a high tinting strength, relative to other colours of similar hue: Benzimidazolones; cadmium yellows, oranges and reds; Winsor (phthalo) colours; colours prefixed with 'permanent', for example permanent alizarin crimson; perylenes; quinacridone colours; Prussian blue; Mars colours; burnt Sienna; lamp black and titanium white.

Artists' quality colours generally have higher tinting strength than the equivalent colour in the more moderately priced second-quality ranges. Although this does of course have an effect on colour mixing, providing stronger mixtures, it should not be confused with the relative strength of each pigment. For example, Prussian blue has a high tinting strength in all ranges.

absorbed by the dark surface - typically, a water colour on black paper. Transparent colours therefore appear brightest on white. In comparison, opaque colours reflect the light from the colour itself and appear bright on any surface. Opaque colours will also appear very bright when surrounded by black because the light is being reflected by the colour and absorbed by the black.

TRANSPARENCY

Every colour is relatively transparent or opaque and this also affects colour mixing.

Colours can be optically mixed by layers of transparent colours on the surface rather than directly on the palette. Depth is built up in paintings by this method, called 'glazing'. Flat areas of colour are achieved by using opaque colours such as cadmiums.

When mixed on the palette, transparent colours will tend to give bright, clean mixtures while opaque colours will give mixtures of lower tone.

The thickness of the paint film will of course affect the relative transparency. Thin films of colour will tend to be transparent either because they are physically thin or because the colour has been substantially diluted with medium before application. Thick films will always tend to be opaque because of the density of pigment on the surface.

Thick films of transparent colours will actually appear almost black in masstone. Transparent colours can only be seen when light is reflected back through the paint film from the support. In thick films, the light is absorbed and the colour appears dark.

When used thinly on black or dark backgrounds, transparent colours will not show as the light is

THE USE OF BLACK, GREY AND WHITE

In general, the addition of black will 'dirty' a colour. If the artist wishes to tone down a colour, Davy's gray will achieve this. For example, cadmium lemon and black will tend to an olive green while cadmium lemon and Davy's gray will tend towards a citrus green.

When using black as a colour, you can avoid dirtiness to some degree by taking note of the colour bias and tinting strength. Ivory black has a brown undertone and a low tinting strength, most suitable for tinting landscape colours. Lamp black has bluer undertone, more suitable for tinting skies, and has a higher tinting strength. Mars black is the densest, most opaque black, ideal for large areas of black and where the blackest black is required.

The addition of white to colour produces tints. Tints will be imperative for many artists to alter tone and produce shadows and highlights. However, a common mistake is the reliance on white to lighten all colours rather than develop colour-mixing skills to produce hues of varying intensity.

For opacity and high tinting strength, titanium white is best. For toning down a colour the lower tinting strength of zinc white (or mixing white or Chinese white) is excellent.

EFFECT OF MIXTURES ON LIGHTFASTNESS AND PERMANENCE

A mixture can never be more lightfast than the original two colours. If a fugitive pink is used with a blue to make violet, the pink will fade over the years, leaving the blue.

Almost all modern colours can now be safely intermixed without affecting permanence. If you have any concerns you should contact the manufacturer.

COLOUR AND TEXTURE OF SURFACE

What may seem a minute variation between two canvas textures or the colour of two water colour sheets can magnify itself when colour is applied. Increased canvas texture will tend to subdue the colour, while bright white paper will give very bright washes. Any surface which is over-absorbent, for example paper used for oil colour, will result in dullness of the colours. Choose a transparent colour, decide on a method of application and build up a comparison library by painting out this colour on to every new surface which you come across. You will be surprised by the difference.

LIGHT QUALITY

The light in your painting area will affect your colour enormously. Wherever possible, paint in daylight. North light is the preferred studio light because it is the most constant. In the summer, avoid painting in direct sunlight or your painting will be too bright indoors. If painting in electric light, daylight bulbs are best. Conventional tungsten lighting is yellow while fluorescent strip lighting tends to be blue. Any colours you mix under these lights will appear very different in daylight.

ARTISTS' BRUSHES

The large number of artists' brushes available reflects both the many different brushes that have been required over time to perform many different jobs, and the different hairs used to provide brushes with various price points. The result is a complicated array of products which many artists do not understand in full. The following is a glossary of brush terms for reference.

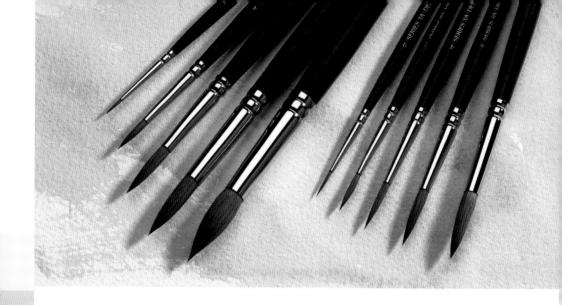

BRUSH VOCABULARY

Acrylic brush Synthetic brushes, with a mix of hair specially made for use with acrylic colour.

Balance The correct weight and shape of a handle in relationship to the weight of the brush head.

Belly The mid-section and thickest part of the brush head, or the individual hair filament itself. Sable filaments have excellent bellies, which result in well-shaped round brushes.

Blunt A hair which is missing its natural tip. Finest-quality brushes do not contain blunts or trimmed hairs.

Bright A chisel-ended, square-headed bristle brush. Bright was a painter.

Bristle Hog hair Coarse, strong hair, suited to thick brushwork in oil, alkyd and acrylic painting. Different qualities of hog brushes are available; the most expensive ones carry the most colour and retain their shape best when wet.

Camel A pseudonym for a mixture of miscellaneous hairs of low quality.

Crimp The compressed section of the ferrule which holds the handle to the brush head.

Designers' An elongated round sable, most common for illustration work.

Egbert An extra-long filbert.

Fan A flat fan-shaped brush, used for blending, available in both bristle and soft hair:

Ferrule The metal tube which supports the hair and joins it to the handle.

Filbert Flat brushes with oval-shaped heads, available in both bristle and soft hair.

Flag The natural, split tip of each bristle. Flags carry more colour and are evident on the highest-quality hog brushes.

Flat Usually long flat; flat hog brushes with a chisel end.

Goat Makes good mop wash brushes.

Gummed Newly made brushes are pointed with gum in order to protect them in transit.

Interlocked Bristle brushes with hairs curving inward towards the centre of the brush.

Kolinsky The highest-quality sable hair.

Length out The length of hair exposed from the ferrule to the tip.

Lettering Very thin, long, chisel-ended sables, traditionally used for lines and letters in sign-writing.

Liners See lettering.

Long flat See flat.

Mop Large, round, domed brushes, often goat or squirrel, used primarily to cover whole areas in water colour.

One stroke A flat soft-hair brush which allows an area to be covered in one stroke, traditionally used in signwriting for block letters.

Ox Bovine ear hair is used for flat wash brushes.

Pencil See spotter.

Polyester Synthetic hair is made of polyester; different diameter filaments, varying tapers, different colours and different coatings result in as many possible variations in synthetic brushes as in those made from natural hair.

Pony A low-cost cylindrical hair, that is lacking a point, often used for childrens' brushes.

Quill Bird quills were originally used for ferrules prior to the development of seamless metal ferrules. Still used in some squirrel brushes.

Rigger Very thin, long, round sable, traditionally used for painting rigging in marine pictures.

Round Available in both bristle and soft hair, the latter having different types of rounds.

Sable Produces the best soft-hair brushes, particularly for water colour. The conical shape and scaled surface of each hair provide a brush with an unrivalled point, responsiveness and colour-carrying capacity. There are different qualities, the finest being taper-dressed Kolinsky [Winsor & Newton Series 7].

Short flat See bright.

Snap See spring.

Solid-dressed Sable which is sorted in bundles of equal length prior to brush-making. Resultant brushes are not as responsive as taper-dressed sables.

Spotter Extra-short and small sable rounds, used for retouching photographs and other high-detail work.

Spring The degree of resilience of the hair and its ability to return to a point. Sable displays excellent spring.

Squirrel This hair makes good mop brushes but does not hold its belly or point well.

Stripers See lettering.

Taper-dressed Kolinsky sable which is sorted into different lengths prior to brushmaking. Resultant brushes have wider bellies and finer points.

Wash Large, flat, soft-hair brushes, used primarily for flat washes in water colour.

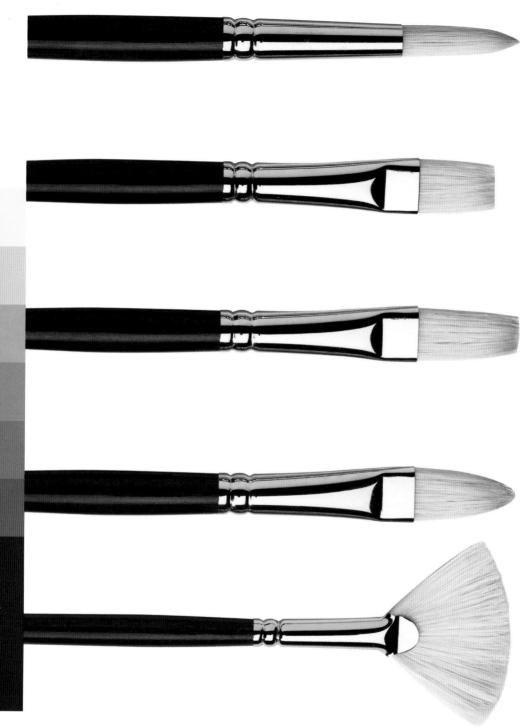

108. Bristle head shapes available (actual size, size 8, from top): Round, Short Flat/Bright, Long Flat, Filbert and Fan (size 5)

BRUSH TYPES

Artists' brushes can generally be categorized into two types, according to the type of hair used – bristle or soft. Each type can then be further categorized by the shapes available in each hair type. The bristle category includes the original hog but also the synthetic stiff brushes such as 'Artisan' for water-mixable oils. Soft brushes are

made of sable, ox, goat, squirrel, pony, camel and synthetic fibre. Sable produces the best soft hair brushes, particularly for water colour; its conical shape and scaled surface provide unrivalled points, responsiveness and colour-carrying capacity. The other types of soft hairs are available largely because of the high cost of sable and may be bought either with a single type of hair or a mixture.

Long-handled brushes are available for oil,

109. Soft hair head shapes available (actual size, from left): Rounds; Spotters/Pencils, Designers, Riggers, Lettering/ Stripers/Liners, One Stroke

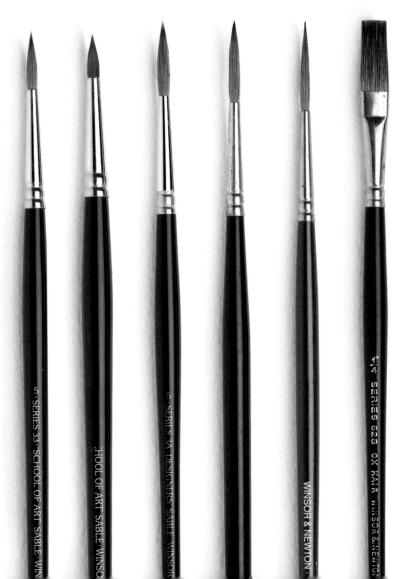

alkyd and acrylic painters, who are more likely to be at a distance from their work than water colourists, whose brush handles are shorter. Specialized brush shapes are also available, such as pointed mops.

109 (cont.). Soft hair headshapes (actual size) from left: Mops, Wash, Filberts and Fans

BRUSH SIZES

The sizing of brushes is most commonly done by a number system. Each number does not necessarily correlate to the same size brush in different ranges and this is particularly noticeable between English, French and Japanese sizes. It is important therefore that actual brushes are compared rather than relying on the sizes of the brushes you currently own.

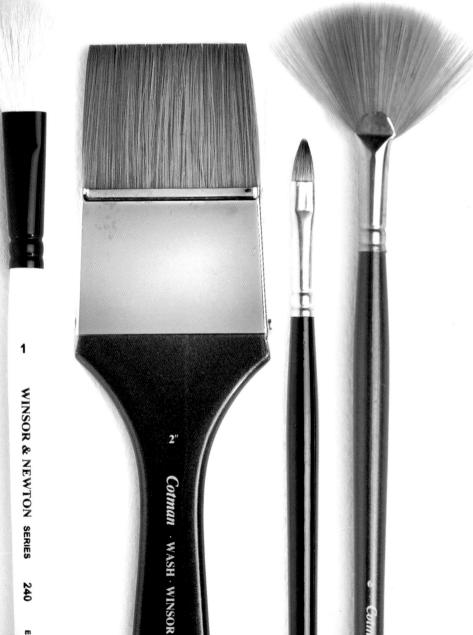

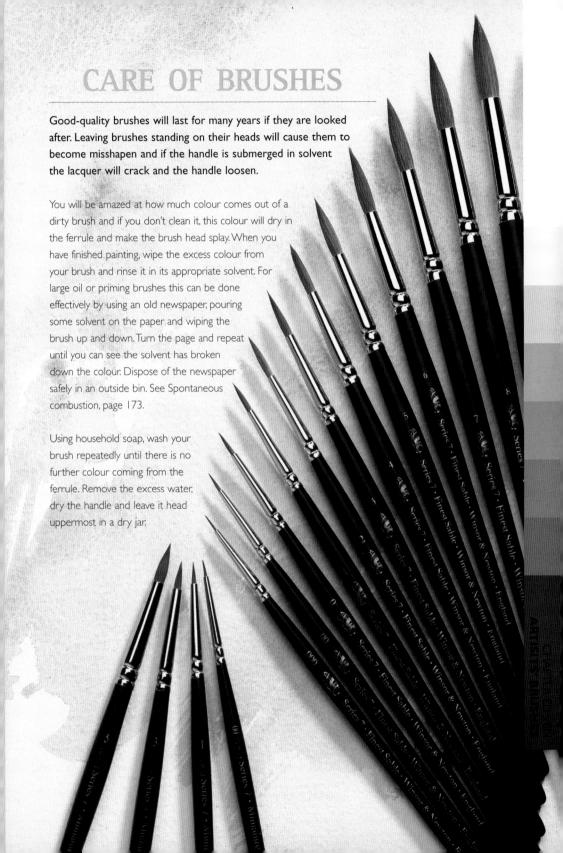

CHAPTER TWELVE HEALTH AND SAFETY

Artists' materials should not present a risk to health if handled in the correct manner. Health and safety, however, commands an increasing interest.

ROUTES OF EXPOSURE

For a product to cause a health risk it has to enter the body through ingestion, inhalation, or skin or eye contact. Precautions should be taken to avoid these according to the nature of the material being used.

When using dry pigments or other powdery products, minimize the mobility of the dust. Take out only what you need from the container and mix as soon as possible with the chosen medium. If possible, clean up powders by vacuum. If using dry pigments listed with *Caution* in the pigment list (page 139), ensure you wear an appropriate mask.

The most hazardous materials encountered by the artists are probably solvents. Exposure to turpentine and white spirits (mineral spirits) should be minimized. Avoid inhaling vapours and direct skin contact. Always keep bottles tightly closed and avoid pouring out more than you need. See *Economical use of thinners*, page 28

and *Good working practices* below. If possible use low-odour solvents with low aromatic content (for example Winsor & Newton Sansodor).

GOOD WORKING PRACTICES

Before you start Read the product labels in case there are any hazard warnings. This information is for your safety.

The place in which you paint Ensure there is adequate ventilation, and fresh air circulating in your work area. Do not sleep in your studio without removing painting materials elsewhere. Store all materials, particularly solvents, tightly capped when not in use. Do not expose artists' materials to naked flames or excessive heat sources. Keep artists' materials out of reach of children, animals and foodstuffs.

While working Do not eat, drink or smoke

when working due to the risk of ingestion (swallowing). Avoid excessive skin contact or inhalation of solvent vapours. Do not point your brushes in your mouth or apply colour directly with your fingers - use a barrier cream or surgical gloves. Wear an appropriate mask and exterior extraction system if airbrushing. Should materials get into the eyes, wash immediately with plenty of water. Wash the skin with soap and water. Clean up all spills. In the event of excessive exposure by the routes mentioned to any material, contact your doctor.

After painting Dispose of unused solvents and dirty rags in fireproof and solvent proof containers (see also *Spontaneous Combustion*, page 173). Wash hands thoroughly at the end of your painting session. Wear gloves when cleaning up and washing brushes.

LEGISLATION

EUROPEAN UNION

In Europe the Dangerous Substances and Dangerous Preparations directives, introduced in the 1960s, require the labelling of products which are considered hazardous to health or the environment. Look for the symbols with orange backgrounds, for example skull and crossbones for Toxic. In addition they will be accompanied by 'Risk' and/or 'Safety' phrases.

The most common classifications in artists' materials are Harmful, indicated by a St Andrew's Cross and Flammable. Only lead white (for example flake white) commonly carries the Toxic 'Skull and cross bones' symbol. Preparations which are dangerous for the environment have the so-called 'Dead fish, dead tree' symbol.

If you are a professional artist you will come

under the jurisdiction of the Safety at Work Act in the UK and will need to comply with the COSHH (Control of Substances Hazardous to Health regulations). Safety Data sheets on the materials you use are obtainable from your supplier. Details of safety legislation in the UK can be found on the Health & Safety Executive website.

All Hazardous preparations in the EU require child-resistant closures and have tactile warning triangles.

USA

Although common criteria may be used to determine hazards, the labelling thresholds differ between the EU and USA, as do the labelling phrases. In the USA the Labelling of Hazardous Art Materials Act requires specific labelling for artists' materials which has been determined by a government-approved toxicologist. All art materials, whether hazardous or not, will carry a statement 'Labelling complies with ASTM D4236'. Some products may have a seal of approval from the Art and Creative Materials Institute (ACMI) with AP (Approved Product) for non-hazardous products or CL (Certified Label) for hazardous products. In addition, products may carry warnings specific to state law, the most common being California Proposition 65. Data sheets are also available.

All hazardous preparations in the USA require child-resistant closures.

OTHER COUNTRIES

Different specific labelling may be found in other countries, in particular Canada, Australia and Japan. There is a proposal for a globally harmonized labelling system in the not too distant future, and if all countries adopt this it will be much easier to understand the labelling. Data sheets are also available in various countries.

ADDITIONAL INFORMATION

BRAND OF PRODUCT

Manufacturers all work from individual formulations, unique to themselves. This results in a wide choice of colours with slightly different characteristics being available under the same, or very similar commonly accepted names, for example 'cadmium red'. While this breadth of choice is essential to the artist, it should be remembered that the variance arises from the use of different ingredients and formulations. Because of this you should not use information provided by one manufacturer in connection with products from another. It is also worth remembering that a pigment, preservative or other ingredient may present a potential hazard in one product and not in another, depending upon the concentration of that ingredient.

PIGMENT VS PRODUCT

The pigment list (page 141) shows *Caution* against some pigments, for example cobalt blue, but this does not necessarily mean that cobalt blue oil colour will carry a label. This may mean the caution refers to the dry pigment only or that a manufacturer has used a particular grade of pigment which does not require caution. Look at the product labels of the colours you use and contact the manufacturer if you have any concerns.

MATERIALS FOR CHILDREN

Artists' materials are manufactured for use by adults, that is, persons over the age of 14. Small children are exposed to greater risks than adults because of their smaller body size and lower

weight. Artists' materials should be kept out of reach of children in order to prevent accidents from occuring.

TOY SAFETY

Some artists' materials do pass EN71, which means they can be used to make childrens' toys. This does not mean the materials themselves are for use by children.

SPONTANEOUS COMBUSTION OF OIL COLOURS AND LINSEED OIL

In combination with certain pigments such as raw or burnt umber, or in combination with driers as in Drying Linseed Oil, or alone, linseed oil can present a risk of spontaneous combustion when left on paper, rags or other easily combustible material in a confined space. As the linseed oil dries, heat can be generated to the extent of igniting the combustible material. The more the volume of waste increases in a confined space, the higher the fire risk. Discarded oily palettes and rags should be disposed of in airtight, metal containers, or alternatively, soaked in water, securely tied in a plastic bag and placed outdoors in a metal dustbin, placed away from buildings.

CONSTANT PRODUCT DEVELOPMENT

As raw materials improve, manufacturers are sometimes able to replace hazardous materials with safer substitutes. Consequently, you may find that a product which has a warning now will appear without such a warning in the future. As it is common for artists and retailers to retain products for a considerable time, it is advisable to read each label rather than to associate a particular hazard with a certain colour or product name.

APPENDIX I STORING, FRAMING AND CARE OF ARTWORK

STORING WORK

Works of art should be stored in conditions in which you would expect to feel comfortable yourself. Dampness must be avoided to prevent mould growing on paper, canvas, wood or gesso. Extremes of temperature should also be avoided. Work should be kept in the house, not in the garage or attic where temperatures are very cold in the winter and hot in the summer. Extreme cold may cause paintings to crack.

STORING WORK ON PAPER

Work on paper should be stored between sheets of acid-free tissue in a portfolio. Layer each piece of work individually. Pack the portfolio evenly, using the whole surface area, so that when shut, it will be packed firm rather than with a bulge in the middle and nothing in the outer edges. The work will get damaged if it

moves around inside the portfolio.

If the work is not smudgeproof (for example charcoal or pastels) or a thick paint film is likely to be squashed (for example acrylic or oil), a mount can be used to separate the surface of the picture from the next one. The width of the mount needed will depend on the size of the work. A piece approximately 56×76 cm (22 × 30 in) will need a mount approximately 38 mm (1 $\frac{1}{2}$ in) wide to support the piece on top of it. Mounts should be made of acid-free mountcard.

110. View of mounts and work sandwich

STORING CANVASES

Canvases should be carefully stacked against an inside wall in the house, that is, one that is the least likely to get cold or damp. Make sure that all the canvases are leaning against each other's stretchers and not against the canvas itself.

should be a millimetre or two wider than the painting to allow the wood of the stretcher to expand. For canvas boards, a stout backing board should be used to keep the canvas board flat in the frame.

PREVENTING DAMAGE TO WORK ON BOARDS

Care must be taken not to drop these boards, as without frames the edges are very susceptible to damage.

FRAMING YOUR WORK

FRAMES FOR CANVASES

The frames must be independent structures which the canvases fit into – the painting should not be hung using the stretcher. The frame

GLAZED FRAMES

The glass in the frame should not be directly on top of the work since condensation can build up from lack of circulation and mould will grow on canvas or paper. An oil or acrylic painting will also look squashed if the glass is directly on it. A mount or spacer must be used. A mount is usually coloured and shows as a border within the frame, while a spacer fits inside the lip of the frame and cannot be seen when looking at the picture. Both should be acid-free.

BACKBOARDS

A backing is used to keep dirt out of the frame. If a canvas already has a paper backing on the back of the stretcher (see page 22), gumstrip covering the gap between the stretcher and the frame will prevent any dirt getting to the

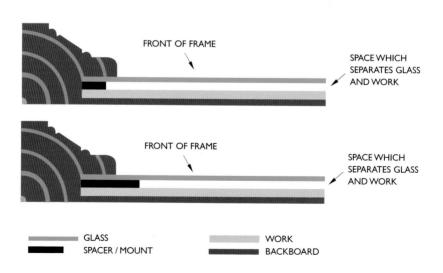

111. Cross-section of frames showing spacer and mount

painting. If there is no backing on the stretcher, a backboard must be used to exclude dirt and moderate the effect of changes in moisture from the atmosphere. The backboard does not need to be acid-free. Double-stretched canvases will keep the painting cleaner and less susceptible to humidity changes, but a backboard will be an added protection.

For work on paper, a hardboard backing is needed. To ensure an acid-free environment, the side of the hardboard which is to be against the paper can be covered in aluminium foil. You can glue it on with PVA glue. Acid-free tissue should be used if any further packing is needed. Gumstrip should be used to cover the gap between the backboard and the frame to help keep the work dirt-free.

HANGING WORK

Do not hang work over fireplaces or radiators as the heat will dry them out too much. Bathrooms and kitchens are not recommended either because of the excess of moisture, and kitchen atmospheres are also too greasy.

DAMAGED AND DIRTY WORK

If you want your work repaired or cleaned without risking further damage, you should take it to a conservator. To make the right decision and avoid damaging the work further requires a great deal of skill and knowledge.

APPENDIX II

NOTES FOR VEGETARIANS

If you are alkyd priming your own canvases you may prefer to use SMC rather than rabbit-skin glue.

You should enquire with the manufacturer for specific details, but generally speaking the following materials may include animal products: water colour, gouache, drawing inks, and water colour papers. Ivory black is bone black (PBk9) and should therefore be avoided in all colour ranges.

GLOSSARY

Aluminium stearate A possible stabilizer for oil paint.

Binder The substance which binds the pigment in a paint, ground or drawing material.

Casein Adhesive made from skimmed milk.

Chassis Wooden frame, fixed or expandable, used to brace a wood-based board on which to stretch either paper or a canvas. Interchangeable with 'stretcher' and sometimes 'frame'.

Cradled board Originally a hardwood panel with fixed strips along the grain and movable strips across the grain on the reverse, used to brace the board but still allow it to expand. In this book, 'cradled' is used to mean a woodbased board which has been glued and screwed to a fixed chassis. See fig. 69.

Canvas Loosely used to mean a stretched and primed canvas ready for use or already being painted on.

Double-stretched canvas Two layers of canvas stretched on one frame.

Drying oil Vegetable oil which dries to a film by oxidation.

Essential oil Extracted from plants, an oily liquid which is partly volatile.

Fugitive Indicates instability in the colour of a pigment.

Glazing Transparent colour over dry underlayer, used to create spatial and/or colour effects. Oil paint offers the widest manipulative possibilities in glazing but any transparent medium can be used for the purpose.

Ground A layer on the support which can vary in colour, absorbency or texture. In this book, 'primer' is also used for 'ground'.

Gum Hardened sap of plants which is either water-soluble or absorbs water.

Handling properties Group of properties which reflect smoothness, brushability, spreadability, tactility and so on.

Humidifier Material or equipment which retains moisture or prevents it escaping.

Imprimatura Coloured veil over a white ground. The term 'veil' is used in this book. See Coloured grounds in Index.

Key Rough surface.

Mahlstick A long rod with a padded end, used to steady your hand against a painting.

Masking fluid Rubber latex solution used to mask out areas on paper.

Media May be used for a particular method, for example oils, water colour and so on.

Medium Used either to indicate a particular method, or to indicate a material used for further manipulation of a method, for example glaze medium in oil painting. Plural is mediums.

Mineralized methylated spirit Type of alcohol.

Mineral oil Type of oil refined from petroleum.

Mineral wax Wax/es refined usually from petroleum.

Mull, Mulling Grind, grinding (rubbing) pigment with muller and plate (slab).

Parchment Prepared skin of sheep or goat, mainly for calligraphy.

pH of paper Measure of acidity. pH7 is neutral and indicates a paper which is acid-free.

Polymerized oil See stand oil.

Primer Ground.

Proprietary Often a trade-named product.

Resin, natural Hardened sap of plants which is insoluble in water.

Resin, synthetic Resinous compound, usually synthesized from petroleum.

Shellac Resin secreted by stick insects on certain trees, mainly in India. Available in a number of grades.

Sinking paint Layer of paint which sinks into underlayer.

Stand oil A drying oil which has been processed by heat. In this book stand oil can be assumed to be linseed stand oil. It can also be called polymerized oil.

Stretcher See chassis.

Support Material which supports the ground and painting or drawing.

Surfaced Rough surface.

Thixotropic A gel or fluid which flows when stress is applied eg. Liquin Light Gel.

Tooth Rough surface.

Toothed 'Toothed' and 'surfaced' are both used to indicate a roughened ground.

Vehicle The substance that carries the pigment. Often interchangable with binder.

Veil See imprimatura.

Vellum Prepared calf-skin, mainly used for calligraphy.

Wetting agent Usually a detergent-based liquid which breaks surface tension of a binder, and 'wets' the pigment or support.

BIBLIOGRAPHY

Unfortunately, some of these very good books are out of print. Copies can sometimes be found in local or college libraries. The British Library has copies for reference.

Brushes

TURNER, JACQUES. *Brushes - A Handbook for Artists and Artisans*. Design Press, New York, 1992.

Care of artwork

SMITH, RAY. See under 'General methods and materials'.

Casein and gesso

MAYER, RALPH. See *The Artist's Handbook of Materials and Techniques* under 'General methods and materials'.

Colour Theory

OSBOURNE, ROY. *Lights and Pigments, Colour Principles for Artists*. John Murray, London, 1980.

Distemper painting (also size painting)

KAY, REED. See under 'Tempera'.

STEPHENSON, JONATHAN. *The Materials and Techniques of Painting.* Thames & Hudson, London, 1989.

Encaustic painting; particularly using oil paint in

KAY, REED. See under 'Tempera'. STEPHENSON, JONATHAN. See under 'Distemper painting'.

Fresco painting

KAY, REED. See under 'Tempera'.

MAYER, RALPH. See *The Artist's Handbook of Materials and Techniques* under 'General methods and materials'.

SMITH, RAY. See under 'General methods and materials'.

General methods and materials

BAZZI, MARIA. *The Artist's Methods and Materials*. John Murray, London 1960.

BOMFORD, D., BROWN, C., ROY, A., KIRBY, J., and WHITE, R. *Art in the Making, Rembrandt.* The National Gallery, London, 1988

CHAET, BERNARD. *An Artist's Notebook*. Holt, Rinehart & Winston, New York, 1979.

CHURCH, A. H. *The Chemistry of Paints and Painting*. Seeley & Co, London, 1915 (fourth edition).

GETTENS, RUTHERFORD J. and STOUT, GEORGE L. *Painting Materials*. Dover, New York, 1966.

GOTTSEGEN, MARK DAVID. *The Painter's Handbook – A Complete Reference*. Watson Guptill, New York, 1993

LAURIE, A. O. *The Painter's Methods and Materials*. Dover, New York, 1967.

MAYER, RALPH. *The Artist's Handbook of Materials and Techniques*. Faber and Faber, London, 1991 (fifth edition).

A Dictionary of Art Terms and Techniques, A & C BLACK, London, 1970.

The Painter's Graft. Viking Press, New York, 1979, and Penguin, New York, 1977 (second edition).

PYLE, DAVID. What Every Artist Needs to Know About Paint & Colors. Krause, Wisconsin, 2000.

SEYMOUR, PIP. *Artist's Handbook.* Arcturus, London, 2003.

SMITH, RAY *The Artist's Handbook*. Dorling Kindersley, London, 2003 (second edition).

WEHLTE, KURT. *The Materials and Techniques of Painting.* Von Nostrand, New York, 1975.

Gesso sottile; Gesso, gelatin

THOMPSON, JR, DANIEL V. *The Practice of Tempera Painting*. Dover, New York, 1962.

Grounds, coloured, toned and dark, effects on oil painting

SMITH, RAY. See under 'General methods and materials'.

History of artists' materials

AYRES, JAMES. *The Artist's Craft*. Phaidon, Oxford, 1985.

History of pigments

HARLEY, ROSAMUND. *Artist's Pigments c. 1600-1835: a study in English documentary sources.*Butterworth Scientific, London, 1982 (second edition)

JENNINGS, SIMON. *Artists' Colour Manual.* HarperCollins, London, 2003. CARLYLE, LESLIE. *The Artist's Assistant*. Archetype Publications, London 2001.

Making water colours and gouache

MAYER, RALPH. See *The Artist's Handbook of Materials and Techniques* under 'General methods and materials'.

STEPHENSON, JONATHAN. See under 'Distemper painting'.

Oil media, other ingredients for

MAYER, RALPH. See *Artist's Handbook of Materials and Techniques* under 'General methods and materials'.

Papers

TURNER, SILVIE. Which Paper? Estamp, London, 1991.

Panels

AYRES, JAMES. See under 'History of artists' materials'.

Pigments

Colour Index International Society of Dyers and Colourists, Bradford, 1987 (third edition, third revision) and USA: American Association of Textile Chemists and Colorists. Copy in British Library or contact the Society of Dyers and Colourists.

FINLAY, VICTORIA. *Travels through the Paintbox* Sceptre/Hodder & Stoughton, London, 2002.

See also manufacturers' catalogues.

Winsor & Newton. *Notes on the Composition & Permanence of Artists' Colours.* London, 1997.

Priming metals

SMITH, RAY. See under 'General methods and materials'.

Scraperboard

MAYER, RALPH. See *The Artist's Handbook of Materials and Techniques* under 'General methods and materials'.

WEHLTE, KURT. See *The Materials and Techniques of Painting* under 'General methods and materials'.

Silicone ester painting

MAYER, RALPH. See *The Artist's Handbook of Materials and Techniques* under 'General methods and materials'.

Size painting

See under 'Distemper painting'.

Sodium carboxy methyl cellulose

SMITH, RAY. See under 'General methods and materials'.

Tempera

KAY, REED. *The Painter's Guide to Studio Methods and Materials*. Doubleday & Co., New York, 1972 (first published in 1961 as The Painter's Companion).

MAYER, RALPH. See *The Artist's Handbook of Materials and Techniques* under 'General methods and materials'.

SMITH, RAY. See under 'General methods and materials'.

THOMPSON, DANIEL V. See under 'Gesso sottile'.

Waxes, other

MAYER, RALPH. See *The Artist's Handbook of Materials and Techniques* under 'General methods and materials'.

ACKNOWLEDGEMENTS

I would like to thank Ian McLellan and Tessa Rose at Arcturus and Paul Giddens at Winsor & Newton for their support for updating this manual.

Thank you to Helen Wire, my editor on the original manual, who inspired me to write a new version. Thank you to Diana Vowles for her editing of this edition.

Thank you to Marsha Burke for kindly lending her copy of the original manual to Arcturus.

A sincere thank you to all my colleagues and friends, past and present, at Winsor & Newton. Their support and knowledge has endlessly increased my own abilities and I am as proud as ever to belong and contribute to the company. There is always more to learn!

Thank you to David Pyle, at Winsor & Newton, Piscataway, USA, for all his encouragement.

Thank you to Peter Waldron, Senior Research Chemist at Winsor & Newton, for his expertise on the pigment entries.

A big thank you to Alun Foster, Chief Chemist at Winsor & Newton, for the many hours of help with the pigment chapter and his expert editing of the Health & Safety chapter.

Thank you to Ian Garrett, Ian Maginnis, Davina Greeves, Phil Jones, Susan Bartko, Jackie Rickard and Maria Menear at Winsor & Newton for supplying the many materials used for photography.

Thank you to Alison Cunningham at Winsor & Newton for her help with the paperwork.

Thank you to Lloyd Wothers at Oasis Art and Crafts, Websters (Harpenden), John Cox and Nicholas Walt of Cornelissen for supplying various materials crucial for the illustrations in the book.

Thank you to Roy Perry and Tim Green of Tate Conservation regarding tempera, de-acidification of canvas and types of MDF.

A big thank you to Mick Miller for making the gesso boards and providing encaustic items and the encaustic painting.

Thank you to Eikon Design for a number of the illustrations.

Thank you to Richard Dixon Wright at St. Cuthbert's Mill for assistance with fig.81.

Thank you to Neil Robinson for the photography and all his help, patience and ideas.

Thank you also to Alun and our children Alice and Celia for being so patient while I spent all our spare time on 'the book'! Thank you too for helping to make all the items for the photographs.

And finally, thank you to all those who helped in any way on this and the original manual, Artists' Materials, Which, Why & How.

INDEX

For individual pigments see **The Pigment List** pages 141-151 and for Pigments by Numbers see pages 152-153.

For suppliers of materials, start with your local art shop or search the internet for the more unusual items.

Α	
acrylic binder with dyes 123	asphaltum 29
acrylic binder with pigment 123	atomizer 127
acrylic emulsion 42, 43, 127	
acrylic gesso primer 20-1, 118, 124	В
acrylic gloss medium 42	balsams 29
acrylic grounds 20-1, 43-4, 58	bamboo pens 122
acrylic inks 122-4	barrier cream 172
acrylic paint	beeswax 29, 38-9, 50-2
colour shift 44	bibliography 181-3
making own 45	binders
mediums 45-6	acrylic 123
pigments 45	chalk pastels 128-9
solvents 45	egg tempera 63-4, 65-6
thinners 45	encaustic paint 50-2
types 44-5	gum tempera 64-6
underpainting for oils 32	oils 25, 37-8
white pigments 46	pastels 131-2
acrylic painting	water colour and gouache paint 81-2
care of 51	black ink 123
equipment 47	bleached linen canvas 9
grounds 43-4	blended glues 103
introduction 41	blockboard 91,92
layers gradation 45	blown oil 37
overpainting with oils 46	Blue Wool Scale 137-8
resuming a picture 47	board, gesso supports
sinking 46	construction 92-3
supports and their preparation 42-3	degreasing 92-3
technique 46	preparation 92-3
varnish 47	sanding 93
acrylic picture varnish 47	sizing 95
acrylic primer 22	types 90-1
acrylic primer	boards
making own 45	acrylic painting 42
water colour and gouache painting on 73	bracing uncradled 101
additive colour mixing 157	canvas on 93
additives, acrylic paint 46	encaustic painting 50
alkyd grounds	finishing 98-9
acrylic painting 43	for stretching paper on 74-5
oil painting 20, 21-2	muslin on 93
alkyd mediums 28-9, 31,32	oil painting 9
alkyd paint, underpainting for oils 32	priming 23, 44 sizing 18-19, 95
alkyd resin paint 25	
aluminium 9	sizing, acrylic painting 43 water colour and gouache painting 73
American Society for Testing and Materials	bodied oil 37
(ASTM) 138	boiled oil 37
Artists' vs. student colour 26	brilliant watercolours 123
Aspenite 91	Dilliant Water Colours 125

brushes, artists'	casein 103-4, 131
bristle head shapes 166	chalk pastels
care of 169	binders 128-9
encaustic painting 54	making own 127-9
introduction 163	
sizes 168	paper requirements 124-6
soft hair head shapes 167	pigments 129
	technique 126
types 167-8	charcoals 120-1
varnishing brush 37	children's materials 173
vocabulary of brushes 164-5	China clay 132
wavy mottler 22	Chinese ink 123
buffered paper 113	Chinese white 82
burning in 55	chipboard 91
•	clear gesso base 24, 124
C	clear gesso primer, acrylic painting 43
calf-skin glue 103	cold pressed linseed oil 37
calcium hydroxide 10	Colour Index Generic Names 136-7
canvas	colour mixing
acrylic painting 42	additive 157
commercially prepared 10	black 160
de-acidifying 10-11	characteristics affecting 158-61
dents removal 46	encaustic painting 53
encaustic painting 50	grey 160
initial preparation 10-11	introduction 155
oil painting 9	light quality 161
priming 21-4, 43-4	lightfastness 161
removing from stretcher 34	objectives 157
reuse 34, 46-7	permanence 161
sagging prevention 22-3, 44	single pigments 158
sewing together	subtractive 157
sizing, oil painting 16-18	surface colour 161
stretching 11-15	surface texture 6
types 9-10	tinting strength 159-60
water colour and gouache painting 72	transparency 160
canvas boards	white 160
acrylic painting 42	colour theory
encaustic painting 50	basics 157-8
oil painting 18-9	terminology 156-7
priming 44	three primary colours 158
canvas mounted on board	coloured grounds
gesso ground 93	acrylic painting 43
canvas on open stretchers	gesso 101-2
oil painting 9	oil painting 23-4
canvas pliers 12	paper 124-6
care of finished drawings 133	coloured inks 122-4
care of finished paintings	
acrylic painting 47	coloured pastel paper 125
damaged work 177	coloured pencils 121
dirty work 177	combined resin varnish formulations 36
encaustic painting 55	commercially prepared canvas or board 10, 2
oil painting 34-5	commercial pens 121-2
position when hung in homes 177	commercial primers 21
	complementary of primary colour 156
tempera painting 68	copper 9,50
water colour and gouache painting 87	cotton canvas 9
see also storing work	cotton paper 110
Carnauba wax 51	cracking, oil painting 32
carved gesso 98	

D	genuine gesso 89-107
damaged work 177	acrylic painting 43
Dammar resin 51,65	encaustic painting 50
Dammar varnish 36, 64, 69, 132	oil painting 20
deacidifying canvas 13	silverpoint 118-9
deckle edges 110-1	tempera painting 58
degreasing boards 92-3	water colour and gouache painting 73
dextrin 82	gesso
de-ionized water 59	binders less often used 103-4
dirty work 177	board 90-1,97
drawing boards 74	canvas on board 97
drawing materials	carved 98
grounds 118	coloured grounds 101-3
introduction 117	cracking 106 glue, making own 94-5
supports 118	gritty 106
drying oils 37-8	ground 20, 47, 50, 58, 73, 89, 94-101, 118-9
drying rates in oil 30-1	incised 98
dry tinting 125-6	making own 95-6
E	manufactured powders 104
	opaque coloured 102-3
egg emulsion 69 egg tempera 58, 63-4, 67	patterned 98
egg/oil emulsion 69	pigments 104-5
emulsion for grounds 21	problems 105-6
encaustic paint	sanded 98
binders 50-2	sizing 99-101
making own 52-3	sottile 104
mediums 53	sprigged 98
mixing colours 53	stippled 98
thinners 53	supports 90-3
encaustic painting	surfaced 98
brushes 54	toothed 98
burning in 55	using 96-7
grounds 50	glass, painting on 23
hotplate 52-3, 54	glass palette 47
introduction 49	glaze mediums 28-9
layers gradation 53	glossary 179-80
oil in 30	glycerine 64, 81, 104
pigments 52	gold 118 gouache see water colour and gouache painting
supports 50	graphite drawing materials 120-1
technique 54-5	grounds
eraser 20-	acrylic painting 43-4
F	alkyd, acrylic painting 43
-	alkyd, oil painting 20-1, 21-2
fat over lean 'rule' 32 fixatives 127	coloured, acrylic painting 43
flake white 31-2, 58-9, 104	coloured, gesso 101-3
flocked paper 124	coloured, oil painting 23-4
framing work	coloured paper 124-5
backboards 177	drawing materials 118
canvases 176	emulsion 21
glazed frames 176	encaustic painting 50
paper 177	gesso 89-107
1 12	half chalk 106-7
G	oil painting 20-4
gelatin 16, 103, 131	quality 21
gelatin size 100-1, 112	tempera painting 58

types 20-1	pastels 130-2
water colour and gouache painting 72-3	size 16-18
gum acacia 81, 131	stretcher 15
gum kordofan 64, 81, 86	tempera paints 59-66
gumstrip 77	water colour and gouache 82
gum tempera 58, 64, 67	marble 43
gum tragacanth 128	
garri d'agacariar 120	masking fluid 86
н	mastic 29
	matt oil painting 28
half chalk ground 20, 107	matt varnish 36
handmade paper III	medium density fibreboard (MDF) 90-1
hanging work, position in homes 177	mediums
hardboard 91	acrylic paint 45-6
hazardous materials 171, 172	encaustic paint 53
health and safety 171-3	glaze 28-9
hessian as canvas 10	oil painting 27-30
honey 104	water colour and gouache painting 86
hot plate 52-3, 54	metal 9
Hot-pressed paper 114	
household paint 21	drawing materials 118-19
Household paint 21	encaustic painting 50
1	marks 119
	paintboxes 84-5
impasto 29-30, 41, 49	priming 23
incised gesso 98	methylated spirits 60, 92, 131
Indian ink 123	methyl cellulose 131
inert pigments 140	microcrystalline wax 51
infra red lamp 55	mineral spirits 27
inks, coloured 122-4	mixed white 31
insulation board 91	mixing white 46
ivory 43	mould-made paper 111
,	
K	muller and slab 38, 59, 62, 130
Ketone resin varnish 36	muslin on board 93
retorie resiri varriisi 30	NI.
L	N
	nib cutting 122
labelling of dangerous materials 172	Not paper 114
laid paper 113-14	
lead pencils 120-1	0
leather 42	oil charcoal 121
legislation 172	oil content 32
lightfastness 137-8, 161	oil of spike lavender 29
linen canvas 9	oil paint
linen and cotton mixtures canvas 9	drying rates 30-1
linseed oil 37	
linseed oil dangers 173	filling empty tubes 39
low-odour solvent 27	half dry 34
10W-0d0di 30IVEHL 27	making own 37-9
М	pigments 26
	stick form 26
machine-made paper	storing once exposed 34
making own	types of oils 37-8
acrylic paint 45	white pigments 31
acrylic primer 45	oil painting
chalk pastels 127-9	canvas types 9-10
encaustic paint 52-3	care of finished paintings 34-5
gesso 95-6	cracking 32
gesso glue 94-5	grounds 20-4
oil paint 26, 37-9	introduction 7
	" " Oddellott /

layers gradation 28	water colour and gouache painting 73-80
mediums 27-30	parchment 42
oil paints 25-6	parchment clippings 103
oiling out 33	particleboard 91
painting on sized canvas 19	pastels
painting on supports without sizing or	binders 131-2
priming 20	making own 130-2
sinking 33	oil 132 wax 132-3
sizing gesso 99	
supports 9	see also chalk pastels patterned gesso 98
technique 33-4	pencils 120-1
thinners 27-8	pens 121-2
underpainting 32 varnishing 35-7	permanence of pigments 137-8, 6
white underpainting 32	pigment
Oil Painting Primer 20	artists' 26
oil pastels 132	student 26
oil primer over acrylic primer 21	Pigment List 141-51
oil varnishes 29	abbreviated number order 152-3
oil/resin paint 25, 32	abbreviations used 137
oiling out 33	using 140
oleoresins 29	pigments
oils 37-8	acrylic paint 45
opaque coloured gesso 102-3	Blue Wool Scale 137-8
opaque tinted grounds 23-4, 124-5	caution warnings 173
	chalk pastels 129
P	Colour Index Generic Names 136-7
paper	encaustic painting 52
acid free 109	gesso 104-5
attaching to board 77-8	hue 136
buffered 113	inert 140
coloured pastel 125	inorganic 138-9
colouring 125	introduction 135
cutting on an open frame 79-80	lightfastness 137-8
fibre types	mulling tempera paints 60-2
introduction 109	names 136-7
laid 113-14	oil painting 26
mechanical woodpulp 110	opacity 139
Not 114	organic 138-9 permanence 137-8
preparation for water colour and gouache	permanence ratings 138
painting 73-80	single 158
production 111 recycling stretched paper 80	spectrum order 137, 156
right side 114	stabilizing colours 38-9
sizing 112-13	stringy 38
soaking 75-7	tempera paints 58-9
stretching 74-80	terminology 136-7
stretching on an open frame 78-9	tinting strength 159-60
surface of 114	toxicity 139-40, 171
surfaced pastel 124	types 138-9
weights 115	pin-holes in gesso grounds 105-6
woodfree 110	Plaster of Paris 104
wove 113-14	platinum 118
paper as support	plumber's solder 118
acrylic painting 42	plywood 91,92
encaustic painting 50	polyester as support, acrylic painting 42
oil painting 9	polyester cloths as canvas, oil painting 10

poppy oil 37 precipitated chalk 104 priming boards 23 canvas 20-2, 43 canvas already primed 10	starch glue 78, 112, 132 steel 9, 50, 53 sterilising equipment 62, 64, 65, 128 Sterling board 91 stippled gesso 98 storing work
metals 23, 182	canvases 176
paper 124	paper 175
product brands 173	work on boards 176
product development 173	stretcher
PVA 43, 45	making own 15 making up 11-12
Q	placing canvas on 12-14
quills 122	removing canvas, acrylic painting 47 removing canvas, oil painting 34
R	wedges for tension 14-15
Rabbit skin glue 16-9, 94	stretching canvas 11-15
reed pens 122	stretching paper 74-80
refined linseed oil 37, 121	stringy pigments 38
refined poppy oil 37	subtractive colour mixing 157 Sundeala A 91
resin glaze mediums 28-9 retouching varnish 36	sunflower oil 38
rosin size 112	sun processed oils 37
rough cloth 18	supports
Rough paper 114	acrylic painting 42-3
Rules 32	acrylic painting, absorbency 43
S	drawing materials 118
'safe' solvents 27	encaustic painting 50 gesso 90-3
safflower oil 38	oil painting 9-19
sanded gesso 98	tempera painting 58
sanding boards 93	water colour and gouache painting 72-3
Scotch glue 78-9	surface-sized paper 112
scraperboard 120	surfaced gesso 98
sculptural pieces, encaustic painting 50	surfaced pastel paper 124
shellac 29	synthetic mixtures canvas 9
shellac binder with dyes 122 shellac size 75, 101	Т
silver 118	talc 104, 132
silverpoint 119	tempera paint
sizing	binder for egg tempera 63-4, 65-6
boards 18-19, 43	binder for gum tempera 64-6
boards for stretching paper 75	de-ionized water 59
canvas, oil painting 16-19 gesso 43, 99-101	egg emulsion 69
paper 112-13	egg tempera 58 egg/oil emulsion 69
slate 43	emulsion recipes 69
slubs 18	flake white 58-9
sodium carboxy methyl cellulose 16	gum tempera 58
soft sizing 112-13	making own 59-66
softboard 91	mixing the paint 66-7
solvents 27, 53, 65, 171	pigments 58-9
soya oil 38	stability 66-7 storing 67
spectrum order of pigments 137, 156 spontaneous combustion 173	tempera over wet oil paint 68
sprigged gesso 98	white 58-9
stand oil 28, 31, 33, 37, 64, 69, 107	

tempera painting	solvent for water-mixable oil paints 2/
care of finished paintings 68	thinner for acrylic paint 45
drying time 68	thinner for water colour and gouache paint
durability 67	86
grounds 58	water colour and gouache paint
introduction 57	binders 81-2
layers gradation 67	making own 82
sizing gesso 99	pigments 82
0.0	thinners 86
supports 58	water colour paints 82
technique 67-8	
underpainting for oil 32	white gouache 82
varnish 69	water colour and gouache painting
'temperature' 156	care of finished painting 87
tempered hardboard 91	grounds 72-3
texture gels, acrylic paint 46	introduction 71
thickened oil 31, 33, 37, 107	layers gradation 86
thinners	mediums 86
acrylic paint 45	paper preparation 73-80
encaustic paint 53	paper stretching 74-80
oil paint 27-8	silverpoint ground 118
use 27-8	sizing gesso 99
water colour and gouache paint 86	supports 72-3
o ,	technique 82-4
three primary colours 158	varnish 87
tinman solder 18	
titanium 20, 31, 46, 59, 82, 95, 107, 118, 132,	water mixable oil mediums 30
150	water mixable oil paint 25
toned grounds 23, 102, 124-5	water mixable oils 21
toothed grounds 21,98,124-5	waterleaf paper 12-13
toxicity 171-3	wax pastels 132-3
'toy safety' 173	wax picture varnish 36, 47, 68
transparent veils 23, 102	wedges 14-15
turpentine 27, 65, 171	wet tinting 125
	white
U	acrylic paint 46
underpainting for oils	Chinese white 82
acrylic paint 32	colour mixing 160
	flake white 31-2, 58-9, 104
alkyd paint 32	Gouache 82
oil painting 32	mixing white 46
tempera painting 32	
UV absorber 36	oil paint 31
	pigments for tints 132
V	talc 104, 132
varnish	tempera paints 58-9
acrylic painting 47	titanium 20, 31, 46, 59, 82, 95, 107, 118, 132,
applying 36-7	150
oil 29	underpainting 32
oil painting 35-7	water colour and gouache paint 82
tempera painting 69	zinc 31, 46, 59, 105, 107, 132
UV absorber 36	white spirit 27, 53, 65, 171
water colour and gouache painting 87	whiting 95, 105, 107
vegetarians 177	working practices 171-2
vellum 43	wove paper 113-14
Velium 43	wove paper 113 11
W	Z
walnut oil 38	zinc 50
water	zinc white 31, 46, 59, 105, 107, 132
de-ionized 59	

EMMA PEARCE

A graduate from the Slade School of Fine Art, Emma has had an interest in the mechanics of artists' materials since first painting. On graduation she taught Methods and Materials at many colleges for five years, including the Slade, UCL; the Ruskin School of Drawing, Oxford, and the Tate Gallery, Millbank, while also writing for Artists' Newsletter and The Artists' and Illustrators' Magazine on her subject.

In 1992 her handbook Artists' Materials, Which. Why and How was published by A & C Black and in the same year she joined Winsor & Newton as Technical Adviser, Involved in all aspects of the company, Emma describes her job as 'the perfect job for me'. Maintaining product ranges, developing new colours and products, answering technical enquiries, contributing to lecture programmes, writing Winsor & Newton literature and articles for the art press, acting as consultant on art books, working on the Internet, maintaining the museum and archive, giving factory tours and helping conservation projects are but a few areas which constantly expand her working knowledge of artists' materials and techniques.

WINSOR & NEWTON

William Winsor and Henry Newton founded their business in 1832 with the determination to improve the choice and permanence of artists' materials. They were immediately successful and continue to this day to provide artists with the widest choice of permanent colours. Their exhaustive technical approach combined with the long service of employees results in a depth of information second to none.

Winsor & Newton are delighted to support this new source book for artists.